The publication of this volume was initiated by
Gerard L. Cafesjian, Vice President of West Publishing
Company and Chairman of the West/ART AND THE LAW
exhibition program. For the energy and ideas that have made
the art program a reality, we thank Mr. Cafesjian.
The West Collection is housed at the corporate headquarters
of West Publishing Company, St. Paul, Minnesota.

The West Collection

WEST PUBLISHING COMPANY • ST. PAUL • MINNESOTA

COLOPHON

Art Consultants . Laurel O'Gorman
Otto S. Theuer

Book Design . Laurel O'Gorman
Marie PanLener

Editors . Todd Maitland
Laurel O'Gorman

Editorial Assistance . Sandy Stryker

Photography . Roger Kramer

Production Coordinator . Judy Vicars

Project Director . J. Douglas Grainger

Produced by West Publishing Company on a 28 × 40 Mitsubishi Daiya 3D five-color press on Quintessence Dull Text with Smyth sewn case binding.

The Collector's Limited Edition volume is bound in Cabra leather and stamped with gold foil.

The Standard Edition is bound in Bamburger linen sailcloth and stamped with gold foil.

Copyright 1986 by West Publishing Company
50 W. Kellogg Boulevard
P.O. Box 64526
St. Paul, MN 55164-0526

Library of Congress Cataloging in Publication Data

The West Collection.

Includes index.
1. Art. American—Catalogs. 2. Art, Modern—20th century—United States—Catalogs. 3. Law in art—Catalogs. 4. West Publishing Company—Art collections—Catalogs. 5. Art—Private collections—Minnesota—St. Paul—Catalogs. D. West Publishing Company.

N6512.W438 1986 709'.73'0740176581
86-13131
ISBN 0-314-95791-X

Table of Contents

SELECTORS

Since 1979 the annual ART AND THE LAW exhibition has included a national tour as part of West's corporate art program. The exhibit has traveled to museums, universities, law schools, and courthouses through the cooperation of many people, not only in the art community but also in business, education, and especially the legal profession. More than forty cities across America have seen the annual exhibits, which have presented the work of over five hundred artists since the program's inception.

1986

The House of the Association of the Bar of the City of New York, New York

Loyola Law School
Los Angeles, California

Blanden Memorial Art Museum
Fort Dodge, Iowa

Minnesota Museum of Art
St. Paul, Minnesota

Sunrise Art Museum
Charleston, West Virginia

Travel History

1985

Russell Senate Office Building Rotunda
Washington, DC

Alexandria Courthouse, Virginia
In cooperation with Alexandria Bar
Association

Cedar Rapids Museum of Art
Cedar Rapids, Iowa

Salt Lake Art Center
Salt Lake City, Utah

Minnesota Museum of Art
St. Paul, Minnesota

1984

Minnesota Museum of Art
St. Paul, Minnesota

Albany Museum of Art
Albany, Georgia

Allied Bank Plaza
Houston, Texas
In cooperation with Houston Bar Association

The Canton Art Institute
Canton, Ohio

1983

Atlanta Memorial Arts Center
Atlanta, Georgia

Kittredge Gallery
University of Puget Sound
Tacoma, Washington

Portland Justice Center
Portland, Oregon

Florida District Court of Appeals
Supreme Court Building, Tallahassee

Greenville County Museum of Art
Greenville, South Carolina

Marin County Civic Center
San Rafael, California

1982

Landmark Center, Cortile Gallery
St. Paul, Minnesota

Florida District Court of Appeals
Supreme Court Building, Tallahassee

Nueces County Courthouse
Corpus Christi, Texas

Fiske Planetarium
University of Colorado
Boulder, Colorado

1981

Minnesota Museum of Art
St. Paul, Minnesota

District Court of Appeals
Supreme Court Building, Tallahassee

North Carolina State Bar Association
Raleigh, North Carolina

Cedar Rapids Museum of Art
Cedar Rapids, Iowa

Underwood Law Library
Southern Methodist University
Dallas, Texas

1980

Katherine Nash Gallery
University of Minnesota
Minneapolis, Minnesota

Tulane University
New Orleans, Louisiana
In cooperation with the
City of Dallas
City Hall
Dallas, Texas
In cooperation with the
State Bar of Texas
Texas Law Center
Austin, Texas

1979

Museum of Art
University of Arizona
Tucson, Arizona

University of Missouri Art Gallery
Kansas City, Missouri

Kansas Judicial Center
Topeka, Kansas

Museum of Philadelphia Civic Center
Philadelphia, Pennsylvania

Albrecht Art Museum
St. Joseph, Missouri

Courthouse Gallery Forum
Allegheny County Courthouse
Pittsburgh, Pennsylvania

Robert Kahn Gallery
Houston, Texas

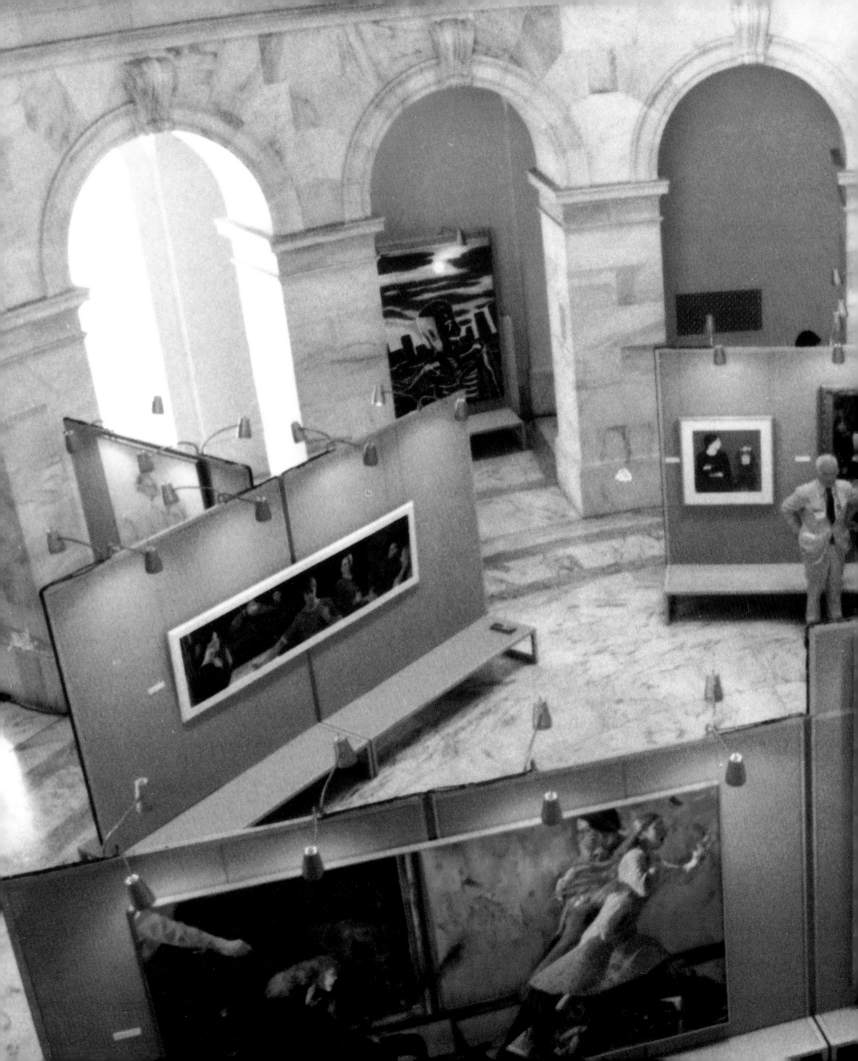

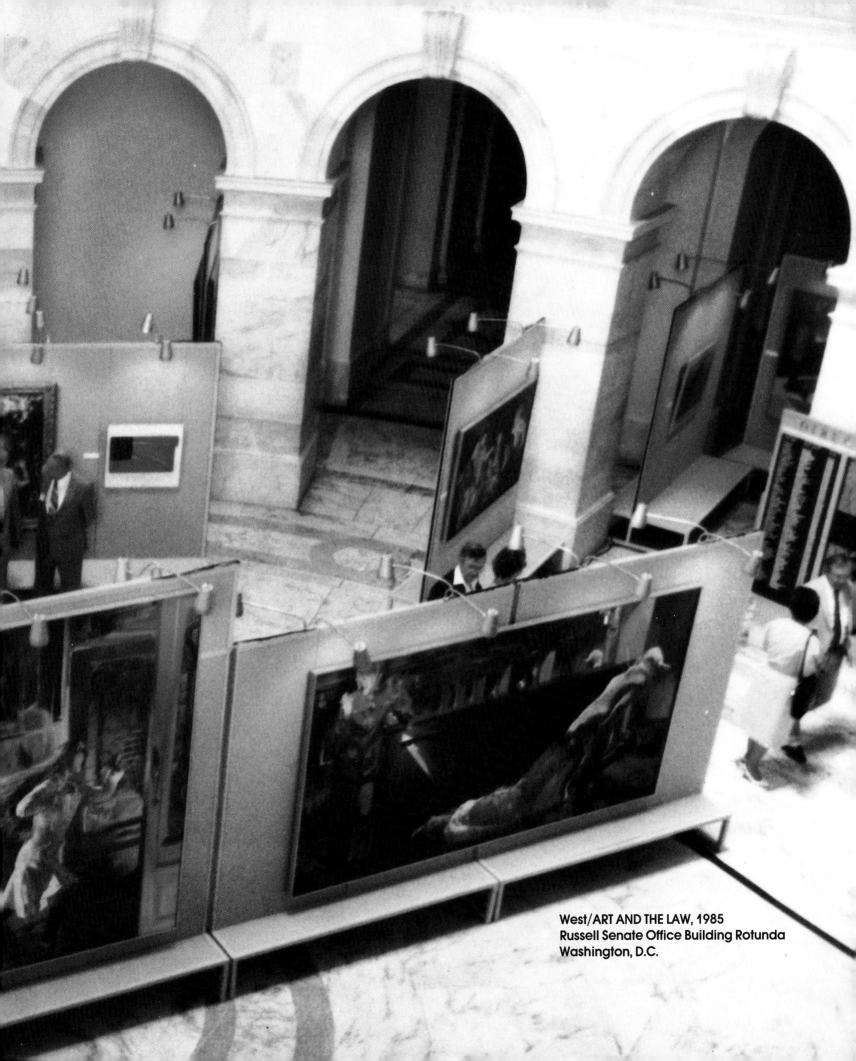

West/ART AND THE LAW, 1985
Russell Senate Office Building Rotunda
Washington, D.C.

As practices and institutions, art and the law are as old as human culture. Indeed they are measures of it; neither would exist without the striving—which is cultural—of the human community to sustain itself by the insurance of orderly conduct and to find meaning for itself through poetic expression. From a concern for order, law has derived such necessary concepts as rights and responsibilities, justice and mercy, innocence and guilt. Art in turn has developed its own abstractions: image and metaphor, form and content, beauty, mystery, even terror.

It would seem, then, that art and the law have long histories not only unto themselves but as allies in the human cause. And surely this is true if we recall how Phidias the sculptor and Pericles the magistrate joined forces to transform the ideals of the Athenian city-state into the substance of the Parthenon.

Yet if the link between art and the law goes back to the earliest human memory, it could have taken on the form it reveals in this volume only in modern times. Through the ART AND THE LAW exhibitions, West Publishing Company has encouraged artists to comment on the law. It has also acted in the ancient role of patron, though from a motive that would have been unthinkable during those periods when patronage expected, and usually got, art to provide it with an unalloyed affirmation of itself. But the artist of the twentieth century is as likely to be a critic of the law as a celebrant of it. We all know this, of course; modern art's origin in rebellion against establishment doctrine is a fact of which schoolboys are aware. But the willingness of a patron to stimulate a broad variety of editorializing, negative as well as positive, about the ideas the patron stands for, is less familiar.

Yet it is every bit as modern. For freedom of expression—a concept equally recognizable to lawyers as to artists—is one of the articles of faith of the modern Western mind. It is, in fact, quite fitting that a body representing the law—in this case, West Publishing Company—should assume the lead in advancing the right of artists to speak out as they choose, for as Clarence Darrow is quoted on page 65, "You can only protect your liberties in this world by protecting the other man's freedom. You can only be free if I am free."

And the contemporary American artist has responded to this invitation—this challenge, if you will—with a vigorous exercise of the imagination. One of the problems in assembling a collection like this one, which West Publishing Company selected from the exhibitions it has sponsored since 1975, is to find a way of mediating between freedom of expression and a single necessary thematic condition, namely that the works of art shown finally address the concept of law in some relevant way. As a past juror, I can attest to the difficulty of making this assessment. Sometimes paintings have been submitted that are formally altogether persuasive, yet they express nothing discernibly pertinent to the law. In such instances the jurors have been inclined to accept works rather than reject them, and West Publishing Company has joined in this further embrace of freedom.

The result has been profitable to the collection, not just because creative freedom has been honored in the abstract, but because artists have produced a wide and surprisingly illuminating range of outlooks on the law. It is fully expectable that some images here elicit our admiration of acts and individuals that have contributed most beneficially to the orderly life the law seeks to enhance. John Wilde's

portrait of Supreme Court Justice Hugo Black comes to mind, along with Wilde's written statement identifying Black as one of his personal heroes. A kindred spirit of optimism is invoked by Alice Dalton Brown in *Lifting Flag*, a painting in which our attention is directed to the relationship between our domestic security and the banner that figuratively protects and precedes it. Meanwhile, Abraham Rattner's *Moses: I Am That I Am* raises the issue of law to the level of the Divinity.

Yet there is no less awareness among the contributing artists of the grimmer aspects of human existence, including those the law has sought to ameliorate as well as those it has at times, alas, grievously abetted. The fractured reality in Robert Birmelin's *City Crowd—Event with Two Police* speaks for itself, while the perversions of patriotism and "law and order" are protested with comparable boldness in Dan F. Howard's *Brotherly Love, and Patriotism Too.*

While reverence for the law and critiques of it occupy many of the artists, other attitudes are manifest as well. In an age all too accustomed to violence, the Victim becomes the central figure in a wide assortment of works here, whether in the prostrate form of Harvey Dinnerstein's *Raped*, the child of divorce in Scott Fraser's *The Pawn*, or the soldier—and his next of kin—in Ruby Grady's *Broken Heart*. The case for the victim can, in fact, be argued even in landscape, as the chaotic tangle of J.L. Steg's *Polluted Wetland* reminds us that the preservation of the natural environment has lately become a major moral problem.

Approaches vary further throughout the collection. Curt Frankenstein shines a surrealist light on the symbols of justice and the obstacles to justice. Jack Levine is content with the physical reality of the courtroom, reporting what he sees rather than sermonizing about it. Colleen Browning reflects on the ambiguous nature of subway graffiti, part urban folk art, part vandalism.

Surely, these few examples only begin to illustrate the richly differentiated content, not to mention the pervasive technical excellence, of the work that comprises the West Collection. As the artists represented have been obliged to teach themselves about the law even as they paint their images of it, lawyers themselves are likely to learn as well, not only about art but about the legal and ethical discipline on which their careers are based and by which this book was inspired.

Franz Schulze
Hollender Professor of Art, Lake Forest College, IL;
Corresponding editor, *Art In America;*
Contributing editor, *Art News*

For more than a decade, West Publishing Company has supported the visual arts through its ART AND THE LAW exhibition program. Presenting the work of major and emerging artists from across America, this annual invitational show travels throughout the country each year. The art program has won the attention of the business and arts communities, and for its support of American artists, West received the Business in the Arts Award in 1980.

The West Collection has been assembled through purchases from the ART AND THE LAW exhibitions, and it shares with the exhibitions a common theme: the experience of law in our society and its influence on our daily lives. This focus is appropriate for the nation's premier publisher of law books and source for WESTLAW,® the computer-assisted legal research service. The underlying purpose of West's art program is to encourage contemporary American artists to interpret aspects of the law and in so doing to illuminate the law as a vital ingredient of civilization.

This selected survey of The West Collection reflects the varied subject areas of the collection. In the first section, **Patriotism-Symbolism,** the law is seen as a source of national pride and domestic tranquillity. The traditional values that honor our forefathers are part of this patriotism. The moral and spiritual forces reflected in the law are interpreted symbolically as emanating from the virtues of family, duty, and reverence for life.

The Court As An Institution presents the law in its everyday setting. The architecture surrounding legislative and legal processes provides the stage for activities of the court, from arraignment to recess. The scenes are as varied as the participants. The courthouse, at the center of a small community or as a classic detail in a metropolis, publicly proclaims the rule of law in society.

The Legal Profession portrays prominent characters and historical events. Lawyers are depicted at work in the statehouse and in *City Hall.* Their presence in the community is quietly indicated by the second floor law office in *Main Street.* A trial lawyer in the court represents the culmination of long hours invested by the subject of *Young Law Student.* Portraits of Daniel Webster, Clarence Darrow, and Justices Black and Woolsey honor the profession. The Scopes Trial, a milestone in American law and the theme of several works here, has inspired artists ever since the Darrow-Bryan courtroom encounter.

Due Process of Law-Justice offers interpretations that both affirm and deny the process. The expediency of frontier justice is contrasted with the careful deliberations of a contemporary jury. Surrealistic impressions of the process and personifications of justice provide a perspective far different from the realism of works showing the courtroom or people appealing for redress through the legal system.

Equal Protection Under The Law brings us in contact with people seeking the compassion of society for circumstances often beyond their control. The young, the old, the outcast, and the nonconformist seek and need protection. Advocates for change have a right to be heard and to be protected under law. The works in this section sensitively communicate the poignant and very personal experiences of individuals involved with the law.

Government Regulation–The Environment examines an urgent issue for many artists who eloquently express their concern. Endangered species, pollution, and other environmental issues have been presented with impact in the annual ART AND THE LAW touring shows. The works selected from the collection for this survey reflect the seriousness of public interest in such areas.

Introduction

Criminal Justice in America mirrors a subject that is ever at the center of the nation's attention. The struggle between those who break the law and those who defend it seems limited only by the human imagination. The artists represented in the collection capture the sweep of this struggle with revealing insights into the nature of crime. They strongly express concern for the victim as they direct the force of their efforts toward the criminal.

Inhumanities shows the artist striving to touch the viewer's conscience. In powerful scenes, victim and offender find themselves in situations for which, without law, there would be no redress. In these works, the nature of the law becomes more than a subject for academic debate. Without justice, human dignity has no security, and these works show the integral relationship between the law and human interactions.

The latest additions to The West Collection bring us into the street. These images are restless and uncompromising as they present the street culture of our cities. Once we experience such works we are no longer innocent observers. We must react. A child as *The Pawn* in custody proceedings, the archetypal *Crime Boss,* the fragmentation of daily life in *City Crowd-Event With Two Police,* or the disturbing challenge to the human conscience of *Death As An Usher, Germany, 1933,* offer penetrating appraisals of life in our times.

As social critic, the artist serves both as adversary and advocate. Some concerns are always with us, others only threaten, and yet all reflect a changing society coping with the limitless possibilities of human experience. Much of that experience has been influenced at some point by the rule of law. With our growing dependence on the complex technology of our support systems, we face even greater challenges in our stewardship of civilization.

In these works the real focus is on ourselves. We interpret the artists' success or failure to communicate about the law and decide whether the abstract has been made visual and approachable. If the works assembled in this survey lead the viewer to new perspectives and a greater understanding of the role of law in society, **THE WEST COLLECTION** will remain a vital and lasting tribute to all the artists who have participated in the ART AND THE LAW program.

As historians measure the degree to which a society has advanced by its art and its legal system, we find that ART AND THE LAW reflects the everchanging aesthetic and legal issues of our times. We are pleased to share the program and this publication with the nation.

Gerard L. Cafesjian
West Publishing Company
Chairman, West/ART AND THE LAW

Patriotism-Symbolism

The highest bliss of the human soul is love, and the noblest love is devotion to our fatherland.

Friedrich von Schlegel/*On the Limits of the Beautiful,* 1794

ROBERT D. BEARD

BORN

September 3, 1946, Chicago

EDUCATION

Governors State University, University Park, IL, 1975–77

Prairie State College, Chicago Heights, IL, 1971–74

American Academy of Art, Chicago, 1969–70

SELECTED SOLO EXHIBITIONS

Thornton College, South Holland, IL, 1980

Mission Gallery, Steger, IL, 1979

Prairie State College, Chicago Heights, IL, 1978

Infinity Gallery, University Park, IL, 1977

SELECTED GROUP EXHIBITIONS

West/ART & THE LAW, 1982–85

Illinois State Museum, Springfield, 1982, 1985

Erie Art Museum, Erie, PA, 1984

Sheldon Swope Gallery, Terre Haute, IN, 1983

Art Institute of Chicago, 1983

Springfield Art Association, Springfield, IL, 1982

Wedge Public Cultural Center for The Arts, Aurora, IL, 1981

Infinity Gallery, University Park, IL 1979

AWARDS, GRANTS, FELLOWSHIPS

West/ART & THE LAW, Purchase, 1982–85

State of Illinois Center Competition, Purchase Awards, 1984

McDonalds Corporation, Purchase, 1983

Sheldon Swope Gallery, Purchase & Merit, 1983

Coos Art Museum, Purchase, 1982

"Cemetery Landscapes," 1982

Illinois Arts Council Project Completion Grants, 1979

SELECTED COLLECTIONS

Erie Art Museum

Governors State University

Illinois State Museum

McDonalds Corporation

Prairie State College

The West Collection

POSITIONS

R. D. Beard & Company, photography, graphic art, and art restoration, 1984–Present

Robert D. Beard
Lake County, Indiana, 1979
silverprint photograph/13¾ x 17¾/1979

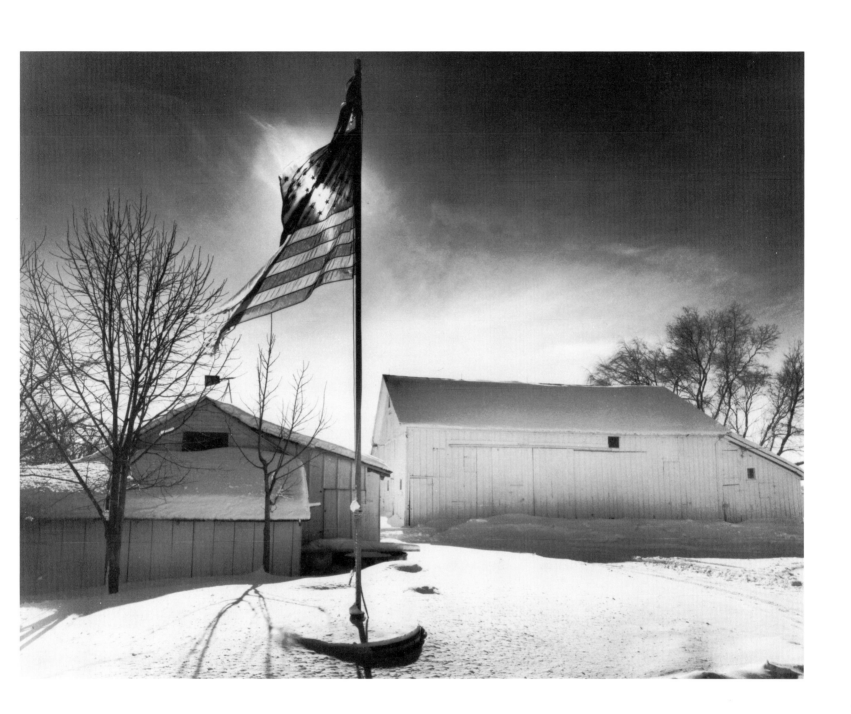

t is, Sir, the people's Constitution, the people's government, made for the people, made by the people, and answerable to the people. That other sentiment, dear to every true American heart–Liberty and Union, now and forever, one and inseparable!

Daniel Webster/Second speech on Foote's Resolution, 1830

GRACE BENEDICT

BORN
September 9, 1955, Windsor, Ontario, Canada

EDUCATION
Tulane University, New Orleans, MFA, 1979
University of Windsor, Ontario, BFA, 1977

SELECTED SOLO EXHIBITIONS
Memorial Hospital, South Bend, IN, 1985
American Bar Foundation, University of Chicago, 1983
Northern Indiana Arts Association, Munster, IN, 1983
New Orleans Public Library, 1979
Natalie Scott Memorial Gallery, New Orleans, 1978

SELECTED GROUP EXHIBITIONS
Community Center for the Arts, Michigan City, IN, 1986
Midwest Museum of American Art, Elkhart, IN, 1985
Evansville Museum of Arts and Science, Evansville, IN, 1985
MacDonald Gallery, Toronto, 1985
St. Thomas/Elgin Gallery, Ontario, 1984

Art Gallery of Windsor, Ontario, 1983
Indianapolis Art League, 1983
West/ART & THE LAW, 1982, 83
Ball State University Art Gallery, Muncie, IN, 1981
University of Windsor, Ontario, 1980
Contemporary Arts Center, New Orleans, 1980

AWARDS, GRANTS, FELLOWSHIPS
The Elizabeth Greenshields Foundation, 1982–83, 85–86
Evansville Museum of Arts and Science, Purchase Award, 1985
Midwest Museum of American Art, Purchase Award, 1985
MacDonald Gallery, Best Drawing Award, 1983
West/ART & THE LAW, Purchase, 1982
St. Thomas/Elgin Gallery, Purchase Award, 1982
Northern Indiana Arts Association, Merit Award, 1982
Crown Life Insurance Company, Merit Award, 1982

University of Southwestern Louisiana, Honorable Mention, 1980
Art in the Park, Honorable Mention, 1978

SELECTED COLLECTIONS
Crown Live Insurance Company
Dabagia, Donoghue, Sweeney & Thorne
Mead, Johnson and Company
Robert Weed Plywood Corporation
The West Collection

POSITIONS
Community Center for the Arts, Michigan City, IN, Drawing Instructor, Present

ARTIST'S STATEMENT
The title is a direct reference to a Rolling Stones record that I played a lot while I was making the drawing. I was teaching part-time and not making much money. The news scene was hyper as usual. The banner was already an interesting subject for me to photograph and draw. Fire illuminates perfect form.

I am always struggling with the changes in my life. I need to represent, ornament, make each drawing a challenge. To allow the folds and pockets of the original material to stand forth, I layer the pencil. The image doesn't force itself upon your emotions. It stirs the memory toward calling the banner "like a bird," "a butterfly," or an icon suspended somewhere between secret depths and heavenly heights.

Grace Benedict
Banner—Hang Fire '82
colored pencil/26 x 40/1982

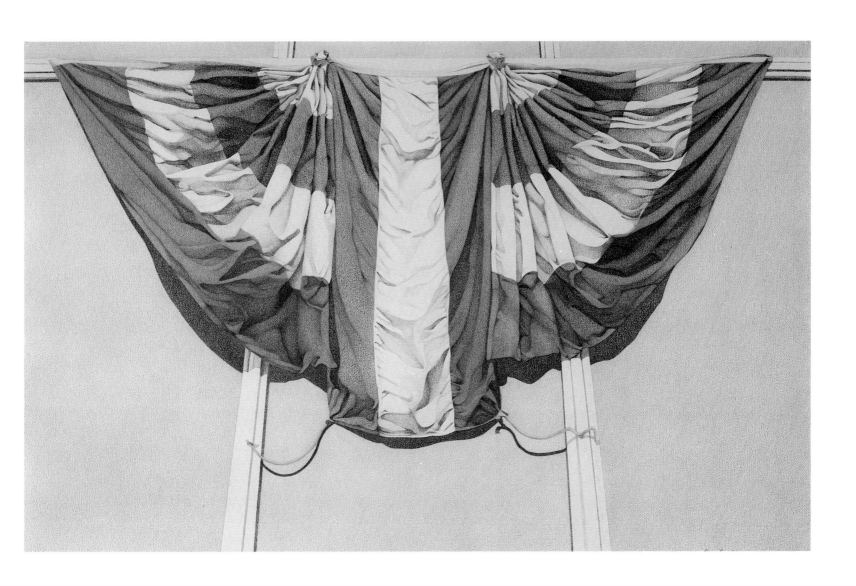

Liberty–not Communism–is the most contagious force in the world. It will permeate the Iron Curtain. It will eventually abide everywhere.

Chief Justice Earl Warren/Address, 1954

ALICE DALTON BROWN

BORN

April 17, 1939, Danville, PA

EDUCATION

Oberlin College, Oberlin, OH, BA, 1962

Cornell University, Ithaca, NY, 1958–59

L'Université de Grenoble, France, 1957–58

Académie Julian, Paris, 1957

SELECTED SOLO EXHIBITIONS

Katherina Rich-Perlow Gallery, NYC, 1985

A. M. Sachs Gallery, NYC, 1982–84

Bartholet Gallery, NYC, 1975, 76

SELECTED GROUP EXHIBITIONS

West/ART & THE LAW, 1985

A. M. Sachs Gallery, NYC, 1981–84

Summit Art Center, Summit, NJ, 1982

McNay Art Institute, San Antonio, TX, 1981

AWARDS, GRANTS, FELLOWSHIPS

West/ART & THE LAW, Purchase, 1985

NYSC, Cayuga County, Judges Award, 1979

SELECTED COLLECTIONS

AT & T Corporate Collection

FMC Corporation

First National Bank and Trust Company

Metropolitan Life Insurance Company

3M Company

Vision & Elkins Law Firm

The West Collection

Westinghouse Electric Corporation

POSITIONS

Full-time Artist

ARTIST'S STATEMENT

The flag, symbol of our country and its laws, is shown here in a movement that is visually repeated in the world around it, just as the laws of our land are reflected in our opportunities as citizens and in the shapes of our lives.

Alice Dalton Brown
Lifting Flag
oil/22 x 38/1985

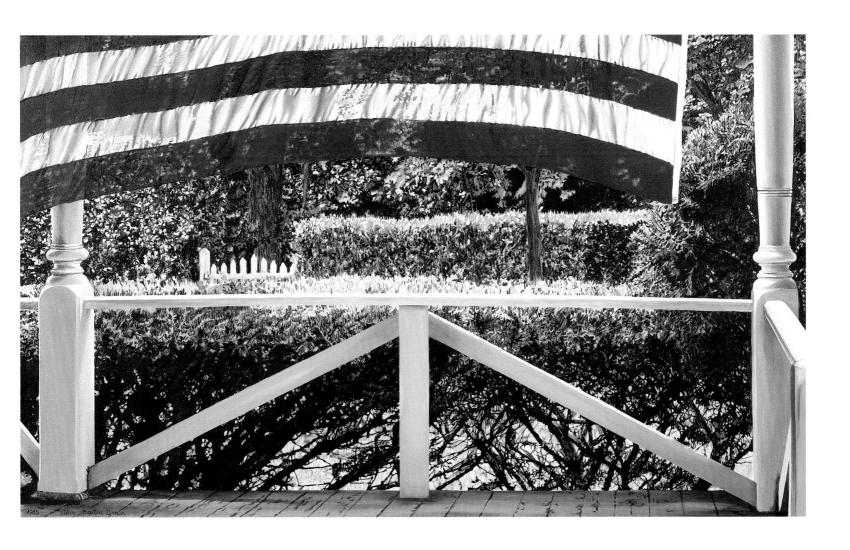

Have not I myself known five hundred living soldiers sabred into crow's meat for a piece of glazed cotton which they called their flag; which, had you sold it in any market-cross, would not have brought above three groschen?

Thomas Carlyle/*Sartor Resartus, III,* 1836

GRANT GILDERHUS

BORN
November 26, 1932, Minneapolis

EDUCATION
Luther-Northwestern Seminary, St. Paul, 1959
Carthage College, Kenosha, WI, 1954

SELECTED SOLO EXHIBITIONS
Good Samaritan United Methodist Church, Edina, MN, 1984
Concordia College Fine Arts Center, St. Paul, 1977
West Bend Gallery of Fine Arts, St. Paul, 1971
National Bank, Hartford, CT, 1970
H. F. Johnson Fine Arts Center, Kenosha, WI, 1968

SELECTED GROUP EXHIBITIONS
West/ART & THE LAW, 1979, 80
Midwest Wildlife Art Show, Kansas City, MO, 1977
Minnesota Museum of Art, St. Paul, 1976
New Orleans International, 1976
Chautauqua International Chautauqua, NY, 1975

AWARDS, GRANTS, FELLOWSHIPS
Bell Telephone Calendar, Painting Selected, 1985
Insurance Industry Advertising Council, National Award, 1984
West/ART & THE LAW, Purchase, 1979
Minnesota Museum of Art, Purchase Award, 1976

SELECTED COLLECTIONS
Carthage College
Minnesota Museum of Art
West Bend Gallery of Fine Arts
The West Collection

POSITIONS
Cofounder Vista III Design, Inc., 1975, Currently President
Designed two sculptures for St. Andrew Lutheran Church, Eden Prairie, MN, 1985
13 paintings commissioned, 1984–85, for Lutheran Brotherhood Calendar
Founder Sacred Design Associates, Minneapolis, 1957; VP & Creative Director until 1975

ARTIST'S STATEMENT
The line between law and tyranny is a fine line, but it is a line. When in our life as a nation, or as individuals, we cease to live by law, then tyranny begins its insidious reign.

When we step over the line from law to tyranny, we give birth to conflict, and that conflict continues until tyranny becomes anarchy or dictatorship or until the influence of law regains its hold.

Our history as a country and as individuals has seen this conflict, and we are always faced with a new choice: on which side of the line will we stand?

Grant Gilderhus
Where Law Ends . . .
watercolor, pencil, collage/24⅞ x 37

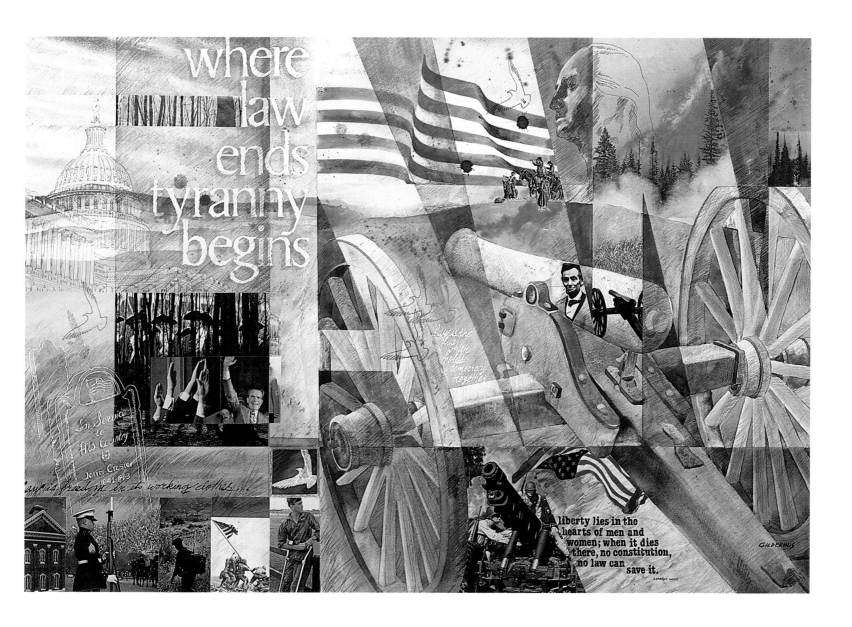

t is not probable that war will ever absolutely cease until science discovers some destroying force so simple in its administration, so horrible in its effects, that all art, all gallantry, will be at an end, and battles will be massacres which the feelings of mankind will be unable to endure.

W. Winwood Reade, *The Martyrdom of Man*, 1872

RUBY GRADY

BORN

January 11, 1934, Bedford, VA

EDUCATION

Maryland University, College Park, 1963

Corcoran School of Art, Washington, DC, 1959–62

SELECTED SOLO EXHIBITIONS

VVKR Atrium, Alexandria, VA, 1984

Roanoke Museum of Fine Arts, VA, 1980

Jack Rasmussen Gallery, Washington, DC, 1978, 79

Second Story Spring Street Gallery, NYC, 1975

Dickson Gallery, Washington, DC, 1974

Agra Gallery of Fine Art, 1970, 71, 72

Pierre's Gallery, Alexandria, VA, 1968

Lee Gallery, Alexandria, VA, 1962, 64, 67

The R Street Gallery, Washington, DC, 1964

SELECTED GROUP EXHIBITIONS

Washington Square Sculpture 84, Washington, DC, 1984

Virginia Sculpture Exhibition, Alexandria, 1983–84

West/ART & THE LAW, 1982

15th Annual Avant Garde Show, NYC, 1981

Virginia Museum of Fine Arts, Richmond, 1978

American Artists Exhibit, Paris, 1975–76

Corcoran Gallery of Art, Washington, DC, 1972, 76

Textile Museum, Washington, DC, 1973–75

Southeastern Museums Tour of Washington Artists, 1973

Washington Artists Annual, 1966

AWARDS, GRANTS, FELLOWSHIPS

West/ART & THE LAW, Purchase, 1982

John James Audubon Bronze Medal, 1974

American Fine Arts Exhibits, 18 Paintings Purchased

Annapolis Fine Arts Foundation, Cash Award

Included in *The National Community Arts Book*

Virginia Beach Foundation Exhibit Catalogue Cover, Purchase Award

SELECTED COLLECTIONS

Agra Collections Palm Beach

Americana Hotel and Executive House

Chakin Enterprises, Inc.

Kiplinger Collection

Maeght Collection, Paris

The West Collection

POSITIONS

Painter and Sculptor, Present

Three Washington, DC, Restaurants, Exhibitions Coordinator, 1961–74

Potowmack Studio, Fort Washington, MD, Instructor, 1961–73

Federal Bureau of Investigation, Washington, DC, Art Illustrator, 1956–59

ARTIST'S STATEMENT

As a result of obeying the Selective Service laws, my young brother was drafted into the army during the Vietnam War. He soon found himself serving in combat in the war zone. While the daily reports of the deaths of so many young soldiers mounted, my family and I worried about his survival. As the army carried out the military law of "the notification of the next of kin" I was very much aware of the grief each family suffered and how in a moment . . . that telegram . . . from the army . . . shattered their lives. This painting was done during this war to share their grief and to prepare myself for that moment.

Ruby Grady
Broken Heart
acrylic on masonite/32 x 24/1971

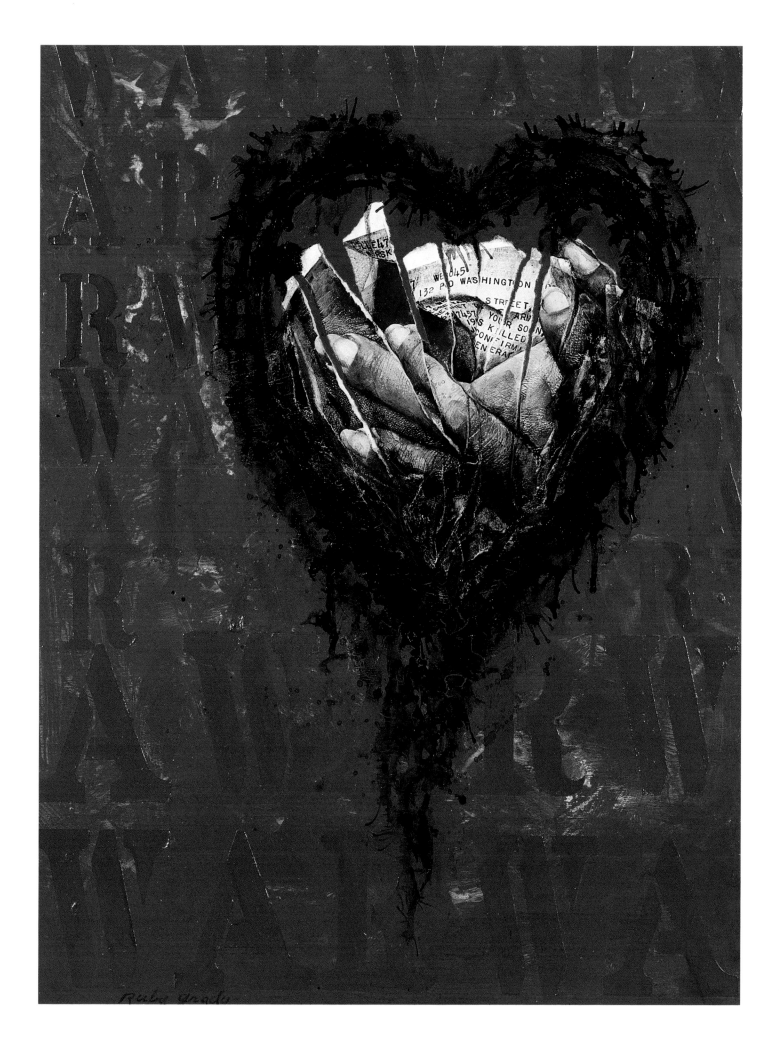

> *hick-sprinkled bunting! Flag of stars! Long yet your road, Fateful flag!–long yet your road, and lined with bloody death.*
>
> Walt Whitman/*Drum-Taps,* 1865

RICHARD HAINES

BORN

December 29, 1906, Marion, IA

DIED

October 19, 1984

EDUCATION

Minneapolis School of Art, Minneapolis, 1932–34

Ecole des Beaux-Arts, Fontainebleau, France, 1934

SELECTED SOLO EXHIBITIONS

Love Gallery, Chicago, 1982–85

Abraxas Gallery, Newport Beach, CA, 1978–82

Adele Bednarz Galleries, 1967, 69, 70, 73, 75

Laguna Beach Museum of Art, CA, 1959, 64

Hatfield Gallery, Los Angeles, 1948, 54, 58, 62, 64

Santa Monica Art Gallery, CA, 1961

Pasadena Art Museum, CA, 1960

Santa Barbara Museum of Art, CA, 1959

Scripps College Art Galleries, Claremont, CA, 1956

American Contemporary Gallery, Los Angeles, 1944

SELECTED GROUP EXHIBITIONS

West/ART & THE LAW, 1979

University of Illinois, 1950, 51, 61

California State Fair, 1944–55

Third Biennial, São Paulo, Brazil, 1955

Carnegie Institute International, Pittsburgh, 1954

Metropolitan Museum of Art, NYC, 1952

Corcoran Gallery of Art, Biennial, Washington, DC, 1951

Pennsylvania Annual, 1950

Los Angeles County Museum of Art, 1944

AWARDS, GRANTS, FELLOWSHIPS

West/ART & THE LAW, Purchase, 1979

Frye Museum, Seattle, 1964

Tupperware Award, 1957

National Orange Show, 1954

California Watercolor Society, 1948, 52

California State Fair, 1948, 51

Corcoran Gallery of Art, Biennial, 1951

Los Angeles County Museum of Art, 1944, 45, 49

San Francisco Museum, 1948

Society of Lithographers and Etchers, NYC, 1948

SELECTED COLLECTIONS

Dallas Museum of Art

Kansas City Museum

Lessing J. Rosenwald Collection

Los Angeles County Museum of Art

Metropolitan Museum of Art

Portland Museum of Art

San Diego Museum of Art

Santa Barbara Museum of Art

Seattle Art Museum

The West Collection

POSITIONS

Murals and architectural designs, national and international, 1935–67

Richard Haines
From Our Forefathers
oil/40 x 36

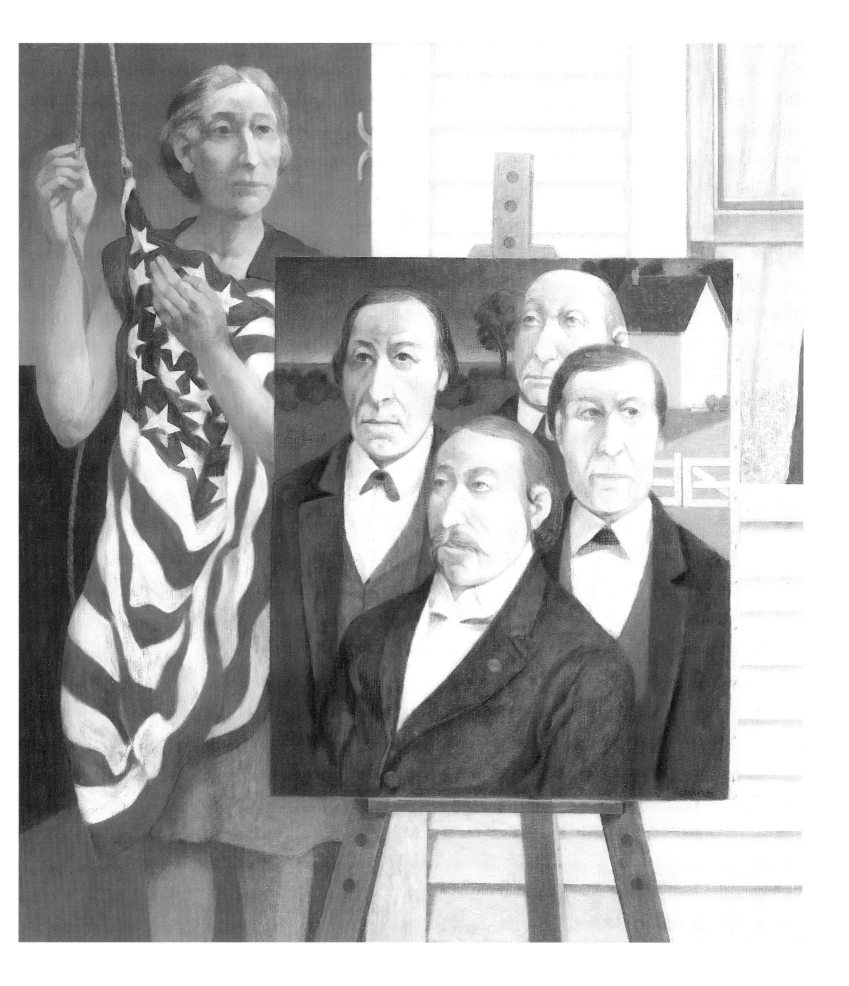

We desire most what we ought not to have.

Publilius Syrus, c. 50 B.C.

BARBARA D. HULTMANN

BORN
January 18, 1941, Minneapolis

EDUCATION
San Jose State College, CA, Summer Sessions, 1964–65

University of Minnesota, Minneapolis, BS, 1963

SELECTED SOLO EXHIBITIONS
White Oak Gallery, Minneapolis, 1985

SELECTED GROUP EXHIBITIONS
West/ART & THE LAW, 1982–85

AWARDS, GRANTS, FELLOWSHIPS
West/ART & THE LAW, Purchases, 1982–85

Minnesota State Fair, Merit Award, Jurors' Award, Celebrity Peoples' Choice Award, 1977–82, 84

Art Center of Minnesota, Honorable Mention, 1981–84

SELECTED COLLECTIONS
Amfac Hotel

Barclay Bank

Farm Credit Bureau

Federal Land Bank

First Bank of Robbinsdale

First Bank Plaza

First Federal Bank

The West Collection

POSITIONS
Art Center of Minnesota, Minnetonka, Instructor, 1985

Governor's Task Force: A High School for the Arts, 1985

Edina Public Schools, MN, Instructor, 1964–80

North St. Paul Public Schools, Instructor, 1963–64

ARTIST'S STATEMENT
The development of our legal process commenced with the birth of man. My painting is an austere dramatization of the most elementary motive for lawbreaking—the desire to possess the unattainable.

Barbara D. Hultmann
Exhibit A—The Temptation
acrylic/32 x 26/1983

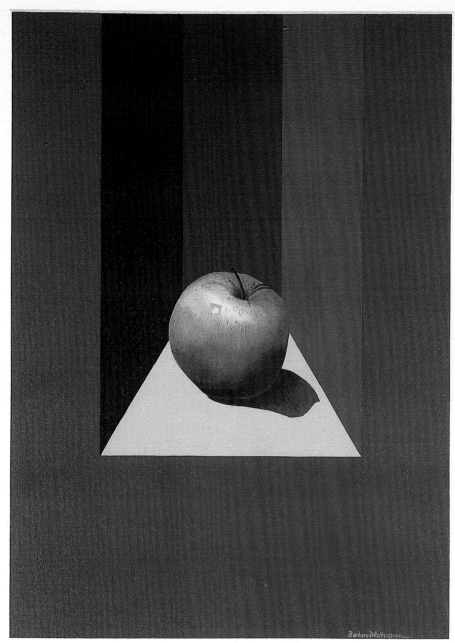

EXHIBIT A — THE TEMPTATION

I t is rather for us to be here dedicated to the great task remaining before us—that from these honored dead we take increased devotion to that cause for which they gave the last full measure of devotion—that we here highly resolve that these dead shall not have died in vain—that this nation, under God, shall have a new birth of freedom—and that government of the people, by the people, for the people, shall not perish from the earth.

Abraham Lincoln/Gettysburg Address, Nov. 19, 1863

VIOLETTE JAHNKE

BORN
June 19, 1922, Milwaukee

EDUCATION
University of Wisconsin, Milwaukee, MS–Art, 1977

Milwaukee State Teachers College, BS–Art, 1944

SELECTED SOLO EXHIBITIONS
Concordia College, Meguon, WI, 1985

New Visions Gallery, University of Wisconsin, Marshfield, 1985

Alverno College, Milwaukee, 1981

First Unitarian Church, Milwaukee, 1980

Concordia College, Milwaukee, 1979

SELECTED GROUP EXHIBITIONS
Gallery 222, Lake Geneva, WI, 1985

University of Wisconsin, Milwaukee, 1981, 84

Invitational Governor's Suite, State Capitol, Madison, 1984

Muscatine Art Center, Muscatine, IA, 1984

Charles A. Wustum Museum of Fine Arts, Racine, WI, 1984

Gallery La Luz, La Luz, NM, 1983

West/ART & THE LAW, 1982

American Art, Pillsbury Company, St. Paul, 1981

Biennial Watercolor Show, Scottsdale, AZ, 1978

AWARDS, GRANTS, FELLOWSHIPS
West/ART & THE LAW, Purchase, 1982

International Society of Artists, NY, 1979

Kohler Art Center, 1976, 79

American Artist Magazine, 1st National Competition, 1978

National League of American Pen Women State Show, 1970, 74, 76, 77

SELECTED COLLECTIONS
Concordia College Collection

Miller Brewery

Mount Sinai Hospital

Ozaukee Bank

Three Lakes Library

The West Collection

University of Wisconsin

POSITIONS
Private Instructor, 1976–Present

Studio Six, Co-op, Cedarburg, WI, Currently

Milwaukee Area Technical College, North Campus, Part-time Teacher, 1979–83

Freelance Artist, 1950–60

ARTIST'S STATEMENT
Laws are constantly being written, changed, challenged. Laws seem to be a necessity because man is unable to practice the kind of self-control that would make law unnecessary. This painting, I hope, suggests what can happen when law is defied. It suggests that we as a nation are capable of burying ourselves if we are not vigilant.

Law begins with individual self-control and continues as rules designed to answer the needs of everyone. Usurpation of law by power to serve a few can fracture and bury a nation. We have come close with our race problems, our seeming differences in rich man's/poor man's justice. We always hope that law prevails. As an artist it is my hope that viewers of my painting will realize the value of law and the concepts upon which it is based.

Violette Jahnke
Without Law
watercolor/30 x 40/1982

> *Patriotism is easy to understand in America. It means looking out for yourself by looking out for your country.*
>
> Calvin Coolidge, 1923

HUGH KEPETS

BORN
February 6, 1946, Cleveland

EDUCATION
Ohio University, MFA, 1972
Carnegie-Mellon University, Pittsburgh, BFA, 1968

SELECTED SOLO EXHIBITIONS
Michael Berger Gallery, Pittsburgh, 1976, 82
Orion Editions Gallery, NYC, 1980
Graphics 1 & Graphics 2, Boston, 1976, 79
A. J. Wood Galleries, Philadelphia, 1979
Fischbach Gallery, NYC, 1974, 76, 78
New Gallery of Contemporary Art, Cleveland, 1978
Rubicon Gallery, Los Altos, CA, 1977
Vick Gallery, Philadelphia, 1974, 76, 77
G. W. Einstein, NYC, 1976

SELECTED GROUP EXHIBITIONS
College of St. Rose, Albany, NY, 1982
Cleveland Museum of Art, 1972–78, 80, 81
State University of NY at Oswego and Fredonia, NY, 1981
American Academy of Arts and Letters, NYC, 1978–80
West/ART & THE LAW, 1979
Indianapolis Museum of Art, 1976, 78
FIAC, Grand Palais, Paris, 1976
Museum of Fine Arts, Boston, 1975
Akron Art Museum, 1974
Yale University Art Gallery, New Haven, CT, 1973

AWARDS, GRANTS, FELLOWSHIPS
Creative Artists Public Service Grant, 1980
West/ART & THE LAW, Purchase, 1979
Cleveland Arts Prize, 1979
Fashion Institute of Technology, Purchase Award, 1976
Davidson National Competition, Purchase Award, 1976
National Endowment for the Arts Grant, 1976
Creative Artists Public Service Grant, 1975
Philadelphia Print Club, Purchase Award, 1975
Cleveland Museum of Art, 55th May Show Award, 1974

SELECTED COLLECTIONS
Art Institute of Chicago
Chase Manhattan Bank
Citicorp, NY
IBM Corporation
Indianapolis Museum of Art
Metropolitan Museum of Art
Minnesota Museum of Art
Prudential Insurance Company of America
The West Collection
Xerox Corporation

POSITIONS
Full-time Artist

Hugh Kepets
Madison Square II
acrylic/72 x 60/1978

see those who in any land have died for a good cause,
The seed is spare, nevertheless the crop shall never run out.
(Mind you, O Foreign Kings, O priests, the common seed shall never run out.)

Walt Whitman/*Song of the Broad-Axe*

LEONARDO LASANSKY

BORN
March 29, 1946, Iowa City, IA

EDUCATION
University of Iowa, MFA, 1972
University of Iowa, MA, 1972
University of Iowa, BGS, 1971

SELECTED SOLO EXHIBITIONS
Jane Haslem Gallery, Washington, DC, 1986
Slusser Gallery, University of Michigan, Ann Arbor, 1985
Northern Arizona University, Flagstaff, 1984
University of Arizona, Tucson, 1984
Museum of Art, Utah State University, Logan, 1983
Hood Museum of Art, Dartmouth College, Hanover, NH, 1982
University Art Museum, University of Minnesota, Minneapolis, 1982
Joan Whitney Payson Gallery, Westbrook College, Portland, ME, 1982

SELECTED GROUP EXHIBITIONS
International Print Biennial, Lisbon, Portugal, 1986
West/ART & THE LAW, 1979, 80, 85
International Triennial of Colored Graphic Prints, Grenchen, Switzerland, 1985
International Print Biennial, Cracow, Poland, 1984
Figura 3, IBA, Leipzig, Germany; Grunwald Center, UCLA, Los Angeles, 1982
University of Iowa Museum of Art, 1982
Hood Museum of Art, Dartmouth College, 1982
Brooklyn Museum, 1981
6th International Exhibition of Graphic Art, Frechen, Germany, 1981
5th Norwegian International Print Biennial, Fredrikstad, Norway, 1980

AWARDS, GRANTS, FELLOWSHIPS
West/ART & THE LAW, Purchase, 1985
National Hawaii Print Exhibition, Purchase Award, 1985
Theatre de la Jeune Lune, Portrait of The Count of Saint Germain, 1984
The Berkshire Museum, Drawing Award, 1982
Distinguished Young Alumni, University of Iowa Award, 1981
Intergrafik '80, Special Award/Purchase Award, 1980
The Philadelphia Print Club, Purchase Award, 1980
5th National Hawaii Print Exhibition, Purchase Award, 1980
4th Miami International Print Biennial, Second Prize/Purchase Award, 1980
James Ford Bell Library, Commission: Christopher Columbus, The International 500 Year Celebration

SELECTED COLLECTIONS
Alvar Aalto Museum, Jyväskylä, Finland
Brooklyn Museum
Fine Arts Museum, San Francisco
Honolulu Academy of Arts
Minnesota Museum of Art
Minneapolis Institute of Art
National Museum, Cracow, Poland
Philadelphia Museum of Art
Art Museum, Princeton University
The West Collection

POSITIONS
Hamline University, Associate Professor of Art, 1972–Present
Dartmouth College, Artist-in-Residence and Lecturer, Spring, 1982

Leonardo Lasansky
Birth of a Nation
collage drawing/79 x 44/1985

ext to love of God, the love of country is the best preventive of crime. He who is proud of his country will be particularly cautious not to do anything which is calculated to disgrace it.

George Brown/*The Bible in Spain, IV*, 1843

LAUREL O'GORMAN

BORN
January 9, 1947, St. Paul

EDUCATION
University of Minnesota, Minneapolis, MFA, 1979
University of Minnesota, BES, 1976

SELECTED SOLO EXHIBITIONS
Katherine Nash Gallery, University of Minnesota, 1984
Catherine G. Murphy Galleries, St. Paul, 1982
Coffman Gallery, University of Minnesota, 1979

SELECTED GROUP EXHIBITIONS
College of St. Catherine, St. Paul, 1985
West/ART & THE LAW, 1982–84
General Mills Corporate Show, Minneapolis, 1983
Coffman Gallery, University of Minnesota, 1982
WARM Gallery, Minneapolis, 1982
Friends Gallery, Minneapolis Institute of Art, 1980
Purdue University, 1979

AWARDS, GRANTS, FELLOWSHIPS
West/ART & THE LAW, Purchases, 1982–84

SELECTED COLLECTIONS
Judith Connor Design
MS Interiors
University of Minnesota
The West Collection

POSITIONS
College of St. Catherine, Art Instructor, 1982–Present
Catherine G. Murphy Galleries, St. Paul, Gallery Director, 1981–Present
West Publishing Company, Art Consultant, 1983–Present
Minnesota Museum of Art, St. Paul, Exhibitions Coordinator, 1979–81

ARTIST'S STATEMENT
These symbols serve as a constant celebration of the gifts we share and the rich endowment of our heritage. Our society has provided us with an environment for creative minds to flourish. How easily we take this for granted. I am grateful to be an American, to have the freedoms to express my artistic vision, my spiritual and political beliefs, my patriotism, my love. Such gifts must be constantly shared and remembered.

Laurel O'Gorman
With Love, Liberty and Justice for All
acrylic/64½ x 46/1982

The law of God, which we call the moral law, must alone be the scope, and rule, and end, of all laws.

John Calvin

ABRAHAM RATTNER

BORN
July 8, 1895, Poughkeepsie, NY

DIED
February 14, 1978

EDUCATION
Académie des Beaux-Arts, Paris, 1921
Académie Julian, Paris
Académie Ranson, Paris
Académie de la Grande Chaumière, 1920
US Army, 1917–19
The Corcoran School of Art, PAFA, 1916–17
George Washington University

SELECTED SOLO EXHIBITIONS
Kennedy Galleries, NYC, 1972, 78, 81
Guild Hall Museum, East Hampton, NY, 1977
Travel Exhibit, National Collection of Fine Arts, 1977
Jewish Museum, NYC, 1976
Wadsworth Atheneum, Hartford, CT, 1971
Galerie Weil, Paris, 1969
National Collection of Fine Arts, 1966

SELECTED GROUP EXHIBITIONS
Charles H. MacNider Museum, Mason City, IA, 1979
University Gallery, Gainesville, FL, 1979
West/ART & THE LAW, 1979
Mitchell Museum, Mt. Vernon, IL, 1978
American Academy of Arts and Letters, NYC, 1978
Centre Georges Pompidou, Paris, 1977
Palm Springs Desert Museum, CA, 1977
Sunderland Arts Centre, England, 1976
World's Fair, Osaka, Japan, 1970
Exhibited in Russia with American artists, 1962

AWARDS, GRANTS, FELLOWSHIPS
Michigan State University, Honorary Degree for Humanity, 1977
The Royal Academy, London, Elected Member, 1965
National Institute of Arts and Letters, NY, Elected Member, 1958
Carnegie Institute, Honorable Mention, 1949
La Tausca Competition, First Prize, 1947
Pepsi-Cola, Second Prize, 1946
Pennsylvania Academy of Fine Arts, Joseph E. Temple Gold Medal, 1945, and Cresson Fellowship, 1919

SELECTED COLLECTIONS
Albright-Knox Art Gallery
Art Institute of Chicago
Detroit Institute of Arts
Hirshhorn Museum
Metropolitan Museum of Art
National Museum of American Art
Pennsylvania Academy of Fine Arts
The West Collection
Walker Art Center
Whitney Museum of American Art

POSITIONS
Michigan State University, Art Department, Distinguished Visiting Professor, 1956
Art Students League, NY, Instructor, 1954
American Academy, Rome, Artist in Residence, 1951
New School for Social Research, NY, Instructor, 1947
Yale University, New Haven, and Brooklyn Museum School, NY, Visiting Artist, 1949

ARTIST'S STATEMENT
Life, death, love, resurrection, salvation, beauty, and justice are the things about which Rattner felt most passionately. He explored them all as a springboard for his art in terms of their ethical and inspirational content. Old Testament texts from Genesis and Exodus provided him with provocative subjects. The legend of Moses as lawgiver was particularly appealing to Rattner as he explored considerations of morality and justice.

Gloria-Gilda Deak, Author Kennedy Galleries, *Profiles of American Artists*, 1984

Abraham Rattner
Moses "I Am That I Am"
oil/24½ x 35/1965

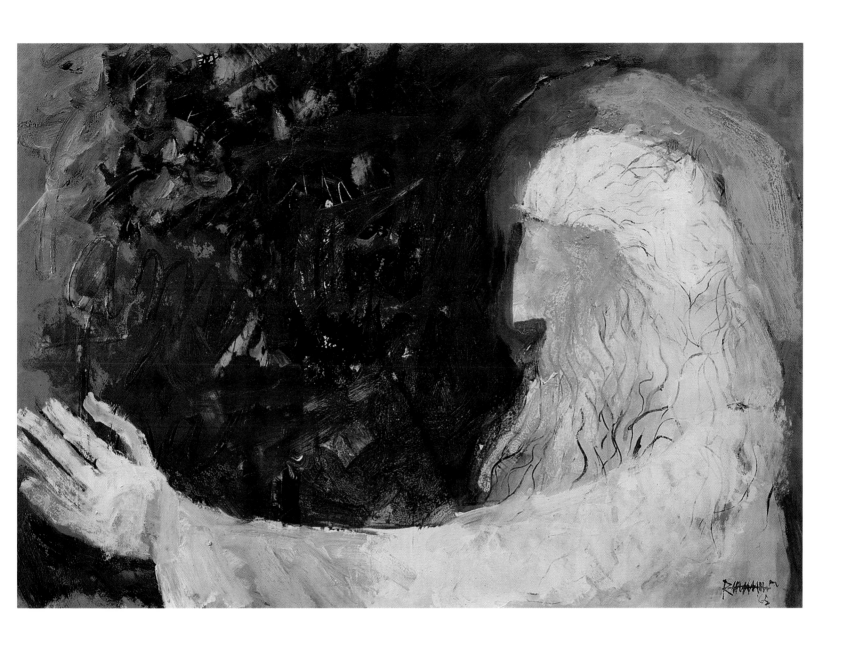

The Court
as an
Institution

*F*ill the seats of justice with good men, not so absolute in goodness as to forget what human frailty is.

T. N. Talfourd/*Ion*, 1835

ROBERT D. BEARD

BORN

September 3, 1946, Chicago

EDUCATION

Governors State University, University Park, IL, 1975–77

Prairie State College, Chicago Heights, IL, 1971–74

American Academy of Art, Chicago, 1969–70

SELECTED SOLO EXHIBITIONS

Thornton College, South Holland, IL, 1980

Mission Gallery, Steger, IL, 1979

Prairie State College, Chicago Heights, IL, 1978

Infinity Gallery, University Park, IL, 1977

SELECTED GROUP EXHIBITIONS

West/ART & THE LAW, 1982–85

Illinois State Museum, Springfield, 1982, 1985

Erie Art Museum, Erie, PA, 1984

Sheldon Swope Gallery, Terre Haute, IN, 1983

Art Institute of Chicago, 1983

Springfield Art Association, Springfield, IL, 1982

Wedge Public Cultural Center for The Arts, Aurora, IL, 1981

Infinity Gallery, University Park, IL 1979

AWARDS, GRANTS, FELLOWSHIPS

West/ART & THE LAW, Purchase, 1982–85

State of Illinois Center Competition, Purchase Awards, 1984

McDonalds Corporation, Purchase, 1983

Sheldon Swope Gallery, Purchase & Merit, 1983

Coos Art Museum, Purchase, 1982

"Cemetery Landscapes," 1982

Illinois Arts Council Project Completion Grants, 1979

SELECTED COLLECTIONS

Erie Art Museum

Governors State University

Illinois State Museum

McDonalds Corporation

Prairie State College

The West Collection

POSITIONS

R. D. Beard & Company, photography, graphic art, and art restoration, 1984–Present

ARTIST'S STATEMENT

This photograph was taken in the Starke County Courthouse in Knox, Indiana. It is part of a series on the American flag. The flag is the most widely used symbol of this country. It belongs to all segments of this society and, consequently, is used in a varied number of ways. We associate the flag with the laws and ideals of this democracy. The flag may be our only common denominator, representing a connection between our past and present.

Robert D. Beard

Knox, Indiana,

silverprint photograph/28 x 22/1981

Why should there not be a patient confidence in the ultimate justice of the people? Is there any better or equal hope in the world?

Abraham Lincoln/First Inaugural Address, March 4, 1861

ROBERT D. BEARD

BORN
September 3, 1946, Chicago

EDUCATION
Governors State University, University Park, IL, 1975–77

Prairie State College, Chicago Heights, IL, 1971–74

American Academy of Art, Chicago, 1969–70

SELECTED SOLO EXHIBITIONS
Thornton College, South Holland, IL, 1980

Mission Gallery, Steger, IL, 1979

Prairie State College, Chicago Heights, IL, 1978

Infinity Gallery, University Park, IL, 1977

SELECTED GROUP EXHIBITIONS
West/ART & THE LAW, 1982–85

Illinois State Museum, Springfield, 1982, 1985

Erie Art Museum, Erie, PA, 1984

Sheldon Swope Gallery, Terre Haute, IN, 1983

Art Institute of Chicago, 1983

Springfield Art Association, Springfield, IL, 1982

Wedge Public Cultural Center for The Arts, Aurora, IL, 1981

Infinity Gallery, University Park, IL 1979

AWARDS, GRANTS, FELLOWSHIPS
West/ART & THE LAW, Purchase, 1982–85

State of Illinois Center Competition, Purchase Awards, 1984

McDonalds Corporation, Purchase, 1983

Sheldon Swope Gallery, Purchase & Merit, 1983

Coos Art Museum, Purchase, 1982

"Cemetery Landscapes," 1982

Illinois Arts Council Project Completion Grants, 1979

SELECTED COLLECTIONS
Erie Art Museum

Governors State University

Illinois State Museum

McDonalds Corporation

Prairie State College

The West Collection

POSITIONS
R. D. Beard & Company, photography, graphic art, and art restoration, 1984-Present

Robert D. Beard
Rockville, Indiana
silverprint photograph/13$\frac{1}{8}$ x 10$\frac{3}{8}$ (sight)
1978

> *To none will we sell, to none deny or delay, right or justice.*
>
> The Magna Carta, 1215

HARVEY DINNERSTEIN

BORN
April 3, 1928, Brooklyn, NY

EDUCATION
Tyler Art School, Temple University, Philadelphia, 1950
Art Students League, NYC, 1946–47
Study with Moses Soyer, NYC, 1944–46

SELECTED SOLO EXHIBITIONS
Sindin Galleries, NYC, 1983
Capricorn Galleries, Bethesda, MD, 1980
FAR Galleries, NYC, 1972, 79
Gallery 1199, NYC, 1976
Kenmore Galleries, Philadelphia, 1964, 66, 69, 70
Davis Galleries, NYC, 1955, 60, 61, 63

SELECTED GROUP EXHIBITIONS
West/ART & THE LAW, 1982, 83
Pennsylvania State University Museum of Art, University Park, PA, 1979
New York Historical Society, NYC, 1976
New York Cultural Center, NYC, 1976
American Academy of Arts and Letters, NYC, 1974
Whitney Museum of American Art, NYC, 1964

AWARDS, GRANTS, FELLOWSHIPS
West/ART & THE LAW, Purchase, 1982, 83
American Academy of Arts and Letters, Hassam-Speicher Fund Painting Purchase, 1974, 78
National Academy of Design, Ranger Purchase Award, 1976
Pennsylvania Academy of Fine Arts, Temple Gold Medal, 1950

SELECTED COLLECTIONS
Chase Manhattan Bank
Chemical Bank
Martin Luther King Labor Center
Metropolitan Museum of Art, Lehman Collection
National Academy of Design
New Britain Museum of American Art
Parrish Museum of Southhampton
Pennsylvania Academy of Fine Arts
The West Collection
Whitney Museum of American Art

POSITIONS
Art Students League, NYC, Instructor, 1980–Present
National Academy of Design, NYC, Instructor, 1975–Present
National Academy of Design, NYC, Academician, 1974
School of Visual Arts, NYC, Instructor, 1965–80

ARTIST'S STATEMENT
Arraignment Court, Brooklyn — 1975

This is part of a series of drawings that I did in Arraignment Court, Brooklyn. The procession of people reflects various aspects of urban life in what I understand is the busiest Arraignment Court in the country. The pimp in the right foreground assumed a pose that reminded me of a *majo* (boaster, gallant) at the time of Goya, though he conducted his affairs like a small businessman today.

Harvey Dinnerstein
Arraignment Court, Brooklyn
charcoal/24 x 19¼/1975

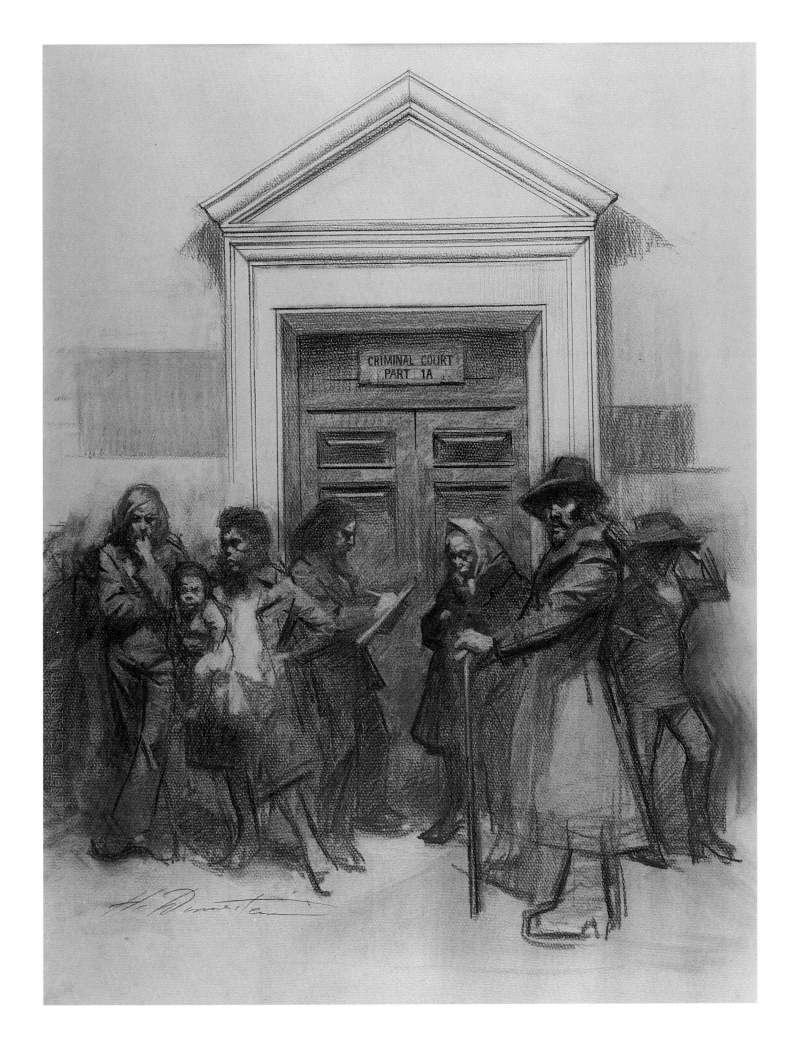

et us have faith that right makes might, and in that faith let us to the end dare to do our duty as we understand it.

Abraham Lincoln/Cooper Union, NY, 1860

FRJE ECHEVERRIA

BORN

June 12, 1944, Detroit

EDUCATION

University of Arkansas, Fayetteville, MFA, 1968

Florida Presbyterian College, St. Petersburg, BA, 1966

SELECTED SOLO EXHIBITIONS

University of Northern Iowa, Cedar Falls, 1975, 76, 77, 84

Charles H. MacNider Museum, Mason City, IA, 1980, 83

Anderson Arts Center, Anderson, IN, 1971

Wartburg College, Waverly, IA, 1970

SELECTED GROUP EXHIBITIONS

Sioux City Annuals, Sioux City, IA, 1968–85

West/ART & THE LAW, 1981

Springfield Art Museum, Springfield, MO, 1978, 80, 81

Joy Horwich Gallery, Chicago, 1980

Pastel Society of America, NYC, 1979

AWARDS, GRANTS, FELLOWSHIPS

Professional Development Leave, Costa Rica, 1985

University of Northern Iowa, Summer Research Award, 1977, 82

West/ART & THE LAW, Purchase, 1981

SELECTED COLLECTIONS

Black Hawk County

First National Bank

Shaanxi Teachers College, People's Republic of China

The West Collection

POSITIONS

University of Northern Iowa, Cedar Falls, Professor of Art, Present; Instructor of Art, 1969

Buena Vista College, Storm Lake, IA, Instructor of Art, 1968–69

ARTIST'S STATEMENT

While painting this county courthouse from a third-story window of a condemned apartment building, I found an eviction notice written in both English and Spanish, a closet with a collection of hats, and a Vietnamese Bible.

Frje Echeverria
Franklin County Courthouse, Iowa
pastel/17¾ x 23⅝

36

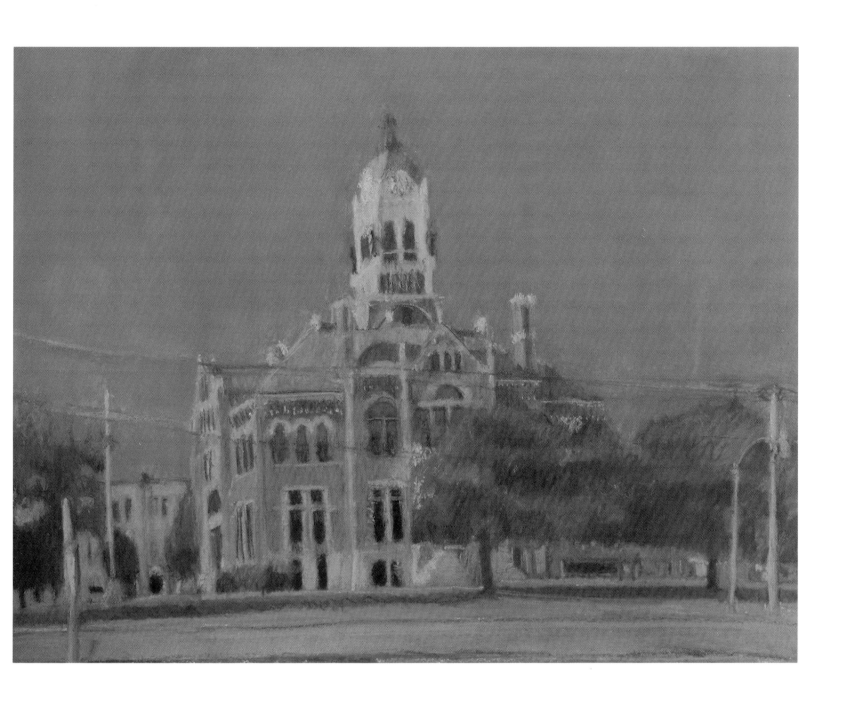

Look with thine eyes: see how yond justice rails upon yond simple thief. Hark, in thine ear: change places; and, hand-dandy, which is the justice, which is the thief?

William Shakespeare/*King Lear, IV,* 1606

CURT FRANKENSTEIN

BORN
March 11, 1922, Hannover, Germany

EDUCATION
Otis Art Institute of Los Angeles, 1953–54
Art Institute of Chicago, 1951–52
American Academy of Art, Chicago, 1947–50

SOLO EXHIBITIONS
Northern Indiana Arts Association, 1977, 84
Wilmette Public Library, Wilmette, IL, 1975, 84
American Bar Association Foundation, Chicago, 1979
Illinois Institute of Technology, Chicago, 1978
Greater Birmingham Arts Alliance, Birmingham, AL, 1978
Chicago Public Library, Chicago, 1969
University of Illinois, 1966

SELECTED GROUP EXHIBITIONS
West/ART & THE LAW, 1980, 82, 83
Northwestern University, Evanston, IL, 1978, 79, 82
Union League Club of Chicago, 1962, 63, 65, 78
Illinois State Fair, 1966, 67, 68
Illinois State Museum, Springfield, 1963, 65, 67
Butler Institute of American Art, Youngstown, OH, 1963, 65
Art Institute of Chicago, 1963, 64
Allied Artists of America, NY, 1962
St. Louis University, St. Louis, MO, 1962

AWARDS, GRANTS, FELLOWSHIPS
West/ART & THE LAW, Purchases, 1979, 80, 82
Northwestern University, Purchase, 1982, 79
Triton College, Award of Excellence, 1979
Illinois Regional Print Show, Award of Excellence, 1978
Municipal Art League Competition, 1st Place, 1970
Illinois State Fair, 1st Place, 1967
Union League Club Competition, 1st Prize, 1965
Art Institute of Chicago, Municipal Art League Prize, 1963

SELECTED COLLECTIONS
Borg-Warner Corporate Collection
City of Springfield Civic Collection
Illinois State Museum
Standard Oil of Indiana Corporate Collection
Union League Club of Chicago
The West Collection

POSITIONS
Painter, printmaker, Present
Printshop with etching press, Wilmette, IL

ARTIST'S STATEMENT
This etching symbolizes the fact that assignment of judges by lot can make the outcome of the lawyer's case as speculative as playing a Wheel of Fortune. If you are lucky, you are assigned a judge who regards your case favorably. I left the face of the judge in the center blank, so that the viewer can mentally project the image of his or her favorite judge.

Curt Frankenstein
Judicial Wheel of Fortune
etching (Artist's Proof III/XV)/18⅝ diameter

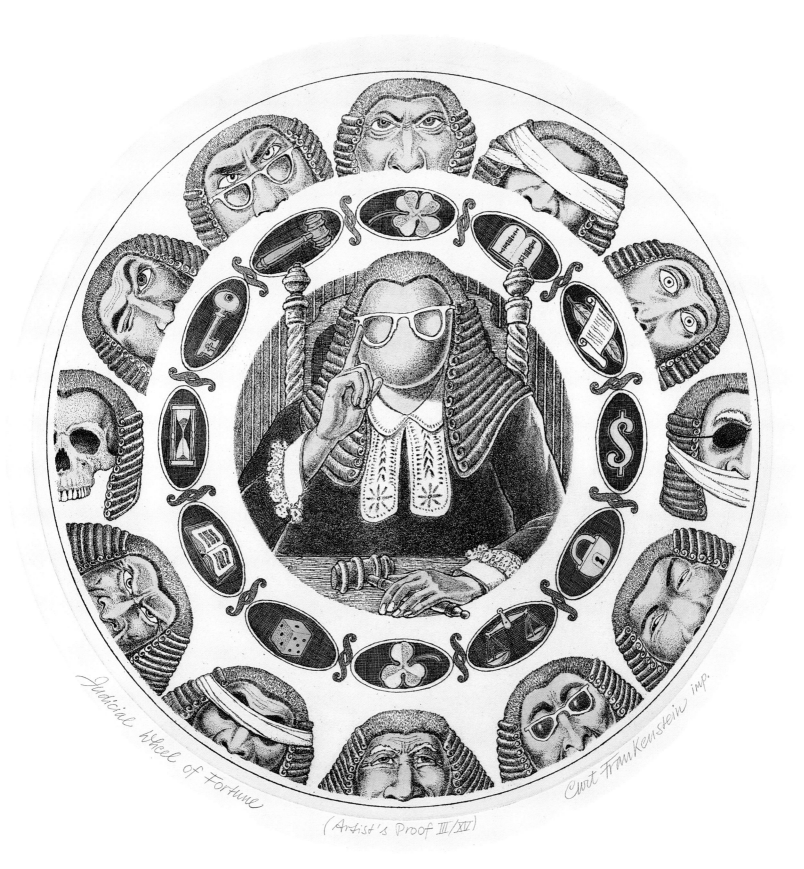

Judicial Wheel of Fortune

(Artist's Proof III/XV)

Curt Frankenstein imp.

The judicial power of the United States shall be vested in one Supreme Court, and in such inferior courts as the Congress may from time to time ordain and establish.

Constitution of the United States/Art. III

DAN F. HOWARD

BORN
August 4, 1931, Iowa City, IA

EDUCATION
University of Iowa, MFA, 1958
University of Iowa, BA, 1953

SELECTED SOLO EXHIBITIONS
Claypool-Young Art Center, Morehead State University, KY, 1985
Retrospective Exhibition: Tarble Art Center, Charleston, IL; Sheldon Memorial Art Gallery, Lincoln, NE; Conkling Gallery, Mankato State University, MN; Blanden Memorial Art Museum, Fort Dodge, IA; Sioux City Art Center, IA; 1983–84
Art Gallery, University of Texas, Tyler, 1983
Joy Horwich Gallery, Chicago, 1982
Joslyn Art Museum, Omaha, NE, 1981

SELECTED GROUP EXHIBITIONS
Contemporary American Painting Exhibition, Palm Beach, FL, 1979, 83, 84, 85
Olin Fine Arts Center, Washington, PA, 1985
Hoyt National Painting Show, New Castle, PA, 1984

Owensboro Museum of Fine Art, Owensboro, KY, 1984
Butler Institute of American Art, Youngstown, OH, 1983, 84
World's Fair Exposition, New Orleans, 1984
Laguna Gloria Art Museum, Austin, TX, 1982, 83, 84
Chautauqua Art Galleries, Chautauqua, NY, 1978, 80, 83
West/ART & THE LAW, 1979, 82

AWARDS, GRANTS, FELLOWSHIPS
Contemporary American Painting Exhibition, Bemis Gold Award, 1985
Mid-America Biennial National Exhibition, Purchase, 1984
National Art Exhibition/World's Fair Exposition, 1st Place, 1984
Spiva Regional Competitive Exhibition, Best in Show Award, 1984
Tom Butler Institute, Top Award, 1984
Biennial Regional Exhibition, Juror's Citation-Purchase Award, 1983
Chautauqua National Exhibition, Baker Memorial Award, 1983

Contemporary American Painting Exhibition, Atwater Kent Award, 1983
West/ART & THE LAW, Purchases, 1979, 82
Mid-Four Annual Exhibition, Top Patron Award, 1982

SELECTED COLLECTIONS
Dick Cavett
Con Agra Corporate Headquarters
Aaron Copland
CPM Corporation
Senator Nancy Landon Kassebaum
Jack Levine
Lowe Art Museum
Omaha National Bank
3M Companies
The West Collection

POSITIONS
University of Nebraska, Lincoln, Professor of Art and Chair, 1974–83
Professor of Art, 1983–Present
Kansas State University, Manhattan, Professor of Art and Head, 1971–74
Arkansas State University, Jonesboro, Associate Professor of Art and Chair, 1965–71; Associate Professor, 1963–71; Assistant Professor, 1961–63; Instructor, 1958–61

Dan F. Howard
Nine Very Human Men
oil/58 x 61

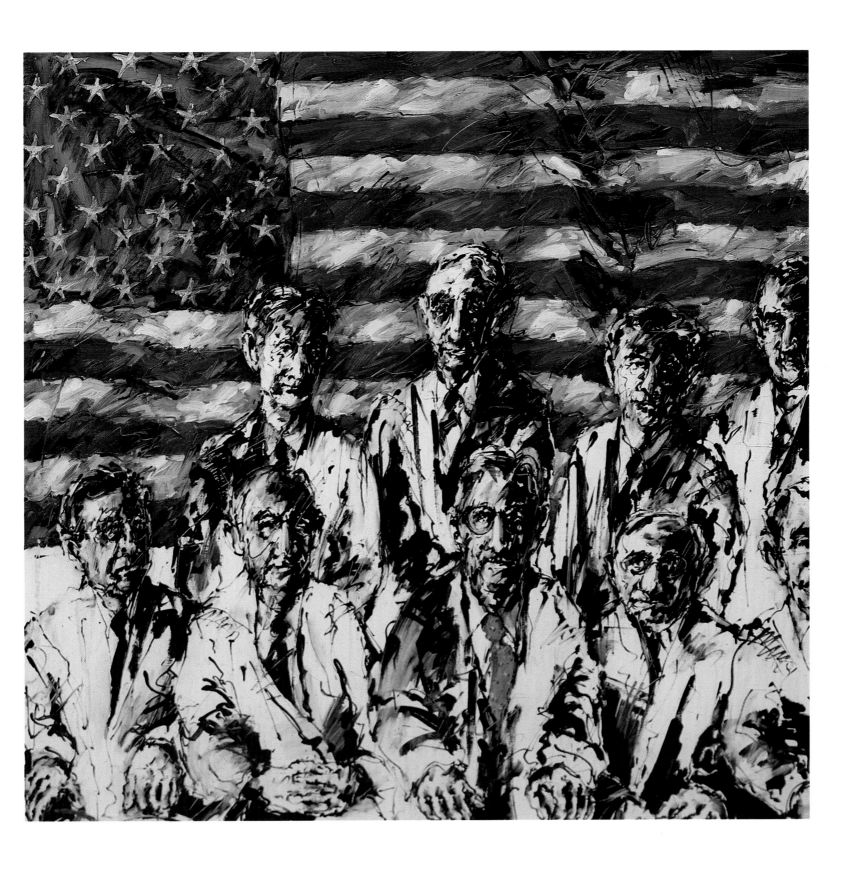

Every profession does imply a trust for the service of the public.

Benjamin Whichcote, 1753

BARBARA D. HULTMANN

BORN
January 18, 1941, Minneapolis

EDUCATION
San Jose State College, CA, Summer Sessions, 1964–65

University of Minnesota, Minneapolis, BS, 1963

SELECTED SOLO EXHIBITIONS
White Oak Gallery, Minneapolis, 1985

SELECTED GROUP EXHIBITIONS
West/ART & THE LAW, 1982–85

AWARDS, GRANTS, FELLOWSHIPS
West/ART & THE LAW, Purchases, 1982–85

Minnesota State Fair, Merit Award, Jurors' Award, Celebrity Peoples' Choice Award, 1977–82, 84

Art Center of Minnesota, Honorable Mention, 1981–84

SELECTED COLLECTIONS
Amfac Hotel

Barclay Bank

Farm Credit Bureau

Federal Land Bank

First Bank of Robbinsdale

First Bank Plaza

First Federal Bank

The West Collection

POSITIONS
Art Center of Minnesota, Minnetonka, Instructor, 1985

Governor's Task Force: A High School for the Arts, 1985

Edina Public Schools, MN, Instructor, 1964–80

North St. Paul Public Schools, Instructor, 1963–64

ARTIST'S STATEMENT
I am a very political person. It is difficult for me, however, to integrate my ideology with my artwork as I feel more strongly compelled to answer aesthetic concerns. *The Bailiffs* are, in reality, two museum guards from Greenville, S.C. I witnessed and was able to capture with my camera a dramatic scene, which I simplified and rendered here in acrylic paint. Law, justice, and order permeate every aspect of society. As parents, teachers, clergy, and museum guards we are all bailiffs at times.

Barbara D. Hultmann
The Bailiffs
acrylic/40 x 30

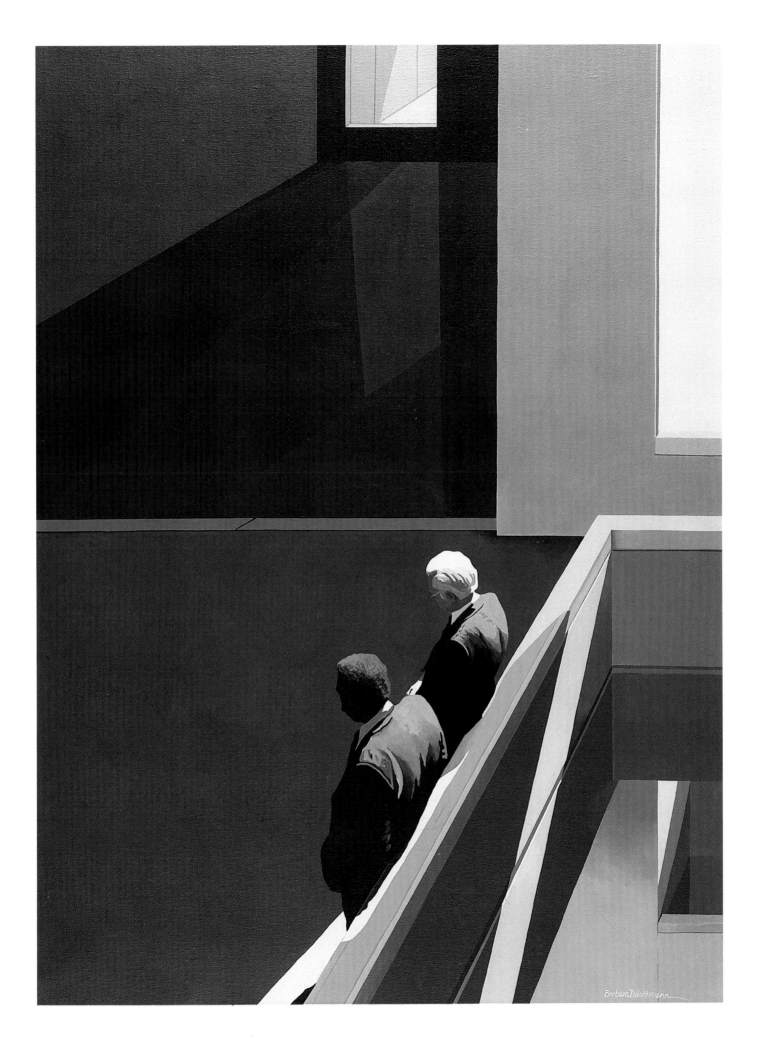

ndividuals may form communities, but institutions alone can create a nation.

Benjamin Disraeli, 1866

BARBARA D. HULTMANN

BORN
January 18,1941, Minneapolis

EDUCATION
San Jose State College, CA, Summer Sessions, 1964–65

University of Minnesota, Minneapolis, BS, 1963

SELECTED SOLO EXHIBITIONS
White Oak Gallery, Minneapolis, 1985

SELECTED GROUP EXHIBITIONS
West/ART & THE LAW, 1982–85

AWARDS, GRANTS, FELLOWSHIPS
West/ART & THE LAW, Purchases, 1982–85

Minnesota State Fair, Merit Award, Jurors' Award, Celebrity Peoples' Choice Award, 1977–82, 84

Art Center of Minnesota, Honorable Mention, 1981–84

SELECTED COLLECTIONS
Amfac Hotel

Barclay Bank

Farm Credit Bureau

Federal Land Bank

First Bank of Robbinsdale

First Bank Plaza

First Federal Bank

The West Collection

POSITIONS
Art Center of Minnesota, Minnetonka, Instructor, 1985

Governor's Task Force: A High School for the Arts, 1985

Edina Public Schools, MN, Instructor, 1964–80

North St. Paul Public Schools, Instructor, 1963–64

ARTIST'S STATEMENT
This painting is first and foremost a figure study. It is intended to describe the apparel and style of certain professional people of the eighties. It is secondly a problem in design—an attempt to integrate the figures into an eye-catching and visually rhythmic pattern. It is my hope that the title would lead the viewer to contemplate the theme of the painting—the legal status of prostitution.

It should be noted that the judge, lawyer, and policeman are actual representatives of their professions. The prostitute, or decoy officer, was portrayed by a professional model.

Barbara D. Hultmann
The Professionals and the Law
acrylic/48 x 72/1986

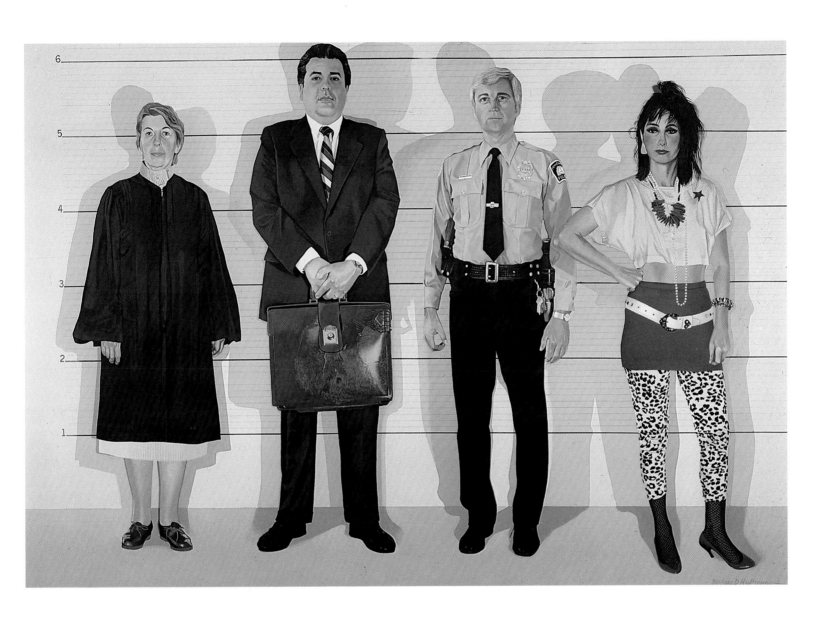

ur Constitution in actual operation; everything appears to promise that it will last; but nothing in this world is certain but death and taxes.

Benjamin Franklin/Letter, 1789

BARBARA D. HULTMANN

BORN

January 18, 1941, Minneapolis

EDUCATION

San Jose State College, CA, Summer Sessions, 1964–65

University of Minnesota, Minneapolis, BS, 1963

SELECTED SOLO EXHIBITIONS

White Oak Gallery, Minneapolis, 1985

SELECTED GROUP EXHIBITIONS

West/ART & THE LAW, 1982–85

AWARDS, GRANTS, FELLOWSHIPS

West/ART & THE LAW, Purchases, 1982–85

Minnesota State Fair, Merit Award, Jurors' Award, Celebrity Peoples' Choice Award, 1977–82, 84

Art Center of Minnesota, Honorable Mention, 1981–84

SELECTED COLLECTIONS

Amfac Hotel

Barclay Bank

Farm Credit Bureau

Federal Land Bank

First Bank of Robbinsdale

First Bank Plaza

First Federal Bank

The West Collection

POSITIONS

Art Center of Minnesota, Minnetonka, Instructor, 1985

Governor's Task Force: A High School for the Arts, 1985

Edina Public Schools, MN, Instructor, 1964–80

North St. Paul Public Schools, Instructor, 1963–64

ARTIST'S STATEMENT

Justice is not static. It must be adjusted to address environmental, cultural, political, and demographic changes. The adjustments sometimes come smoothly and routinely. This is not always the case, however. History shows us systems that experienced decay, revolution, and collapse. This painting is a symbolic, and I hope dramatic, presentation of this concept. My work is photo-realist, and this piece is a rendering of a photograph that I took in Biloxi, Mississippi, after hurricane Camille.

Barbara D. Hultmann
Justice: A Problem of Maintenance
acrylic/50 x 36/1985

ur courts have their faults, as does any human institution, but in this country our courts are the great levelers, and in our courts all men are created equal. I'm no idealist to believe firmly in the integrity of our courts and in the jury system—that is no ideal to me, it is a living, working reality. Gentlemen, a court is no better than each man of you sitting before me on this jury. A court is only as sound as its jury, and a jury is only as sound as the men who make it up.

Harper Lee/*To Kill a Mockingbird*, 1960

HANS A. MATTES

BORN
September 2, 1908, Düsseldorf, Germany

EDUCATION
Pasadena City College, CA, 1955–64
San Francisco University, JD, 1938
Bonn, Germany, JD, 1934

SELECTED SOLO EXHIBITIONS
Commonwealth Club of California, San Francisco, 1983
San Francisco Artists Cooperative, 1980, 81, 82
Alliance Française, San Francisco, 1980
Museo Italo Americano, San Francisco, 1979
Maxwell Galleries, San Francisco, 1977
San Francisco Art Commission, Capricorn Gallery, 1974
San Francisco Bar Association, 1970
Los Angeles Bar Association, 1969

SELECTED GROUP EXHIBITIONS
San Francisco Art Festival, 1965, 68–79
West/ART & THE LAW, 1977, 78
Oakland Jack London Square Art Festival, CA, 1966–67, 1969–70
Marin Art and Garden Fair, CA, 1965–68
Los Angeles Art Festival, 1960, 64
Newport Harbor Art Festival, CA 1964
Pasadena Art Fair, CA, 1962, 64

AWARDS, GRANTS, FELLOWSHIPS
Annual California State Bar Art Exhibits, Numerous 1st and Best of Show Awards
West/ART & THE LAW, Purchases, 1977, 78

SELECTED COLLECTIONS
UCLA Law Library
The West Collection

POSITIONS
Attorney at Law, 1941–Present

ARTIST'S STATEMENT
Twelve faces of men and women assembled at random to perform their duty as citizens, having no other common bond, unequal in wisdom and strength, charged and determined to solve a disputed issue by total agreement.

Hans A. Mattes
Trial by Jury
acrylic/20 x 30/1977

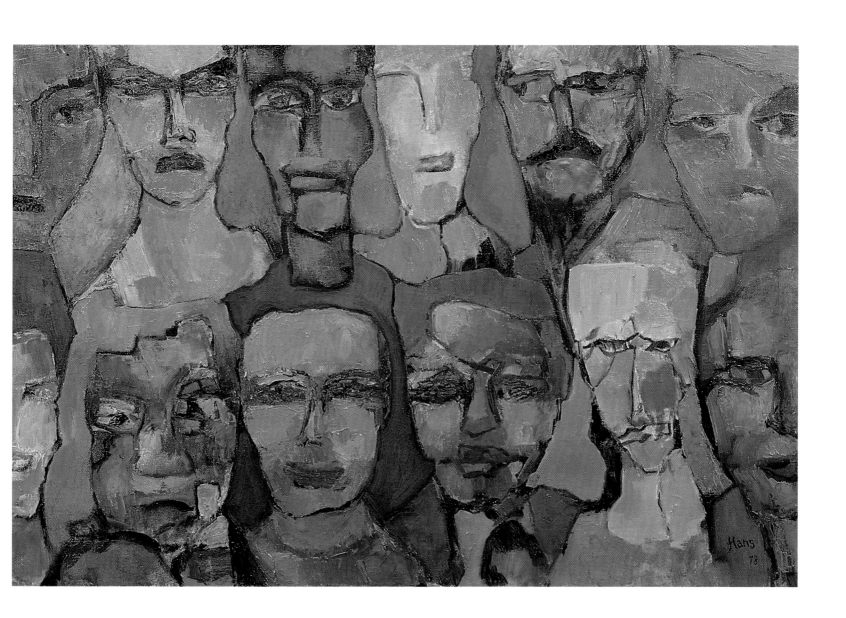

The Old Man Remembers,
* Swimming in the river*
* Kissing in the dark*
* Staying up late on weekends.*
The Old Man Prays,
* My time is over*
* I have tried.*
The Old Man Speaks,
* Today, we are the law*
* Justice is our heart*
* Fairness our will;*
Today, we decide the future.

William L. Newcomb, 1984

WILLIAM L. NEWCOMB

BORN
April 27, 1942, St. Louis, MO

EDUCATION
Washington University School of Law,
St. Louis, 1964–67
Washington University, St. Louis, 1960–64

SELECTED GROUP EXHIBITIONS
West/ART & THE LAW, 1975, 77

AWARDS, GRANTS, FELLOWSHIPS
West/ART & THE LAW, Purchase, 1975, 77

SELECTED COLLECTIONS
The West Collection

POSITIONS
General Counsel, Missouri Secretary of
State, Present
Chief Counsel of Consumer Protection
Division, 1984
Assistant Attorney General of Missouri,
1973–84

William L. Newcomb
Jessie Lupus/Jury Foreman
watercolor/16¼ x 13

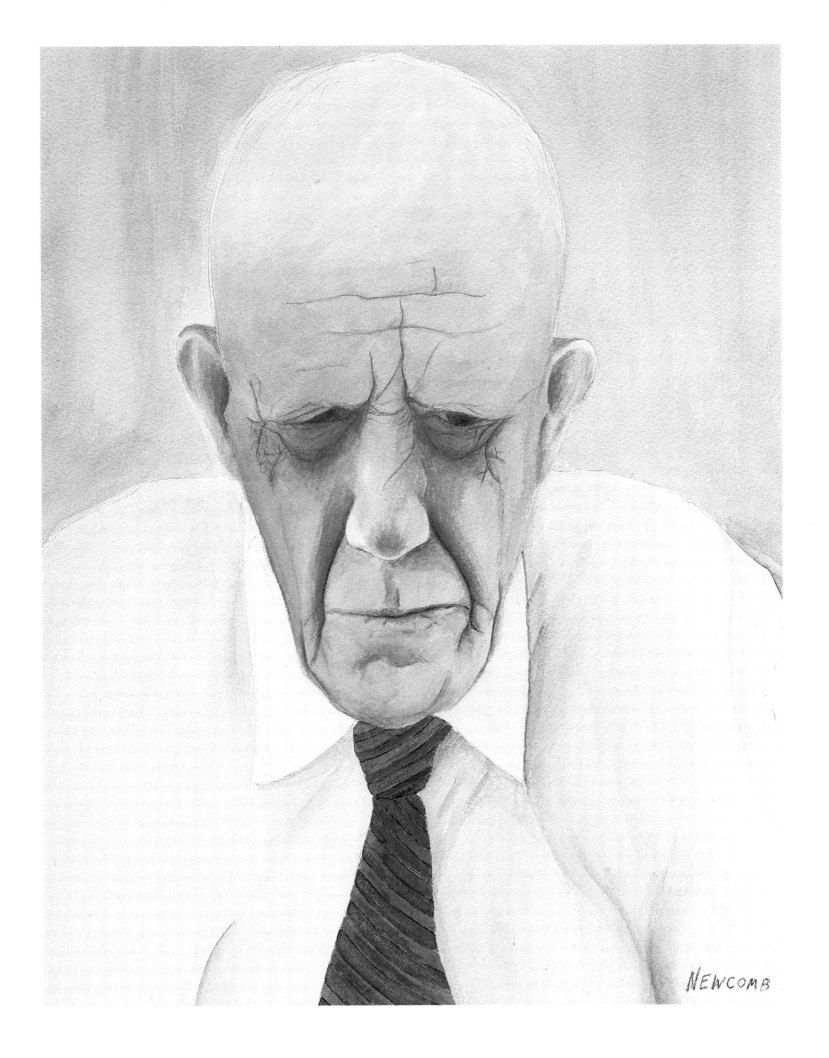

Liberty lies in the hearts of men and women; when it dies there, no constitution, no law, no court can save it.

Learned Hand/*The Spirit of Liberty*, 1944

CHARLES SHANNON

BORN

June 22, 1914, Montgomery, AL

EDUCATION

Cleveland School of Art, 1932–36

Emory University, Atlanta, 1930–32

SELECTED SOLO EXHIBITIONS

Piccolo Spoleto, Charleston, SC, 1982

Tennessee State Museum, Nashville, 1982

Fine Arts Museum of the South at Mobile, AL, 1982

Hunter Museum of Art, Chattanooga, TN, 1981

Southeastern Center for Contemporary Art, Winston-Salem, NC, 1981

Cleveland School of Art, 1938

Jacques Seligmann Galleries, NYC, 1938

Montgomery Museum of Fine Arts, AL, 1937

SELECTED GROUP EXHIBITONS

"Art and Artists of the South," Robert Coggins Collection, circulated to museums across the South, 1985–86

Southern Connections, Blount Inc., Montgomery, AL, 1985

Greenville County Museum of Art, Greenville, SC, 1985

Virginia Museum of Fine Arts, Richmond, circulated to museums across the South, 1983–84

West/ART & THE LAW, 1983

Metropolitan Museum of Art, NYC, 1950

Whitney Museum of American Art, NYC, 1940

Carnegie Institute, Pittsburgh, 1939

Golden Gate Exposition, San Francisco, 1939

AWARDS, GRANTS, FELLOWSHIPS

West/ART & THE LAW, Purchase, 1983

Golden Gate Exposition, 1939

Julius Rosenwald Fund Fellowship, 1938, Renewed 1939

Cleveland Museum of Art, 1st Award, 1936

Scholarships, Cleveland School of Art, 1933–36

SELECTED COLLECTIONS

W. C. Bradley Company Centennial Collection

Robert P. Coggins Collection

Fitzpatrick Associates Collection

Montgomery Museum of Fine Arts

The West Collection

Jim Wilson Associates Collection

POSITIONS

Auburn University at Montgomery, Professor of Art, Department Head, 1969–79

University of Alabama Extension Center in Montgomery, Instructor, 1958–69

West Georgia College, Artist-in-Residence, 1940–42

ARTIST'S STATEMENT

The painting is my statement. It is the result of several months of work and a lifetime of preoccupation with painting. The work is visual, and the answers to questions about it—its purpose, its pertinence to law and how it was approached—can be more fully apprehended by looking into the painting than by verbal translations.

Charles Shannon
View of the Courthouse
oil/30 x 40/1983

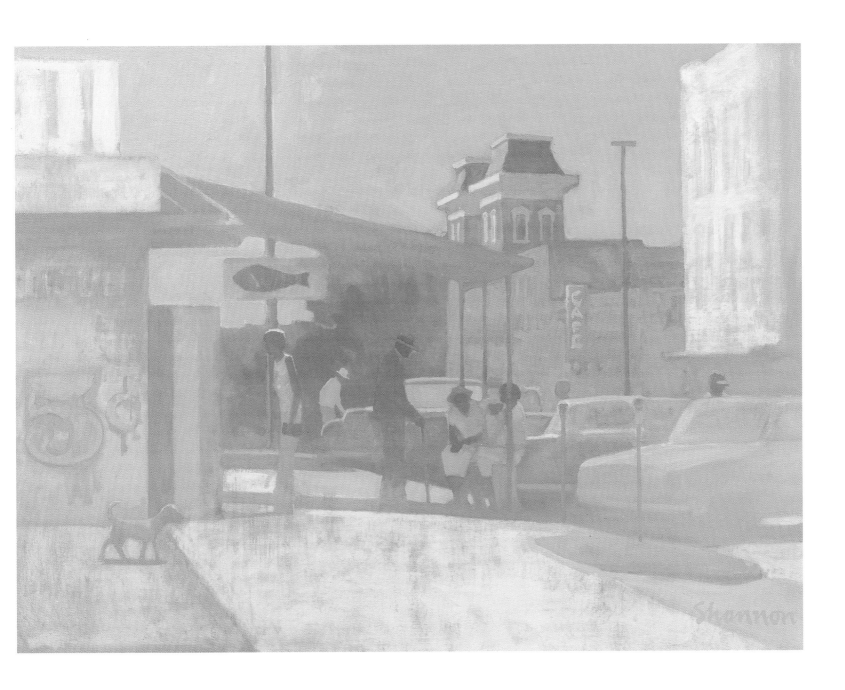

In giving judgment haste is criminal.

Publilius Syrus/*Sententiae*, c. 50 B.C.

BEN-ZION SHECHTER

BORN

August 7, 1940, Tel Aviv, Israel

EDUCATION

School of Visual Arts, NYC, 1967–69

Bezalel School of Art, Jerusalem, Israel, BFA, 1966

SELECTED SOLO EXHIBITIONS

Suffolk County Community College, Seldin, NY, 1984

Cayuga Community College, Auburn, NY, 1983

Martin Sumers Graphics, NYC, 1983

Charles A. Wustum Museum of Fine Arts, Racine, WI, 1982

SELECTED GROUP EXHIBITIONS

Arkansas Art Center, Little Rock, 1985

Brooklyn Museum, 1984

Prince Street Gallery, NYC, 1984

University of Iowa Museum of Art, Iowa City, 1983

Elvehjem Museum of Art, University of Wisconsin, Madison, 1983

Noho Gallery, NYC, 1982

UN Biennial Benefit Show, NYC, 1981

Tweed Museum of Art, University of Minnesota, Duluth, 1980

West/ART & THE LAW, 1980

Terrain Gallery, NYC, 1979

AWARDS, GRANTS, FELLOWSHIPS

West/ART & THE LAW, Purchase, 1980

Israeli Ministry of Education Scholarship, 1965–66

City of Jerusalem Scholarship, 1963–64

SELECTED COLLECTIONS

Museum of Fine Arts, Boston

Brooklyn Museum

Carnegie Institute

Guggenheim Museum Library

Harvard University Houghton Library

Hunt Institute

Israel Museum

New York Public Library

The West Collection

Whitney Museum of American Art

POSITIONS

Commercial Artist, 1966–Present

Henry St. Settlement, 1982

Bet Hillel at Hebrew University, Jerusalem, 1965–66

Exchange Specialist Program, Israeli Government and Jewish Theological Seminary, 1965–66

ARTIST'S STATEMENT

This drawing is a tribute to the unknown juror with whom I spent time in the waiting room of the Brooklyn Supreme Court in 1978. There were long days of assembly and disassembly, calls for duty and returning to the waiting room. Some people never served on a single court case in two weeks. But this period gave me the opportunity to study the waiting men and women in their frustration and boredom.

The drawing is the result of this experience. It reflects my involvement at that time with stylized figures in crowds.

Ben-Zion Shechter
The Waiting Room—The Jurors
silverpoint/4¾ x 6¼/1979

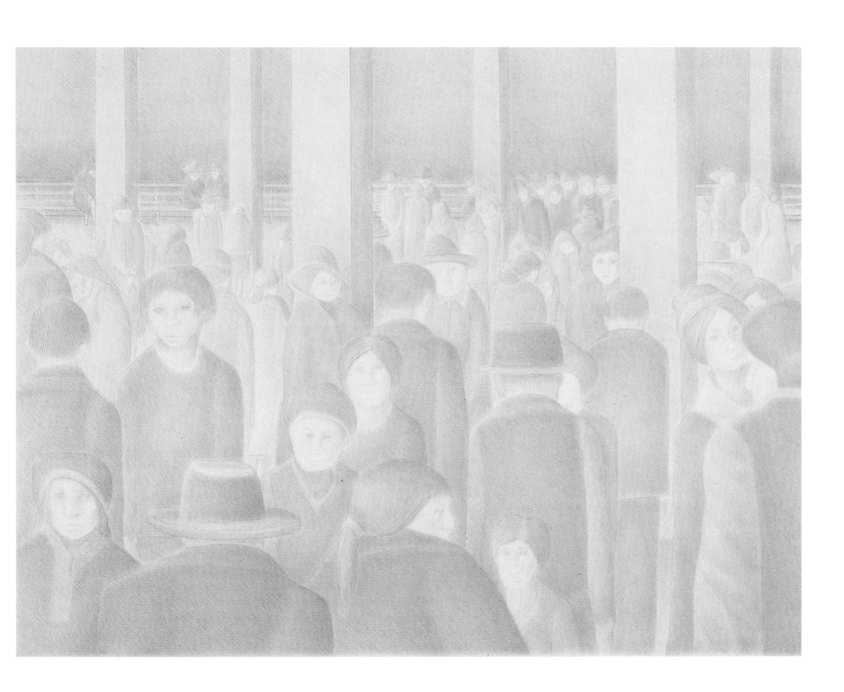

good and faithful judge prefers what is right to what is expedient.

Horace/*Carmina*, c. 13 B.C.

HANK VIRGONA

BORN
October 24, 1929, Brooklyn, NY

EDUCATION
Pratt Institute Evening School, NYC, 1954

SELECTED SOLO EXHIBITIONS
Mazin-Wyckoff Gallery, 1984
New York Borough President's Gallery, 1984
Rittenhouse Gallery, Philadelphia, 1974, 77, 80, 83
Washington Irving Gallery, NYC, 1982
Perin-Sharpe Gallery, CT, 1981
Summa Gallery, NYC, 1978, 80
FAR Gallery, NYC, 1977
Roko Gallery, NYC, 1970, 72, 75, 77

SELECTED GROUP EXHIBITIONS
Lehman College Gallery, NYC, 1984
Parson School Gallery, NYC, 1984
Dorsky Galleries, NYC, 1983
Invitational Printmakers Exchange, 1982
Pratt Graphic Center, NYC, 1982
West/ART & THE LAW, 1981
Rutgers University, New Brunswick, NJ, 1975
American Federation of Arts, 1971, 72, 73, 75
Norfolk Museum, 1969
Sung Harbor Cultural Center, 1953

AWARDS, GRANTS, FELLOWSHIPS
Pratt Graphic Center, 1982
West/ART & THE LAW, Purchase, 1980
National Academy of Design, 1979
National Arts Club, 1975
Wheaton College National Drawing Exhibition, 1974
Georgia State University, Purchase, 1970

SELECTED COLLECTIONS
Butler Institute of American Art
Metropolitan Museum of Art
Museum of the City of New York
New York Public Library
Slater Memorial Museum
Smithsonian Institution
The West Collection
Wichita Art Museum

POSITIONS
Pratt Graphic Center, Instructor, 1985–Present
Illustrator, 1960–Present
Art Instructor, 1984
Illustrations for: Doubleday Publishing, *New York Times*, "OP-ED" Section; NBC–TV; *Harper's* Magazine

ARTIST'S STATEMENT
The rule of law is one of the most important pillars of freedom. As an artist who frequently uses satire to make a point, I have always kept in mind the words of Thomas Jefferson: "the price of freedom is eternal vigilance."

My personal observation of the courts has shown that they are only as perfect as the men who run them.

In graphically depicting these observations I have tried, without judgment, to show this, for only through honest appraisal can we maintain the vigilance required to safeguard this most vital element of freedom.

Hank Virgona
Conference at the Bench
ink and wash/17½ x 14¾ (sight)

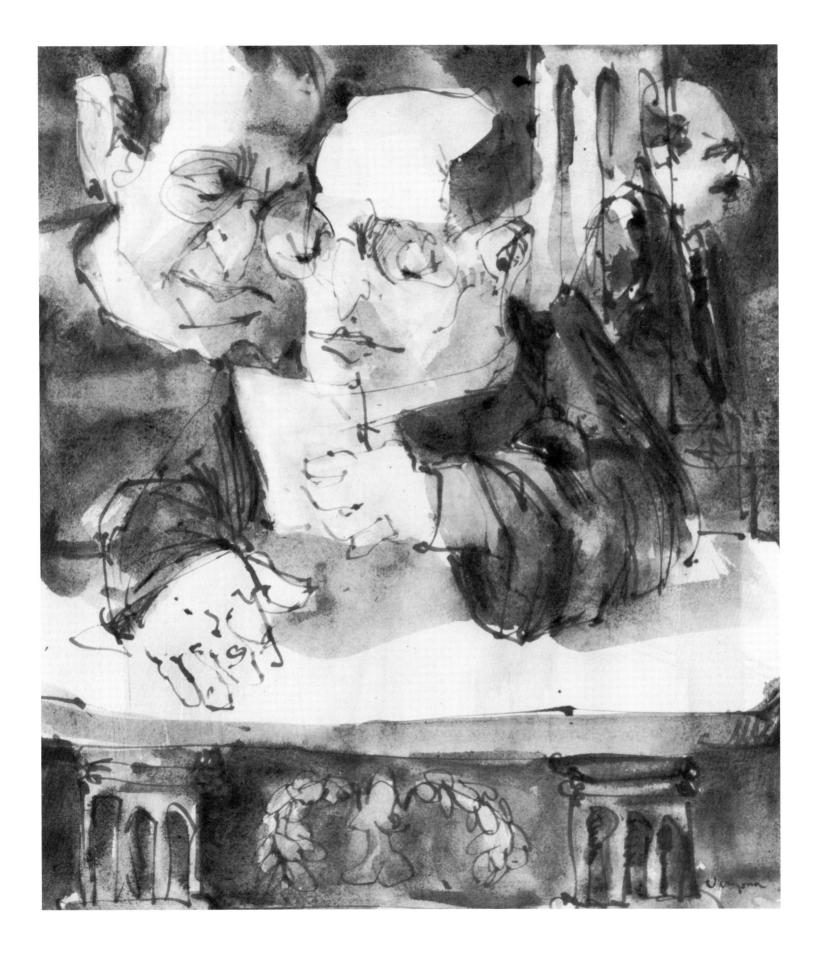

overnment by the people is possible, but highly improbable.

J. William Fulbright/Fund for the Republic pamphlet, 1963

BUD WALL

BORN
January 21, 1939, Monroe, NC

EDUCATION
University of Guanajuato, San Miguel de Allende, Mexico, MFA, 1964

East Carolina University, Greenville, NC, 1962

Ringling School of Art, Sarasota, FL, 1960

SELECTED SOLO EXHIBITIONS
Water Street Gallery, Milwaukee, 1981

Marine Plaza Galleries, Milwaukee, 1981

Wingate College, NC, 1965

East Carolina University, Greenville, NC, 1963

SELECTED GROUP EXHIBITIONS
National Gallery of Modern Art, Lisbon International, Portugal, 1982

National Academy of Design Gallery, NYC, 1982

Pillsbury Exhibition, Minneapolis, 1981

Milwaukee Art Museum, 1981

Westbury Gallery, NYC, 1979

Contemporary Fine Arts Gallery, Dallas, 1966

Instituto Allende, San Miguel de Allende, Mexico, 1964

AWARDS, GRANTS, FELLOWSHIPS
University of Wisconsin, Stevens Point, 1982

West/ART & THE LAW, Purchase, 1981

First Miami National, FL

First North and South Carolina Show, Lancaster, SC

University Art Museum, Milwaukee

Ringling School of Art, Sarasota, Gold Medal Award

Sarasota Art Association, FL

SELECTED COLLECTIONS
Pillsbury Collection

The West Collection

Private Collections in USA, Canada, Mexico and Holland

POSITIONS
University of Wisconsin, Instructor, 1967–Present

San Angelo, TX; Marshfield, WI, Murals, 1975–78

Instituto Allende, San Miguel de Allende, Instructor

ARTIST'S STATEMENT
The judge reaches for his gavel, the doors to the courtroom suddenly open, and someone screams, "The bluefish are running!" Everyone runs for their fishing rods, and the stampede is on for the pier! It's everyone for himself—one-on-one with nature. For a few brief moments there is no hierarchy, no law! It's great! Then as suddenly as it began, the bluefish run was over and reality returned. In the months that followed, all but one was recaptured . . . me! I'm now posing as an artist in a major midwestern university.

Bud Wall
Court Will Recess 'til after the Bluefish Run
charcoal/57½ x 40½/1981

The Legal Profession

The law: it has honoured us, may we honour it. I would invoke those who fill seats of justice . . . that they execute the wholesome and necessary severity of the law.

Daniel Webster

B. H. ARMSTRONG

BORN

December 13, 1926, Horton, KS

EDUCATION

University of Illinois, MFA, 1955

Bradley University, Peoria, IL, BFA, 1949

SELECTED GROUP EXHIBITIONS

West/ART & THE LAW, 1983, 82

St. Louis Academy of Professional Arts, 1969

Cleveland Museum of Art, 1986

Butler Institute of American Art, Youngstown, OH, 1956, 59, 61, 64, 67

Pennsylvania Academy of Fine Arts Philadelphia, 1956, 59, 61, 64, 67

Society of American Graphic Artists International Exhibition, 1960

Walker Biennial, Minneapolis, 1960

American Federation of Arts International Traveling Exhibition, 1956

AWARDS, GRANTS, FELLOWSHIPS

West/ART & THE LAW, Purchases, 1982, 83

Watercolor USA, 1960, 63, 66–69, 72

California National Watercolor Society, 1970

Pennsylvania Academy of Fine Arts, 1967

Museum of Fine Arts, Boston, Purchase, 1964

Birmingham Museum of Art, AL 1963

Knoxville National Print and Watercolor Exhibition, TN, 1962

Washington, DC, Watercolor Society, 1960

San Francisco Fine Arts Museums, 1959

Brooklyn Museum, 1958

SELECTED COLLECTIONS

Albrecht Museum Drawing & Watercolor Collections

Brooklyn Museum Print Collection

Fine Arts Museums, San Francisco

Hallmark Collection

Madison Art Association

Museum of Fine Arts, Boston

Springfield Art Museum

The West Collection

POSITIONS

Southwest Missouri State University, Professor of Art, 1963–Present

Freelance Illustrator, 1955–81

University of Wisconsin, Madison, Assistant Professor, 1955–63

Ford Foundation Art Consultant, Southeast Asia, 1957–58

Graphic Designer, 1949–56

ARTIST'S STATEMENT

If I were to do a series of portraits of prominent historical members of the legal profession, the logical choice after Clarence Darrow would be Daniel Webster, and after him, Henry Clay.

The difficulty with the choice of Webster was selecting an appropriate quotation to include with the composition. His penchant for verbosity made it necessary to use an abbreviation. The descriptions of his prominent, oversized brow and penetrating eyes made the portrait easy.

B. H. Armstrong
Webster
watercolor/38 x 40

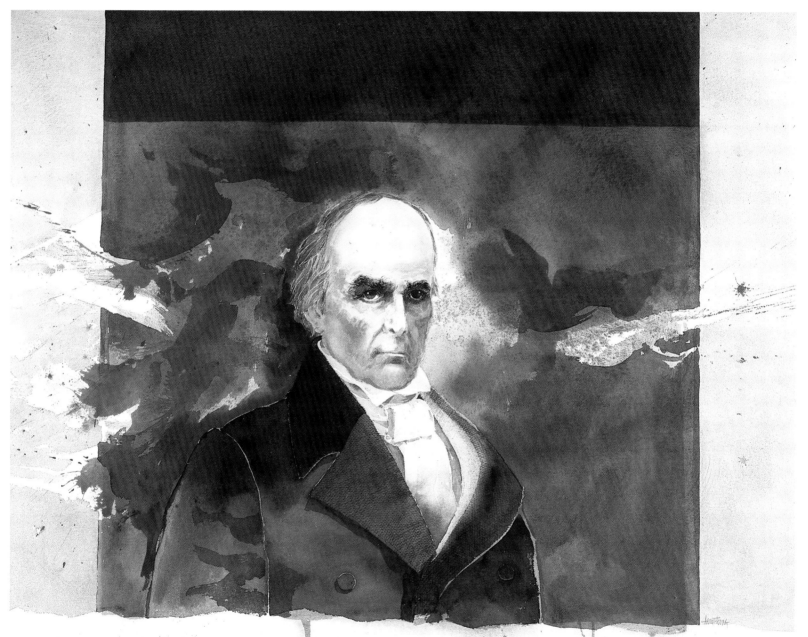

The law: it has honoured us, may we honour it.
· · · ·
I would invoke those who fill seats of justice,... that they execute the
wholesome and necessary severity of the law.

DANIEL WEBSTER

> *A courtroom is not a place where truth and innocence inevitably triumph; it is only an arena where contending lawyers fight not for justice, but to win.*
>
> Clarence Darrow

B. H. ARMSTRONG

BORN

December 13, 1926, Horton, KS

EDUCATION

University of Illinois, MFA, 1955
Bradley University, Peoria, IL, BFA, 1949

SELECTED GROUP EXHIBITIONS

West/ART & THE LAW, 1983, 82
St. Louis Academy of Professional Arts, 1969
Cleveland Museum of Art, 1986
Butler Institute of American Art, Youngstown, OH, 1956, 59, 61, 64, 67
Pennsylvania Academy of Fine Arts Philadelphia, 1956, 59, 61, 64, 67
Society of American Graphic Artists International Exhibition, 1960
Walker Biennial, Minneapolis, 1960
American Federation of Arts International Traveling Exhibition, 1956

AWARDS, GRANTS, FELLOWSHIPS

West/ART & THE LAW, Purchases, 1982, 83
Watercolor USA, 1960, 63, 66–69, 72
California National Watercolor Society, 1970
Pennsylvania Academy of Fine Arts, 1967
Museum of Fine Arts, Boston, Purchase, 1964
Birmingham Museum of Art, AL 1963
Knoxville National Print and Watercolor Exhibition, TN, 1962
Washington, DC, Watercolor Society, 1960
San Francisco Fine Arts Museums, 1959
Brooklyn Museum, 1958

SELECTED COLLECTIONS

Albrecht Museum Drawing & Watercolor Collections
Brooklyn Museum Print Collection
Fine Arts Museums, San Francisco
Hallmark Collection
Madison Art Association
Museum of Fine Arts, Boston
Springfield Art Museum
The West Collection

POSITIONS

Southwest Missouri State University, Professor of Art, 1963–Present
Freelance Illustrator, 1955–81
University of Wisconsin, Madison, Assistant Professor, 1955–63
Ford Foundation Art Consultant, Southeast Asia, 1957–58
Graphic Designer, 1949–56

ARTIST'S STATEMENT

Clarence Darrow is a uniquely American phenomenon, and the calligraphic quotation used in this painting personifies his marvelous, perceptive wit. Irving Stone's romantic biography and Henry Fonda's portrayal on the stage have established Darrow as one of this country's immortal and colorful heroes. I thought it appropriate to paint his portrait in watercolor in a manner reminiscent of Winslow Homer and John Singer Sargent, a painting style that seems to me to best express the free and spontaneous creativity that is peculiarly American.

B. H. Armstrong
Darrow
watercolor/60 x 40

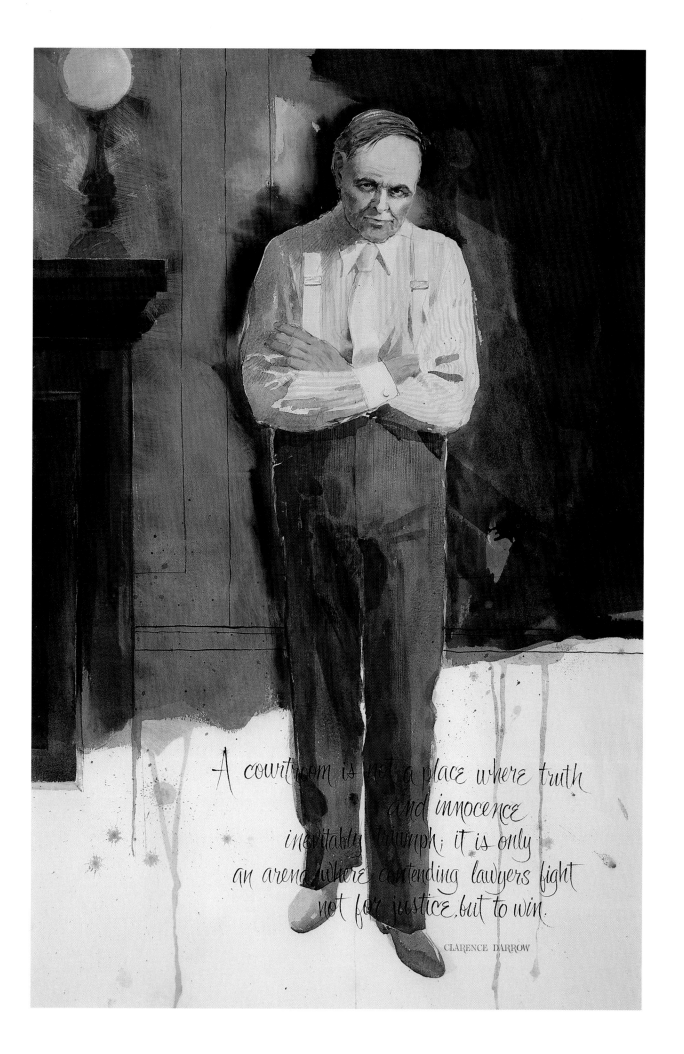

A courtroom is not a place where truth
and innocence
inevitably triumph; it is only
an arena where contending lawyers fight
not for justice, but to win.

CLARENCE DARROW

> *The litigants and their lawyers are supposed to want justice, but, in reality, there is no such thing as justice, either in or out of the court. In fact, the word cannot be defined.*
>
> Clarence Darrow/Interview, 1936

HARVEY BREVERMAN

BORN
January 7, 1934, Pittsburgh

EDUCATION
Ohio University, MFA, 1960
Carnegie Institute of Technology, Pittsburgh, BFA, 1956

SELECTED SOLO EXHIBITIONS
Gadatsy Gallery, Toronto, 1975, 76, 78, 80, 81, 84
Art Gallery of Hamilton, Ontario, 1981
Nardin Galleries, NYC, 1980
FAR Gallery, NYC, 1974, 79
Grand Rapids Art Museum, MI, 1977
Kalamazoo Institute of Arts, MI, 1976
Impressions Gallery, Boston, 1974
Canton Art Institute, OH, 1971
University of Oregon Museum of Art, Eugene, 1970
Albright–Knox Art Gallery, Buffalo, NY, 1967

SELECTED GROUP EXHIBITIONS
Jewish Museum, NYC, 1982
American Academy of Arts and Letters, NYC, 1980, 81
West/ART & THE LAW, 1980
Art Gallery of Ontario, Toronto, 1979
Arte Fiera di Bologna, Italy, 1978
Department of State, US Embassies, Belgrade, Caracas, 1976
Museum of Modern Art, Oxford, England, 1974
Whitechapel Art Gallery, London, 1973
Kanazawa Art Museum, Japan, 1972
Royal Academy of Fine Arts, Amsterdam, 1968
Corcoran Gallery of Art, Washington, DC, 1963

AWARDS, GRANTS, FELLOWSHIPS
National Endowment for the Arts Fellowship, 1974–75, 1980–81
American Academy of Arts and Letters, Hassam–Speicher Fund Painting Purchases, 1980, 81
West/ART & THE LAW, Purchase, 1980
2nd Norwegian International Print Biennial, Graphics Award, 1974
3rd British International Print Biennial, Graphics Award, 1972
New York State Council on the Arts, Grant (CAPS), 1972
Museum of Fine Arts, Boston, Paul J. Sachs Memorial Award, 1967
Netherlands Government Grant, 1965
Louis Comfort Tiffany Foundation Grant, 1962

SELECTED COLLECTIONS
Albright–Knox Art Gallery
Israel Museum, Jerusalem
Minnesota Museum of Art
Museum of Modern Art
National Museum of American Art
Pushkin Museum, Moscow
Victoria and Albert Museum, London
The West Collection
Whitney Museum of American Art

POSITIONS
State University of NY at Buffalo, Professor, 1961–Present
Visiting Artist: Maryland Institute, 1984; Skidmore College, 1983; University of Michigan, 1978; Oxford University, Ruskin School, England, 1974, 77; Illinois State University, 1969

ARTIST'S STATEMENT
From the *Halcyon Days Series,* this painting fixes a group of men at a precise and informal moment when they are perhaps most like themselves—gesturing, posturing, interacting singly and in groups, connected and even disconnected from one another.

Each scenario will be played out simultaneously. A courtroom setting is suggested but is not explicit.

Figuring prominently in this composite of "types" are a few friends, acquaintances, and even the artist.

Over the years I've frequently used an oblique compositional vantage point. In this instance, the composition was triggered by an archival photo from the Nuremberg War Trials.

Harvey Breverman
Halcyon Days No. III
oil/54³⁄₈ x 66

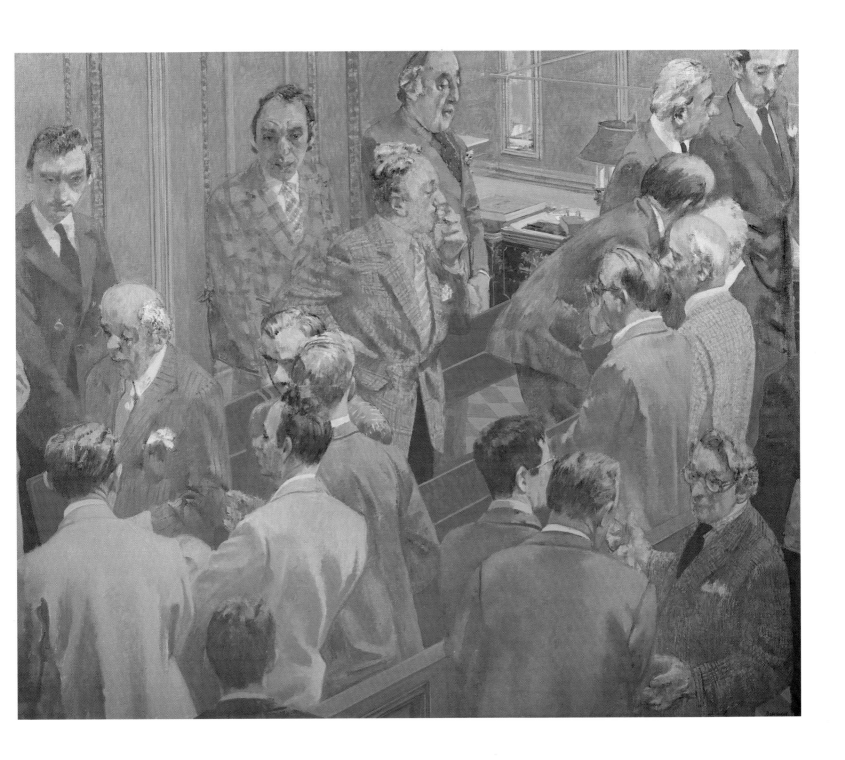

There is no more reason to believe that man descended from an inferior animal than there is to believe that a stately mansion has descended from a small cottage.

William Jennings Bryan/The Scopes Trial, 1925

EDWIN ROBERT CARTER

BORN

November 25, 1939, Bartow, FL

EDUCATION

Florida State University, MFA, 1965

SELECTED SOLO EXHIBITIONS

Galeria Palacio Clavijero, Morelia, Mexico

Ed Heist Studios, Jacksonville, FL

Rourke Gallery, Moorhead, MN

SELECTED GROUP EXHIBITIONS

Midwestern Artists Invitational, 1980–83

Rohm & Haas Corporation, 1980

West/ART & THE LAW, 1980

North Dakota Artists, 1979

6th National Print/Drawing Show, Charlottesville, VA, 1977

Lexington Gallery, University of Chicago

PK Fine Arts, NYC

AWARDS, GRANTS, FELLOWSHIPS

Danforth Associateship, 1981

Southern US Print/Drawing Competition, 1st Place

Southeastern US Painting Competition, Award

Eastern US Drawing Competition, Award

West/ART & THE LAW, Purchase, 1980

SELECTED COLLECTIONS

Florida State University

IMC Corporation

The West Collection

Private Collections in US, Mexico, Canada, Iceland, Europe

POSITIONS

St. Andrews Presbyterian College, Laurinburg, NC, Associate Professor

ARTIST'S STATEMENT

There are of course many kinds of law. It seemed appropriate to contrast two extremes: the archetypal and spiritual as opposed to the civil and social. In doing so, it was also possible to contrast two great cultures, Eastern and Western, by juxtaposing images of Clarence Darrow and William Jennings Bryan (of the infamous Scopes trial) with the image of the Hindu god Vishnu, incarnate as Hanuman, a monkey god.

Edwin Robert Carter
The Law
colored pencil/33 x 42/1979

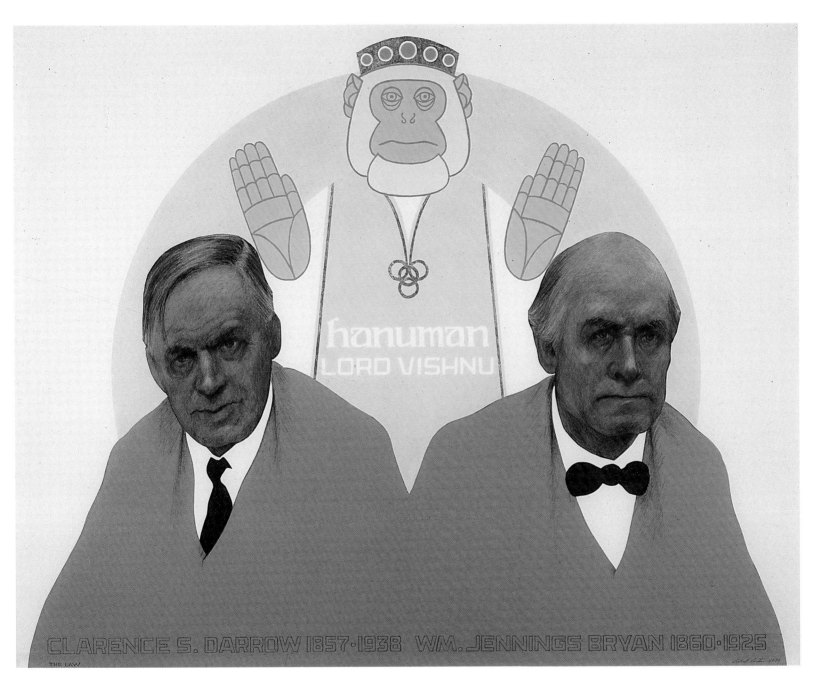

hanuman
LORD VISHNU

CLARENCE S. DARROW 1857·1938 WM. JENNINGS BRYAN 1860·1925

THE LAW

To think is to differ.

Clarence Darrow/The Scopes Trial, 1925

JONATHAN DeFREES

BORN
April 22, 1946, Oneida, NY

EDUCATION
State University of New York, Oneonta, 1972–75

University of Kentucky, Lexington, 1966–68

Union College, Barbourville, KY, 1964–66

SELECTED SOLO EXHIBITIONS
"Nashville Reflections," 1986

SELECTED GROUP EXHIBITIONS
West/ART & THE LAW, 1981

Mid-South Art Show, Nashville, TN, 1977

State University of New York, Oneonta, 1975

AWARDS, GRANTS, FELLOWSHIPS
West/ART & THE LAW, Purchase, 1981

Nashville Century III, Purchase, 1980

Opryland Hotel, Purchase, 1978

SELECTED COLLECTIONS
Opryland Hotel Collection

Third National Bank

The West Collection

POSITIONS
Arts Chairman, West End Middle School, Nashville, TN, Present

Metro Public School System, Nashville, TN, Visual Arts Instructor, 1976–86

ARTIST'S STATEMENT
Hand-torn paper fragments, toned by man and machine, aged by time, create the images of a landmark case in the history of American law. The subject became the vehicle for a personal style of visual expression and a unique use of the paper medium.

Jonathan DeFrees
The State of Tennessee vs. John Thomas Scopes
collage/16³⁄₈ x 23½/1982

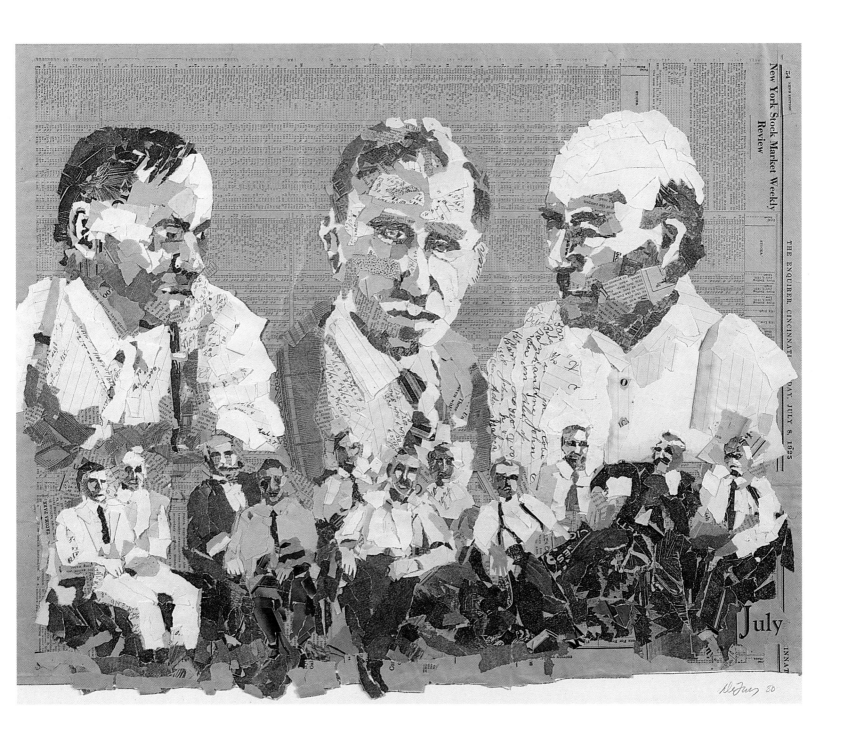

> *he profession of the law is the only aristocracy that can exist in a democracy without doing violence to its nature.*
>
> Alexis de Tocqueville/*Democracy in America,* Vol. I, 1835

SCOTT FRASER

BORN
November 23, 1957, Evanston, IL

EDUCATION
European Study—Atelierhaus, Worpswede, West Germany, 1985–86
University of Colorado at Denver, 1983
Kansas City Art Institute, 1976–79

SELECTED SOLO EXHIBITIONS
Ken Caryl, Littleton, CO, 1978

SELECTED GROUP EXHIBITIONS
NSPCA, NYC, 1986
West/ART & THE LAW, 1984, 85
Audubon Artists, NYC, 1985
Foothills Art Center, Golden, CO, 1984
NSPCA and Audubon Annuals, Lotus Club, NYC, 1984
Allied Artists of America, NYC, 1983
Carson Gallery of Western American Art, Denver, 1983
International Watercolor Exhibition, San Diego, CA, 1983

AWARDS, GRANTS, FELLOWSHIPS
Dr. Maury Leibovitz Artists' Welfare Fund Award, 1985
Audubon Artists, Alice G. Melrose Memorial Award, 1984
NSPCA, Doris Kreindler Award, 1984
International Watercolor Exhibition, Winsor/Newton Award, 1983–84, Travel Exhibition
Allied Artists of America, Silver Medal of Honor, 1983
National Portrait Awards, Certificate of Special Commendation #1, 1983
Rocky Mountain National Watermedia Exhibition, Columbine Award, 1982, Century Award of Merit, 1981
Scholastic Magazine National Competition, Two Gold Medals, 1976

SELECTED COLLECTIONS
Cherry Creek National Bank
Hiwan Homestead Museum
International State Bank
Petro–Lewis Oil Company
United Bank
The West Collection

POSITIONS
Full-time Artist

ARTIST'S STATEMENT
When I first received the invitation to participate in "West '84/ART & THE LAW," there was no other thought in my mind than to paint my brother Gregg, my closest relationship to the law.

"ART & THE LAW" has a special and personal significance for me, because it describes the paths my brother and I have chosen to pursue. Both still young, we have set our sights on these careers with the great determination and dedication it takes to become a lawyer or an artist. Over the years, there has been mutual support and camaraderie between us in our quest for our goals.

I have a realist's concern for life, and it carries over into my work. I paint subjects that I understand and have compassion for, and I would hope that my work conveys this sense of intimacy. I want to paint Gregg again in the future when the trappings of the student—the backpack bulging with books and the favorite sweater—have been exchanged for a briefcase and a three-piece suit. Meanwhile, we are both emerging into the world of our choice—art and the law—with great expectations of a contribution to be made.

Scott Fraser
**Young Law Student—
A Portrait of My Brother**
acrylic on masonite/35³/₄ x 20/1984

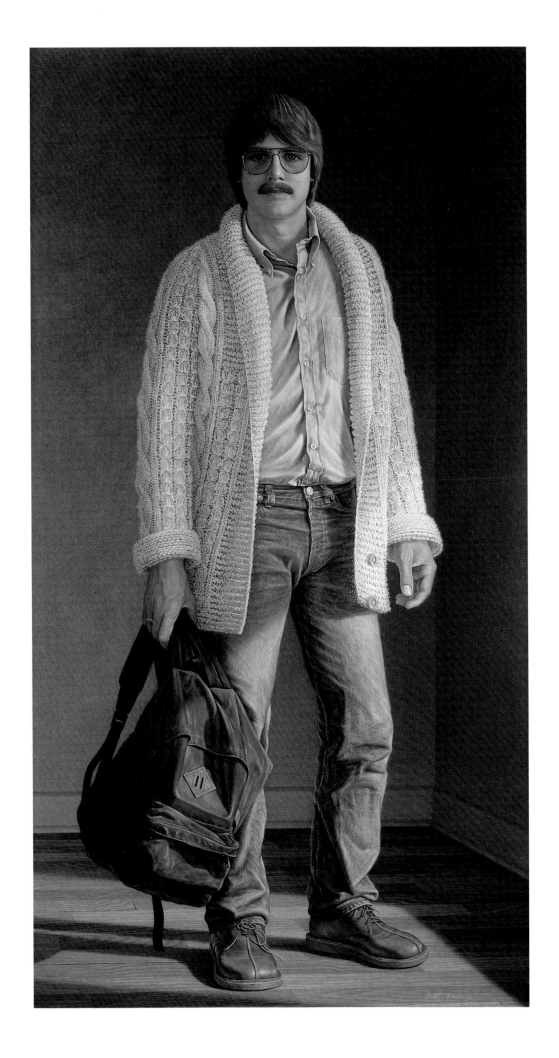

way of belief that has existed for decades cannot be radically modified overnight. A single event, such as the trial, accomplishes little in the changing of a culture. Prejudice is not unique to Tennessee; it is ubiquitous and not easily eradicated.

John T. Scopes

GEORGE LITTLE

BORN

November 8, 1908, Ashland, KY

EDUCATION

University of Louisville, KY

Private Instruction

SELECTED SOLO EXHIBITIONS

Portsmouth, OH, 1985

Ashland, KY, 1985

SELECTED GROUP EXHIBITIONS

West/ART & THE LAW, 1982

AWARDS, GRANTS, FELLOWSHIPS

Chattanooga Poster, 1985

Chattanooga Trade Center, Purchase, 1985

Chattanooga City Seal, 1984

West/ART & THE LAW, Purchase, 1982

SELECTED COLLECTIONS

Chattanooga City Hall

First Federal Savings

Dr. Lassiter Collection

David Parkers

The West Collection

POSITIONS

Little Art Shops, Chattanooga

ARTIST'S STATEMENT

In 1925, the Tennessee legislature quietly passed a law that no theory of evolution could be taught in Tennessee schools.

A group of Dayton, Tennessee business men, not necessarily for or against the measure, decided to put it to the test. John Scopes, a high school teacher (though not in science), was persuaded to allow himself to be arrested and stand trial for the teaching of evolution.

The great William Jennings Bryan volunteered to lead the prosecution. Clarence Darrow, backed by the American Civil Liberties Union, and assisted by Arthur Garfield Hayes and Dudley Field Malone, defended Mr. Scopes.

Tempers flared high and both Bryan and Darrow displayed their skills brilliantly and vehemently. Bryan overtaxed himself in the extreme heat and died five days later in Dayton.

Because of the heat and crowd in the stifling weather from July 10th to 21st, 1925, the evolution trial was moved from the second floor courtroom to a hastily built platform on the north side of the courthouse.

Dayton, Tennessee's population of 1800 was swelled including over 100 newspaper photographers and reporters. A special passenger train ran from Chattanooga, 35 miles south, each morning. Ringling Brothers sent in three cars of monkeys. Would-be evangelists preached to anyone who would listen in the ample spaces surrounding the courthouse grounds. WGN, Chicago radio station, made the first nation-wide hookup.

Dayton, Tennessee is now, fifty seven years later, a busy, pretty little town nestling between the foothills of the Cumberlands and the Tennessee River. The basement of the now restored Rhea County Court House has a small museum of memorabilia from the early years up to and including the trial. It has many visitors.

The painting is authenticated by Dr. Theodore Mercer of Bryan College and historian of Rhea County as well as Dan Wade, County Executive of Rhea County.

George Little

The Scopes Trial (at Dayton, TN, 1925)

acrylic/30 x 40/1982

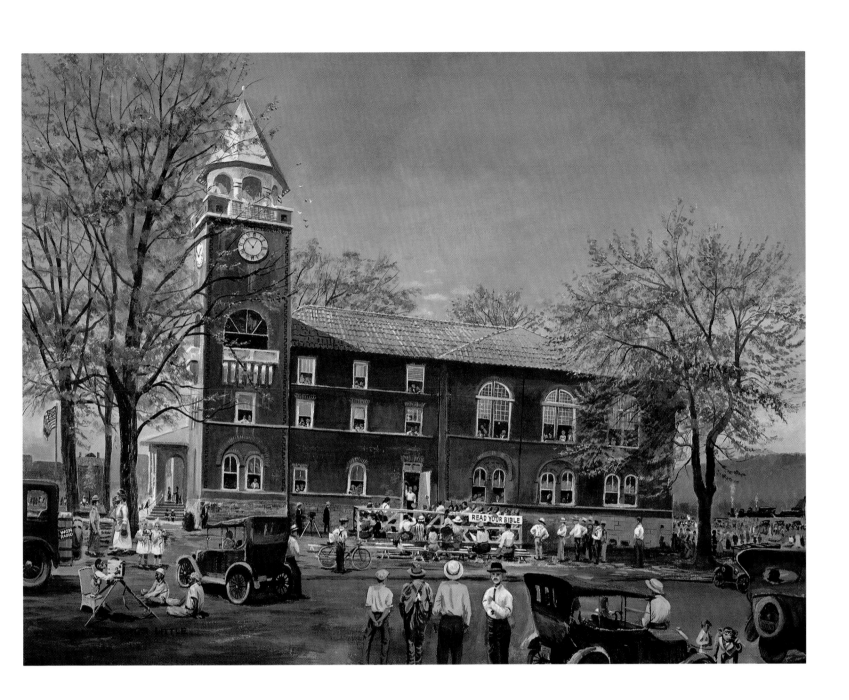

The best augury of a man's success in his profession is that he thinks it the finest in the world.

George Eliot/*Daniel Deronda*, 1876

R. C. ROTHCHILD

EDUCATION
Basel, Switzerland

SELECTED SOLO EXHIBITIONS
Basel, Switzerland

AWARDS, GRANTS, FELLOWSHIPS
New York Art Directors Club Award

SELECTED COLLECTIONS
The West Collection

POSITIONS
Graphic Designer and Art Director with New York design firms, advertising agencies
Freelance Photographer
(Additional biographical information was not available at the time of publication)

R. C. Rothchild
The Lawyer
oil/40 x 30

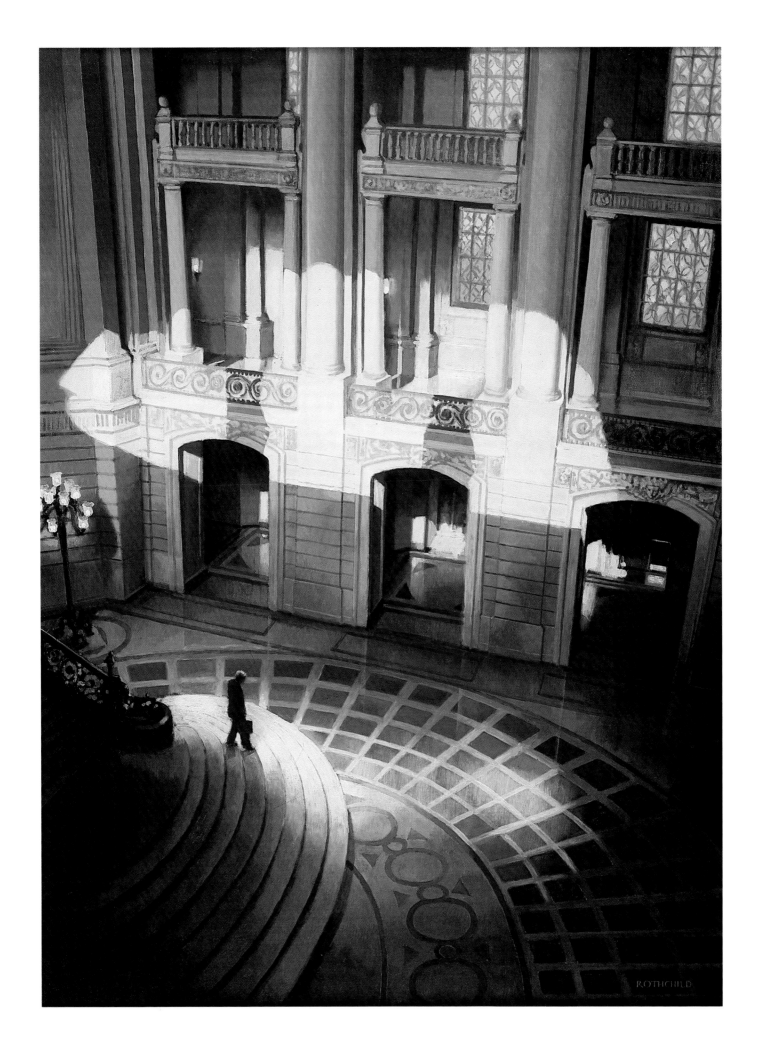

Every person who enters into a learned profession undertakes to bring to the exercise of it a reasonable degree of care and skill. He does not undertake, if he is an attorney, that at all events you shall gain your case; nor does he undertake to use the highest possible degree of skill: there may be persons who have higher education and greater advantages to bring a fair, reasonable, and competent degree of skill.

Lord Chief Justice Tindal
Lanphier and Wife v. Phipos, 1838

R. C. ROTHCHILD

EDUCATION
Basel, Switzerland

SELECTED SOLO EXHIBITIONS
Basel, Switzerland

AWARDS, GRANTS, FELLOWSHIPS
New York Art Directors Club Award

SELECTED COLLECTIONS
The West Collection

POSITIONS
Graphic Designer and Art Director with New York design firms, advertising agencies
Freelance Photographer
(Additional biographical information was not available at the time of publication)

R. C. Rothchild
City Hall
oil/40 x 30

An eminent lawyer cannot be a dishonest man. Tell me a man is dishonest, and I will answer he is no lawyer. He cannot be, because he is careless and reckless of justice; the law is not in his heart, is not the standard and rule of his conduct.

Daniel Webster/Speech, Charleston, SC, May, 1847

R. C. ROTHCHILD

EDUCATION
Basel, Switzerland

SELECTED SOLO EXHIBITIONS
Basel, Switzerland

AWARDS, GRANTS, FELLOWSHIPS
New York Art Directors Club Award

SELECTED COLLECTIONS
The West Collection

POSITIONS
Graphic Designer and Art Director with New York design firms, advertising agencies
Freelance Photographer
(Additional biographical information was not available at the time of publication)

R. C. Rothchild
Main Street
oil/39¼ x 29¼

ll oppression creates a state of war.

Simone de Beauvoir/*The Second Sex*

JERRY RUDQUIST

BORN

June 13, 1934, Fargo, ND

EDUCATION

Cranbrook Academy of Art, Bloomfield Hills, MI, MFA, 1958

Minneapolis College of Art and Design, BFA, 1956

SELECTED SOLO EXHIBITIONS

Suzanne Kohn Gallery, St. Paul, 1971, 73, 76, 78, 84

Minneapolis Institute of Art, 1971

Walker Art Center, Minneapolis, 1963

SELECTED GROUP EXHIBITIONS

Minneapolis Institute of Art, 1959, 61, 63, 65, 75, 81, 86

West/ART & THE LAW, 1986

Plains Art Museum, Moorhead, MN, 1980–85

Walker Art Center, 1958, 60, 62, 64, 66, 77, 79

Fine Arts Museum, San Francisco, 1973

AWARDS, GRANTS, FELLOWSHIPS

West/ART & THE LAW, Purchase Award, 1986

World Print Council, Purchase Award, 1973

Minneapolis Institute of Art, Purchase Award, 1965

Walker Art Center, Purchase Award, 1962

SELECTED COLLECTIONS

Dayton-Hudson Corporation

General Mills

Minneapolis Institute of Art

Minnesota Mining and Manufacturing

Piper Jaffray Hopwood, Inc.

Prudential Insurance Company

Readers Digest Corporation

Walker Art Center

The West Collection

POSITIONS

Macalester College, St. Paul, Professor of Art, Present

ARTIST'S STATEMENT

Incarceration, like a good painting, works more than one way.

This painting depicts multiple qualities of the captive/captor relationship whether lawful or otherwise.

Jerry Rudquist
Captive/Captor
acrylic on rag paper board/30 x 40/1986

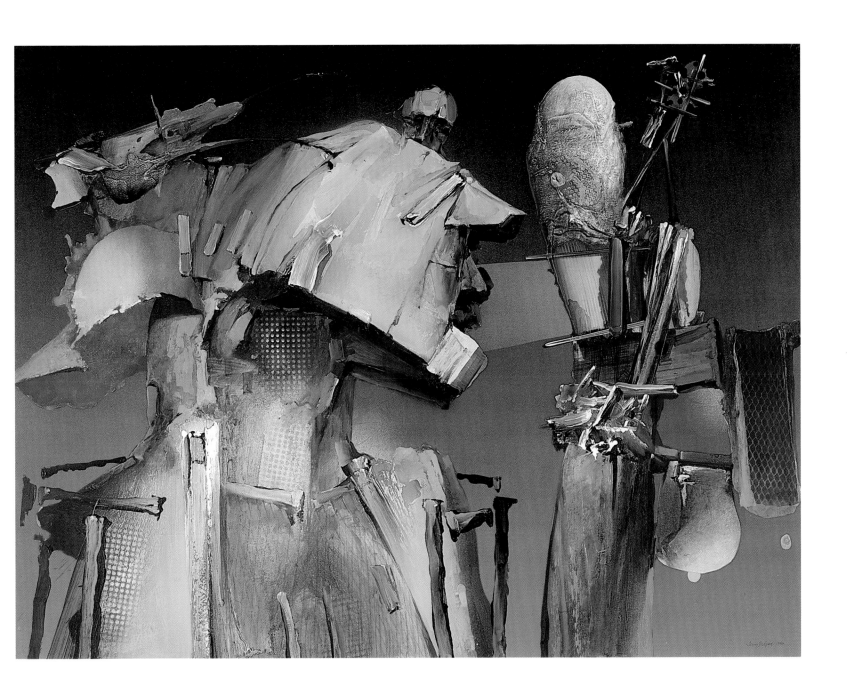

> *ruth is justice's handmaid, freedom is its child, peace is its companion, safety walks in its steps, victory follows in its train.*
>
> Sydney Smith/*A Memoir of the Rev. Sydney Smith,* 1855

SALLY STORCH

BORN
June 22, 1952, Newport Beach, CA

EDUCATION
Art Center School of Design, Pasadena, CA, 1974–75

University of Southern California, Los Angeles, 1972–74

Stephens College, Columbia, MO, 1970–72

SELECTED SOLO EXHIBITIONS
Laguna Beach Museum of Art, CA, 1986

Challis Galleries, Laguna Beach, CA, 1982

Laguna Blanca Exhibit, Katsh Estate, Santa Barbara, CA, 1982

SELECTED GROUP EXHIBITIONS
Laguna Beach Museum of Art, CA, 1980, 83, 84, 85

Suzanne Brown Gallery, Scottsdale, AZ, 1985

La Mirada Festival of Art, 1984

West/ART & THE LAW, 1983

Laguna Beach Festival of Art, 1979, 81

Newport Beach Festival of Art, 1979

AWARDS, GRANTS, FELLOWSHIPS
City of La Mirada, Purchase Award, 1985

Laguna Beach Museum of Art, First Award, 1984

La Mirada Festival of Art, Juror's Award, 1984

West/ART & THE LAW, Purchase, 1983

San Diego Watercolor Society, West Award, 1980

SELECTED COLLECTIONS
Bank of Orange

Hilton International

McFarlane and Lambert Company

Price Waterhouse Company

Rutan and Tucker

The West Collection

POSITIONS
Full-time Artist

ARTIST'S STATEMENT
While researching the relationship between art and law, I came across some photographs taken of a trial in Germany during the 1930s. Although I was inspired to do several sketches based on these photographs, I soon realized it was not the particular scenes or even the aesthetic qualities of the photographs that struck me, but the persistent idea that throughout history both artists and lawyers have been searching for one thing—the truth, or as the title of my painting suggests, the heart of the matter. The men in the painting may look as though they were from another era, or perhaps another country, but they need not be. I wanted to portray them with a timeless quality, adding a sense of mystery to the painting. They symbolize the judiciary past, present, and future working toward an ideal—finding the basic issue at hand.

In working toward depicting the heart of the matter in law, I came across what for me is the basic issue in art: the act of putting paint on canvas. And that, in my art world, is most definitely the heart of the matter.

Sally Storch
The Heart of the Matter
oil/30 x 40

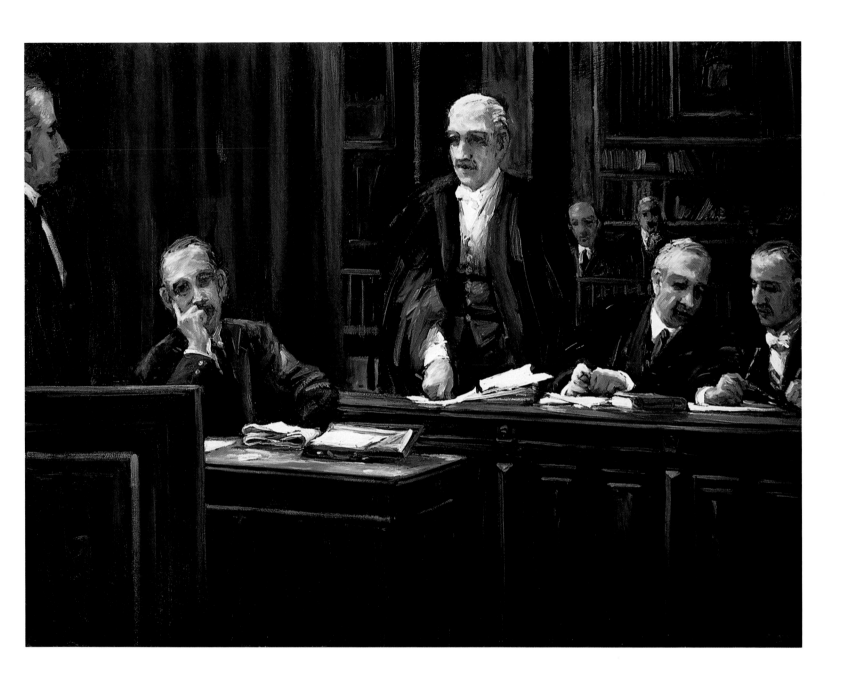

et justice be done, though the world perish.

Ferdinand I/Holy Roman Emperor

DONALD ROY THOMPSON

BORN

March 2, 1936, Fowler, CA

EDUCATION

Sacramento State University, CA, BA, 1960, MA, 1962

SELECTED SOLO EXHIBITIONS

Santa Cruz Art Center, CA, 1985

Foster Goldstrom Fine Arts, San Francisco, 1982

The Gallery, Santa Cruz Main Library, CA, 1980

Cabrillo College Gallery, Aptos, CA, 1980

Galeria Carl Van Der Voort, San Francisco, 1967

SELECTED GROUP EXHIBITIONS

Art Museum of Santa Cruz County, CA, 1983, 85

Eloise Pickard Smith Gallery, Cowell College, University of California, Santa Cruz, 1985

Galleries I & II San Jose State University, CA, 1984

Leila Taghinia-Milani, NYC, 1983

Stedman Art Gallery, Rutgers University, Camden, NJ, 1981

Minnesota Museum of Art, St. Paul, 1981

Cologne Art Fair Theme Exhibition, Cologne, Germany, 1977

Second British International Print Biennial, Bradford, Yorkshire, England, 1970

Tampa Bar Art Center, FL; Ringling Museum, Sarasota, FL; High Museum, Atlanta; Finch College Art Gallery, NYC, 1968

AWARDS, GRANTS, FELLOWSHIPS

West/ART & THE LAW, Purchase, 1981

SELECTED COLLECTIONS

Art Museum of Santa Cruz County

Crocker Art Museum

IBM Santa Teresa Laboratory

Oakland Museum

Seattle First National Bank

The West Collection

POSITIONS

Art Instructor, Cabrillo College, Aptos, CA, 1971–Present

ARTIST'S STATEMENT

This work was inspired by John Houseman's portrayal of Professor Kingsfield, in *The Paper Chase.* I wanted to imply that Houseman's Kingsfield was so powerful a spirit, that even something as common as a simple sneeze would shake a classroom or courtroom.

Donald Roy Thompson
Kingsfield Sneezed
mixed media/23⅞ x 17¾/1980

> *The framers (of the Constitution) knew that free speech is the friend of change and revolution. But they also knew that it is always the deadliest enemy of tyranny.*
>
> Hugo L. Black/Address, 1960

JOHN WILDE

BORN

December 12, 1919, Milwaukee

EDUCATION

University of Wisconsin, Madison, MS, 1948

SELECTED SOLO EXHIBITIONS

David Findlay, Inc., NYC, 1984

Elvehjem Museum of Art, Madison, WI, 1940–84

Oehlschlaeger Gallery, Chicago, 1977

Milwaukee Art Museum, 1964

Columbia Museum of Art, Columbia, SC, 1960

SELECTED GROUP EXHIBITIONS

Norton Gallery, West Palm Beach, FL, 1985–86

West/ART & THE LAW, 1984, '85

Rutgers University Art Gallery, 1982

Milwaukee Art Museum, 1982

National Portrait Gallery, Washington, DC, 1980

"American Master Drawings & Watercolors," Whitney Museum of American Art; Fine Arts Museum, San Francisco; Minneapolis Institute of Art, 1977

AWARDS, GRANTS, FELLOWSHIPS

West/ART & THE LAW, Purchase, 1984, 85

American Academy of Arts and Letters, Childe Hassam Purchase Awards, 1968, 81

Butler Institute of American Art, 1st Purchase Award, 1970

Pennsylvania Academy of Fine Arts, Lambert Purchase Award, 1958

SELECTED COLLECTIONS

Art Institute of Chicago

Milwaukee Art Museum

National Collection of American Art, Smithsonian Institution

Wadsworth Atheneum

The West Collection

Whitney Museum of American Art

POSITIONS

Presently Emeritus Professor

Alfred Sessler Distinguished Professor of Art, 1968–82

University of Wisconsin, Professor, 1960–68; Associate Professor, 1955–60; Assistant Professor, 1951–55; Instructor, 1948–51

ARTIST'S STATEMENT

Long interest in First Amendment concerns (rarely overtly manifest in my work) prompted me to do this homage to Hugo Black, whose "absolutist" position remains, to me, heroic.

John Wilde
Portrait of Hugo Black
silverpoint, pencil, wash/17½ x 8¾/1983

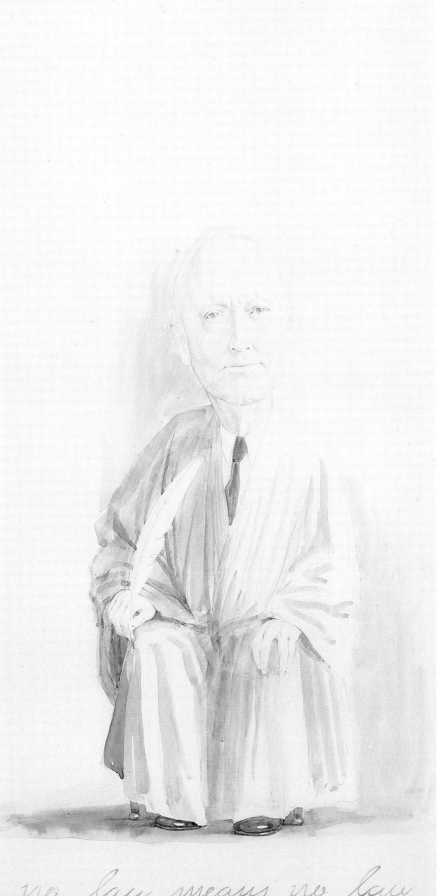

no law means no law

t is only with the normal person that the law is concerned Ulysses is a rather strong draught to ask some sensitive, though normal person to take. But considered opinion, after long reflection, is that whilst in many places the effect of Ulysses on the reader undoubtedly is somewhat emetic, no where does it tend to be an aphrodisiac.

John M. Woolsey/Decision allowing Joyce's *Ulysses* to come into the U.S., 1933

JOHN WILDE

BORN
December 12, 1919, Milwaukee

EDUCATION
University of Wisconsin, Madison, MS, 1948

SELECTED SOLO EXHIBITIONS
David Findlay, Inc., NYC, 1984

Elvehjem Museum of Art, Madison, WI, 1940–84

Oehlschlaeger Gallery, Chicago, 1977

Milwaukee Art Museum, 1964

Columbia Museum of Art, Columbia, SC, 1960

SELECTED GROUP EXHIBITIONS
Norton Gallery, West Palm Beach, FL, 1985–86

West/ART & THE LAW, 1984, '85

Rutgers University Art Gallery, 1982

Milwaukee Art Museum, 1982

National Portrait Gallery, Washington, DC, 1980

"American Master Drawings & Watercolors," Whitney Museum of American Art; Fine Arts Museum, San Francisco; Minneapolis Institute of Art, 1977

AWARDS, GRANTS, FELLOWSHIPS
West/ART & THE LAW, Purchase, 1984, 85

American Academy of Arts and Letters, Childe Hassam Purchase Awards, 1968, 81

Butler Institute of American Art, 1st Purchase Award, 1970

Pennsylvania Academy of Fine Arts, Lambert Purchase Award, 1958

SELECTED COLLECTIONS
Art Institute of Chicago

Milwaukee Art Museum

National Collection of American Art, Smithsonian Institution

Wadsworth Atheneum

The West Collection

Whitney Museum of American Art

POSITIONS
Presently Emeritus Professor

Alfred Sessler Distinguished Professor of Art, 1968–82

University of Wisconsin, Professor, 1960–68; Associate Professor, 1955–60; Assistant Professor, 1951–55; Instructor, 1948–51

ARTIST'S STATEMENT
My interest in First Amendment concerns continues. For the 1984 "West/ART & THE LAW" exhibition I chose Hugo Black as my hero. For this drawing I chose John Woolsey, whose decision exonerating James Joyce's masterpiece of the charge of obscenity "bids fair to become a major event in the history of the struggle for free expression."

John Wilde
Portrait of John M. Woolsey
silverpoint, wash/22½ x 9¾/1985

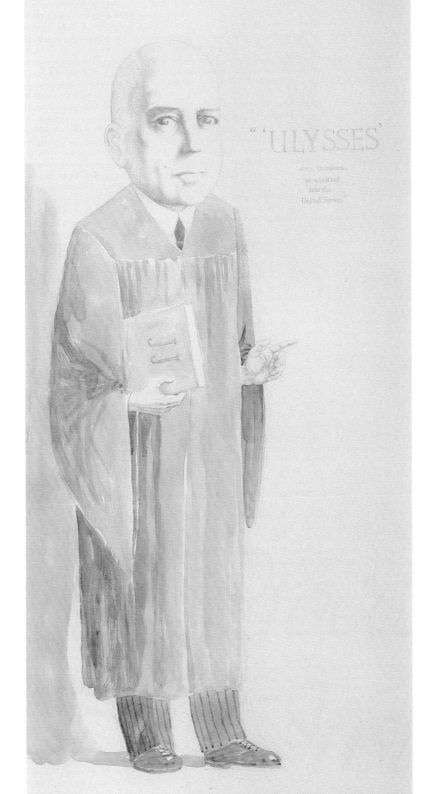

"'ULYSSES'

may, therefore,
be admitted
into the
United States."

John Wright
1985

The sword of the law should never fall but on those whose guilt is so apparent as to be pronounced by their friends as well as foes.

Thomas Jefferson/Letter, 1801

JON ARFSTROM

BORN
November 11, 1928, Superior, WI

EDUCATION
Birney Quick, Zalton Szabo, Robert E. Wood, Milford Zornes, and self-taught

SELECTED SOLO EXHIBITIONS
Lakeshore Playhouse, White Bear Lake, MN, 1983

Mound State Bank, Mound, MN, 1979

Public Library, Albert Lea, MN, 1976

Concordia College, St. Paul, 1973

Compassion Center, Moundsview, MN, 1973

SELECTED GROUP EXHIBITIONS
Midwest Watercolor Society, 1977–80, 82, 83

Allied Artists of America, NYC, 1978

Watercolor USA, Springfield, MO, 1977

San Diego Watercolor Society, CA, 1977

National Society of Painters in Casein & Acrylics, NYC, 1977

AWARDS, GRANTS, FELLOWSHIPS
Midwest Watercolor Society, Award of Excellence, 1982

Northstar Watercolor Society, Award of Excellence & Members' Choice, 1982

American National Miniature Show, 2nd Award, 1977

St. Germain Festival of Arts, Paris Gold Medal, 1977

SELECTED COLLECTIONS
Burlington Northern

Freeborn County Historical Society

Group Health

Normandale Community College

Tweed Museum

Twin City Federal

Wausau Insurance Companies

The West Collection

POSITIONS
Owner/Operator of Otherside Gallery, Present

American Watercolor Society, Associate

Midwest Watercolor Society, Signature Member

Northstar Watercolor Society, Past President

ARTIST'S STATEMENT
Similar to today's hunter or fisherman, posing proudly with his prize catch, the lawman and posse members in the American West would prop up the corpse of a notorious outlaw, whose career they had ended, and have a photographer preserve the event for posterity.

The situation, rather crude and barbaric to our eyes, seemed to call for a distorted, caricatured handling of the painting.

Jon Arfstrom
Felon's Fate
varnished watercolor/23½ x 29¼/1980

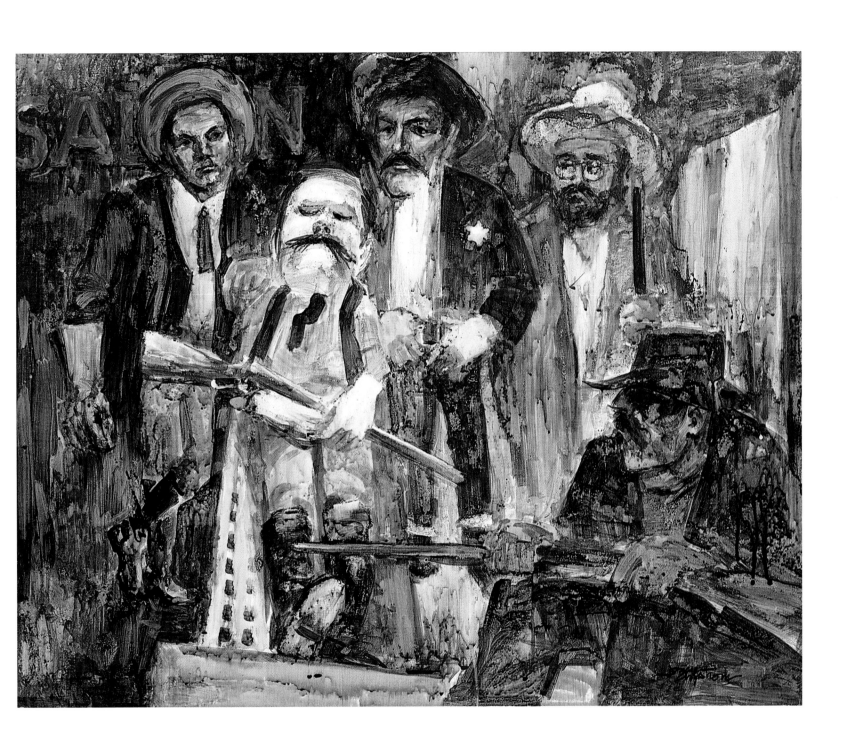

Justice, though she's painted blind, is to the weaker side inclined.

Samuel Butler/*Hudibras*, 1678

TERRY BERRIER

BORN
April 16, 1949, Atlanta, GA

EDUCATION
University of Western Colorado, 1974
West Georgia College, 1974
University of Georgia, 1968–70
University of Georgia, Contora, Italy, 1970
Kennessaw Junior College, 1967–68

SELECTED SOLO EXHIBITIONS
Reinhardt College, Waleska, GA, 1983, 85, 86
Berry College, Mount Berry, GA, 1986
Etowah Creative Arts Gallery, Cartersville, GA, 1985

SELECTED GROUP EXHIBITIONS
Atlanta Arts Festival, Toured Museum of Arts and Sciences, Columbia, MO, 1984
Catherine Lorillard Wolfe Exhibit, NYC, 1982–85
Institute of Electricians and Electronics, Engineer Show, NYC, 1984
Callanwolde Fine Arts Center, Atlanta, 1984
Georgia Tech Dogwood Festival, Atlanta, 1983
West/ART & THE LAW, 1982

AWARDS, GRANTS, FELLOWSHIPS
State of Georgia, Artists Award, 1985
89th Catherine Lorillard Wolfe Exhibit, Helen McChill Slottman Memorial Award, 1985
Powers Crossroads, Award of Merit, 1984
Dalton Arts Festival, Award of Merit, 1984
Roselawn Art Show, Best of Show, 1983, 84
West/ART & THE LAW, Purchase, 1982

SELECTED COLLECTIONS
Georgia Power
The State of Georgia
The West Collection

POSITIONS
Hamilton Crossing Elementary School, Cassville, GA, Art Teacher, 1985–86
Private Teaching, 1980–Present
Retail Art Supplies, 1980–85
Public Education, 1971–76, 77–80

ARTIST'S STATEMENT
While planning *You Have The Right*, I was most interested in making a dynamic statement. By using foreshortening I felt I was accenting the authoritative figure of a law enforcement officer. However, I also wanted to project the idea that an individual should always have basic rights in the judicial system.

Terry Berrier
You Have the Right
oil/28 x 22

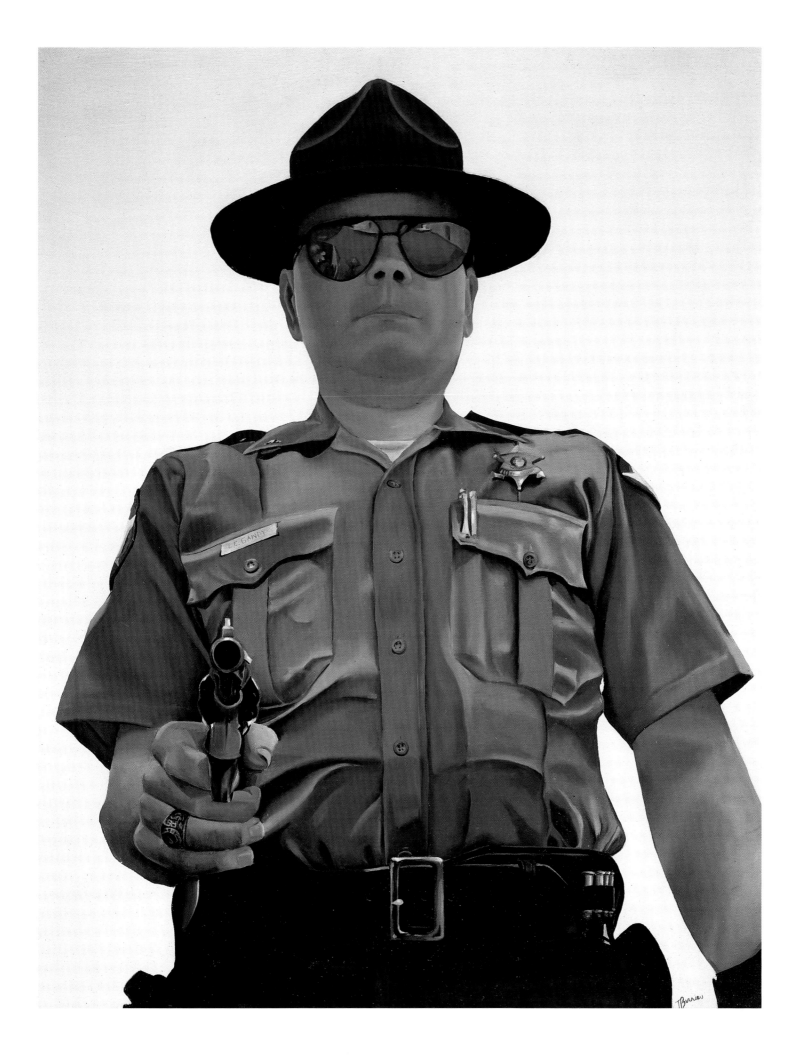

very form of bigotry can be found in ample supply in the legal system of our country. It would seem that justice (usually depicted as a woman) is indeed blind to racism, sexism, war and poverty.

Florynce Kennedy, 1970

CURT FRANKENSTEIN

BORN
March 11, 1922, Hannover, Germany

EDUCATION
Otis Art Institute of Los Angeles, 1953–54
Art Institute of Chicago, 1951–52
American Academy of Art, Chicago, 1947–50

SOLO EXHIBITIONS
Northern Indiana Arts Association, 1977, 84
Wilmette Public Library, Wilmette, IL, 1975, 84
American Bar Association Foundation, Chicago, 1979
Illinois Institute of Technology, Chicago, 1978
Greater Birmingham Arts Alliance, Birmingham, AL, 1978
Chicago Public Library, Chicago, 1969
University of Illinois, 1966

SELECTED GROUP EXHIBITIONS
West/ART & THE LAW, 1980, 82, 83
Northwestern University, Evanston, IL, 1978, 79, 82
Union League Club of Chicago, 1962, 63, 65, 78
Illinois State Fair, 1966, 67, 68
Illinois State Museum, Springfield, 1963, 65, 67
Butler Institute of American Art, Youngstown, OH, 1963, 65
Art Institute of Chicago, 1963, 64
Allied Artists of America, NY, 1962
St. Louis University, St. Louis, MO, 1962

AWARDS, GRANTS, FELLOWSHIPS
West/ART & THE LAW, Purchases, 1979, 80, 82
Northwestern University, Purchase, 1982, 79
Triton College, Award of Excellence, 1979
Illinois Regional Print Show, Award of Excellence, 1978
Municipal Art League Competition, 1st Place, 1970
Illinois State Fair, 1st Place, 1967
Union League Club Competition, 1st Prize, 1965
Art Institute of Chicago, Municipal Art League Prize, 1963

SELECTED COLLECTIONS
Borg-Warner Corporate Collection
City of Springfield Civic Collection
Illinois State Museum
Standard Oil of Indiana Corporate Collection
Union League Club of Chicago
The West Collection

POSITIONS
Painter, printmaker, Present
Printshop with etching press, Wilmette, IL

ARTIST'S STATEMENT
I conceived this painting to show that a (singular) "justice" does not exist; there are only "justices" (plural). Depending on the viewpoints of plaintiffs, defendants, lawyers, or judges, human justice has not a single-minded, but a multi-minded aspect.

Curt Frankenstein
Justitia Fragmented
oil/48 x 60

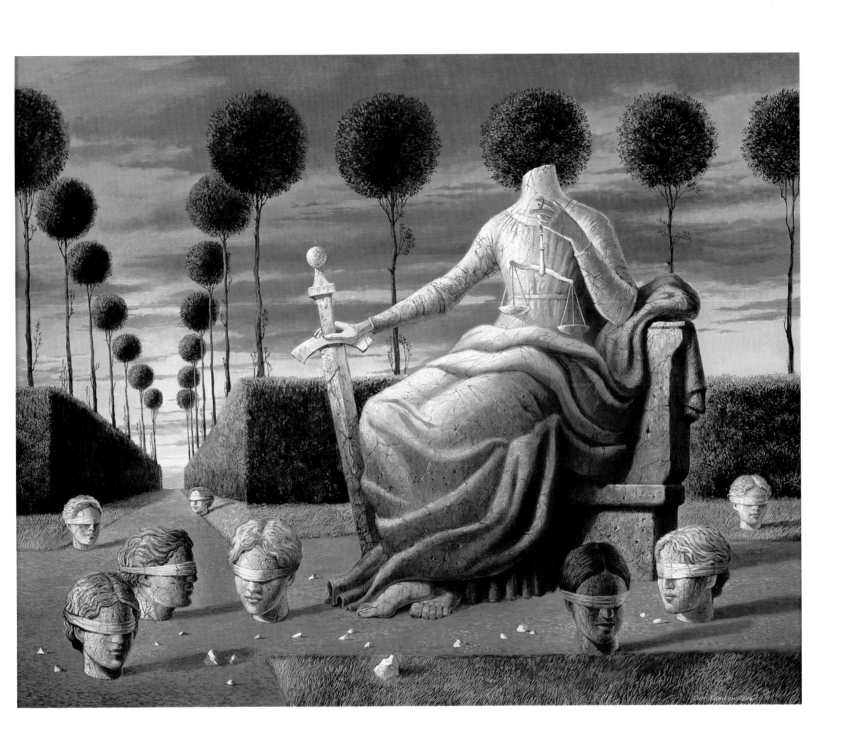

Justice is the end of government. It is the end of civil society. It ever has been and ever will be pursued until it is obtained or until liberty be lost in the pursuit.

Alexander Hamilton/*The Federalist,* 1787–88

CURT FRANKENSTEIN

BORN
March 11, 1922, Hannover, Germany

EDUCATION
Otis Art Institute of Los Angeles, 1953–54
Art Institute of Chicago, 1951–52
American Academy of Art, Chicago, 1947–50

SOLO EXHIBITIONS
Northern Indiana Arts Association, 1977, 84
Wilmette Public Library, Wilmette, IL, 1975, 84
American Bar Association Foundation, Chicago, 1979
Illinois Institute of Technology, Chicago, 1978
Greater Birmingham Arts Alliance, Birmingham, AL, 1978
Chicago Public Library, Chicago, 1969
University of Illinois, 1966

SELECTED GROUP EXHIBITIONS
West/ART & THE LAW, 1980, 82, 83
Northwestern University, Evanston, IL, 1978, 79, 82
Union League Club of Chicago, 1962, 63, 65, 78
Illinois State Fair, 1966, 67, 68
Illinois State Museum, Springfield, 1963, 65, 67
Butler Institute of American Art, Youngstown, OH, 1963, 65
Art Institute of Chicago, 1963, 64
Allied Artists of America, NY, 1962
St. Louis University, St. Louis, MO, 1962

AWARDS, GRANTS, FELLOWSHIPS
West/ART & THE LAW, Purchases, 1979, 80, 82
Northwestern University, Purchase, 1982, 79
Triton College, Award of Excellence, 1979
Illinois Regional Print Show, Award of Excellence, 1978
Municipal Art League Competition, 1st Place, 1970
Illinois State Fair, 1st Place, 1967
Union League Club Competition, 1st Prize, 1965
Art Institute of Chicago, Municipal Art League Prize, 1963

SELECTED COLLECTIONS
Borg-Warner Corporate Collection
City of Springfield Civic Collection
Illinois State Museum
Standard Oil of Indiana Corporate Collection
Union League Club of Chicago
The West Collection

POSITIONS
Painter, printmaker, Present
Printshop with etching press, Wilmette, IL

Curt Frankenstein
The Realm of Justice
oil/48 x 60

n case of doubt it is best to lean to the side of mercy.

Legal maxim

CHARLES SCHMIDT

BORN
March 4, 1939, Pittsburgh

EDUCATION
Cranbrook Academy of Art, Bloomfield Hills, MI, MFA, 1967

Carnegie-Mellon University, Pittsburgh, BFA, 1960

SELECTED SOLO EXHIBITIONS
Rosenfeld Gallery, Philadelphia, 1983

Jane Haslem Gallery, Washington, DC, 1981

Galleria Spoleto, Charleston, SC, 1978

Salt Lake Art Center, Salt Lake City, UT, 1974

Lubin House Gallery, NYC, 1973

National Museum of Malta, Valletta, 1972

Circolo Italsider, Genoa, Italy, 1971

Tyler School of Art in Rome, Italy, 1971

SELECTED GROUP EXHIBITIONS
West/ART & THE LAW, 1984, 85

National Air and Space Museum, Washington, DC, 1982–85

Jane Haslem Gallery, Washington, DC, 1980

Newcastle upon Tyne Polytechnic Museum of Art, England, 1979

FAR Gallery, NYC, 1976

Second British International Drawing Biennial, Middlesborough, Cleveland, England, 1975

American Studies Center Gallery, Naples, Italy, 1971

Fine Arts Museum, San Francisco, 1970

Butler, Institute of American Art, Youngstown, OH, 1963, 66, 69

AWARDS, GRANTS, FELLOWSHIPS
West/ART & THE LAW, Purchase, 1984

La Grange National Competition IV, Purchase, 1978

University of Carbondale, Purchase, 1975

National Invitational-Southern Illinois, 1975

Museum of the Philadelphia Civic Center, 1973

Pennsylvania Academy of Fine Arts, Dana Watercolor Medal, 1969

Kalamazoo Institute of Arts, Michigan Art On Paper Award, 1967

Southeastern Regional Exhibition, High Museum, Award of Merit, 1965

SELECTED COLLECTIONS
Butler Institute of American Art

European Space Agency, Paris

Insurance Company of North America, International Division

National Aeronautics and Space Administration

National Air and Space Museum

National Gallery of Art, Lessing Rosenwald Collection

Fine Arts Museum, San Francisco

Sears, Roebuck and Company, Price Collection

Smith Klein Beckman Corporation

The West Collection

POSITIONS
Tyler School of Art, Temple University, Philadelphia, Professor of Art, 1967–Present

Tyler School of Art in Rome, Italy, Painting Department Head, 1970–72

Atlanta College of Art, Instructor, 1963–65

ARTIST'S STATEMENT
This allegorical painting depicts a concept fundamental to the goal of law.

The personification of Justice reveals her not conventionally blindfolded but transfixed by her image in a mirror, blinded as it were by her own perfection while holding a scale in her right hand. Mercy pleads with Justice to consider something other than herself.

This painting was conceived after listening to G. B. Shaw's *Don Juan in Hell* read by Boyer, Hardwicke, Laughton, and Moorhead.

Charles Schmidt
Justice Tempered by Mercy
oil/36 x 46³/₁₆/1984

J ustice is a faculty that may be developed. This development is what constitutes the education of the human race.

P.J. Proudhon/*De la Justice dans la Révolution,* 1858

LEE N. SMITH III

BORN
May 3, 1950, New Orleans

EDUCATION
El Centro Junior College, Dallas, Architectural Delineation

SELECTED SOLO EXHIBITIONS
The Art Center, Waco, TX
DW Gallery, Dallas
Fort Worth Art Museum, TX
Contemporary Arts Museum, Houston, TX
Texas Christian University
Texas Gallery, Houston
University of Texas, Arlington

SELECTED GROUP EXHIBITIONS
Museum of Fine Arts, Houston, TX, 1986
New Orleans Museum of Art, 1980, 86
Greenville County Museum of Art, SC, 1985
Art Museum of South Texas, Corpus Christi, 1984
Contemporary Arts Museum, Houston, 1984
Dallas Museum of Art, Gateway Gallery, 1984
Laguna Gloria Art Museum, Austin, TX, 1984
Oklahoma Art Center, Oklahoma City, 1984

United States Pavilion, 41st Venice Biennial, Venice, Italy, 1984
West/ART & THE LAW, 1981

AWARDS, GRANTS, FELLOWSHIPS
Art in The Metroplex, TCU, 1st Prize, 1985
West/ART & THE LAW, Purchase, 1981

SELECTED COLLECTIONS
Atlantic Richfield Company
Dannheisser Foundation
Gelco
Huntington Art Gallery
Museum of Contemporary Art
The West Collection
West Texas Museum Association

POSITIONS
Full-time Artist

ARTIST'S STATEMENT
We stepped across the alley into the seemingly endless expanse of hay and sunflower fields.

The landscape fueled our imaginations. It gave us treasures and showed us ways of escape, even when surrounded by the walls of middle-class suburbia.

On the horizon stood a single man-made shape, the Drive-In theater. By day, its stark white, monolithic rectangle echoed the flatness and space of the fields, blank and silent, almost like a monument to the lessons of the land.

It was the apparent nothingness of the land that invited us into its folds. We began to dig deep holes into the earth, then added roofs made of precious sticks and boards covered with hay and dirt.

Years passed and houses began to spring up along the horizon. Our sticks and dirt clods were useless against the bulldozers. We melted back into the row of identical houses that were ruled by the family, church, and school. Rules of expected behavior became almost constant now as we grew older.

It is the continual process of making images and sounds that allows me to remain in a land that is forever open with the vastness that is imagination.

Lee N. Smith III
The Unwritten Law: A Bird for a Bird
oil/48 x 60/1981

> *Who will not mercy unto others show, how can he mercy ever hope to have?*
>
> Edmund Spenser/*The Faerie Queene,* 1590–96

CHARLES H. WATERHOUSE

BORN
September 22, 1924, Columbus, GA

EDUCATION
Newark School of Fine and Industrial Arts, New Jersey, 1947–50
Studied with Steven R. Kidd

SELECTED SOLO EXHIBITIONS
USMC Historical Center, 1975, 78, 83
US Naval Academy Museum, Annapolis, MD, 1975, 83
San Diego Ranch House Museums, 1980
National Geographic, 1977
New Jersey State Historical Society, 1977
New Jersey State Museum, Trenton, 1976
HQ USMC, yearly
Philadelphia Museum of Art
Treasure Island Monterey
US Navy Combat Art Center

SELECTED GROUP EXHIBITIONS
Society of American Historical Artists, Tulsa and Atlanta, 1985
Artists of the Rockies, CO, 1983, 85
Sangre de Cristo, 1983

West/ART & THE LAW, 1982
Society of Illustrators, NYC, 1976
Philadelphia Museum of Art
Salmagundi, NYC
Smithsonian Institution, Washington, DC

SELECTED COLLECTIONS
Bell Telephone
Boy Scouts of America
Museum of Natural History
Nacal Salmagundi
Prudential Insurance Company
San Diego Ranch House Museum
Rutgers University
Society of Illustrators
US Marine Corps, Army, Air Force, Navy
The West Collection

POSITIONS
US Marine Corps, Artist in Residence, 1973
Newark School of Fine and Industrial Arts, Instructor, 1955–73
Freelance Illustrator, 1950–73

ARTIST'S STATEMENT
The subject is a parade of "applicants for mercy," which a judge of the 1880s might have seen during his session on the bench. It gave me the opportunity to indulge in a characterization of the period. The beggars, drunks, derelicts, dispossessed, con men, ladies of the evening, etc., are portrayed in the rich, warm harmonies of a restricted palette on a raw, unprimed, untempered masonite panel. This tone set the key and was approached much in the manner of the time-honored practice of drawing on toned surfaces, such as brown wrapping paper. The composition was carefully drawn from a sketch in mars violet and painted with unbleached titanium, raw sienna, the umbers, red oxide and paynes gray, acrylic colors leaving various areas of the original ground showing. I painted the subject as a change of pace from my duties as artist in residence, US Marine Corps. I couldn't resist placing the two policemen in the rear, and of course they were former marines.

Charles H. Waterhouse
Applicants for Mercy, 1882
acrylic/16 x 20

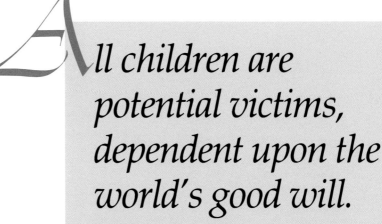

All children are potential victims, dependent upon the world's good will.

Sally Kempton/*Esquire*, July, 1970

ALLEN BLAGDEN

BORN
February 21, 1938, Salisbury, CT

EDUCATION
Cornell University, Ithaca, NY, BFA, 1962

SELECTED SOLO EXHIBITIONS
Kennedy Galleries, NYC, 1982, 84, 86
New Britain Museum of American Art, CT, 1981
Frank Rehn Gallery, NYC, 1965–77
Berkshire Museum, Pittsfield, MA, 1973
Trafford Gallery, London, 1972
Janet Nessler Gallery, NYC, 1964

SELECTED GROUP EXHIBITIONS
West/ART & THE LAW, 1983, 86
Century Association, NYC, 1970–84
Oklahoma Art Center, Oklahoma City, 1981
Wadsworth Atheneum, Hartford, 1980
New Britain Museum of American Art, CT, 1977
National Academy of Design, NYC, 1976
Art Association of Newport, RI, 1974
Berkshire Museum, Pittsfield, MA, 1973
Gallery de Paris, Paris, 1972
Albright-Knox Art Gallery, Buffalo, NY, 1965

AWARDS, GRANTS, FELLOWSHIPS
West/ART & THE LAW, Purchase, 1983
National Academy of Design, NYC, Certificate of Merit, 1976
Century Association Medal, 1970
Allied Artists of America Prize, 1964
Connecticut Art Foundation, Award, 1963
Yale University, Fellowship, 1961

SELECTED COLLECTIONS
New Britain Museum
The West Collection

POSITIONS
Hotchkiss School, Lakeville, CT, Art Instructor, 1968

ARTIST'S STATEMENT
She waits for an answer that will never come. Still too young to comprehend why people she loves cannot love each other, she retreats to the inner chambers of her pain and finds only emptiness and sorrow.

Childhood and innocence have been blown away too soon by the winds of a society that condones divorce. She is forced to choose loyalties in a game where nobody wins but the lawyers.

Allen Blagden
Joint Custody
watercolor/26 x 40½ /1982

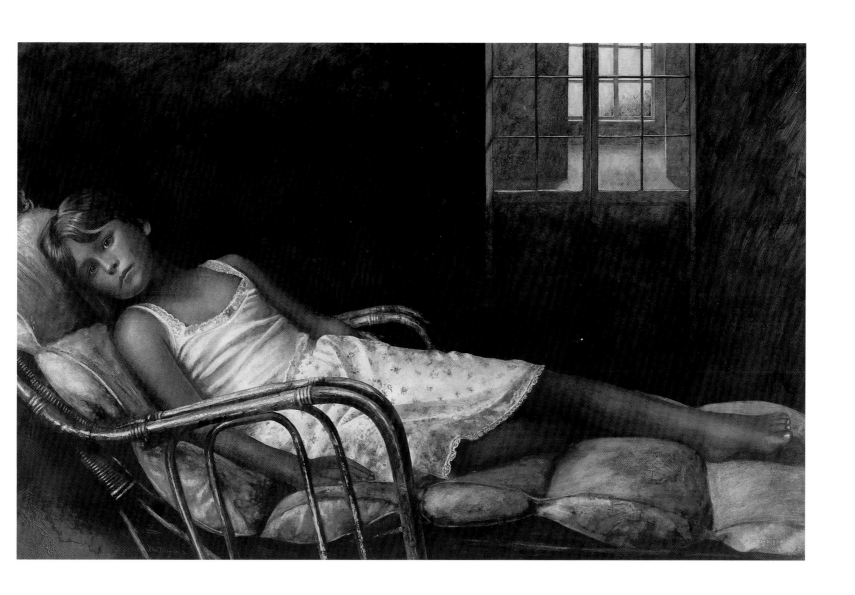

> *Chaos often breeds life when order breeds habit.*
>
> Henry Adams, 1907

COLLEEN BROWNING

BORN
May 16, 1929, Gregg, Ireland

EDUCATION
Slade School of Art, London, 1944–46

SELECTED SOLO EXHIBITIONS
Kennedy Galleries, NYC, 1969, 72, 76, 79, 82, 86
National Academy of Design, NYC, 1985
Towson State College, MD, 1978
Lehigh University, Bethlehem, PA, 1966
Little Gallery, London, 1949

SELECTED GROUP EXHIBITIONS
Rutgers University, New Brunswick, NJ, 1982
Texas Tech University, Lubbock, 1979
Charles H. MacNider Museum, Mason City, IA, 1979
Oklahoma Art Center, Oklahoma City, 1977
Philbrook Art Center, Tulsa, OK, 1977
Indianapolis Museum of Art, 1976
Cleveland Museum of Art, 1975
Detroit Institute of Arts, 1968
Museum of Modern Art, NYC, 1968
Newark Museum, NJ, 1965

AWARDS, GRANTS, FELLOWSHIPS
Archdiocese of NY, Portrait Commission, 1978
Kent Bicentennial Portfolio Spirit of Independence, Poster Commission, 1975
United States Olympics Committee, Poster Commission, 1975
Butler Institute of American Art, Awards, 1954, 74
National Academy of Design, Joseph S. Isidor Medal, 1953, Henry Ward Ranger Fund, Purchase Award, 1963, Adolph and Clara Obrig Prize, 1970
University of Rochester, Memorial Art Gallery, Award, 1950

SELECTED COLLECTIONS
Archdiocese of New York
Butler Institute of American Art
Detroit Institute of Arts
Milwaukee Art Museum
National Academy of Design
Memorial Art Gallery of the University of Rochester
San Francisco Palace of the Legion of Honor
Saint Louis Art Museum
The West Collection
Wichita Art Museum

POSITIONS
Full-time Artist, Present
Set Decorator for J. Arthur Rank Corporation for a series of Rank Films, 1947–48

ARTIST'S STATEMENT
Although I'm a law-abiding person, I found the phenomenon of the law-breaking graffiti on New York's subway trains an extraordinarily fascinating subject.

The elaborate whole-car designs done under dangerous conditions (some "artists" were electrocuted while working) represent a genuine urban folk art and in a crude form they use much of the vocabulary of modern high art—color field, stripe painting, gigantism, etc. But in translating these abstractions one is being a super-realist—a nice painterly paradox.

The visual effect of people trapped inside these moving murals produces an almost surreal image without ever departing from the fact that this is a vandalized subway car.

Colleen Browning
Sly's Eye
oil on canvas/45¾ x 56½ /1977

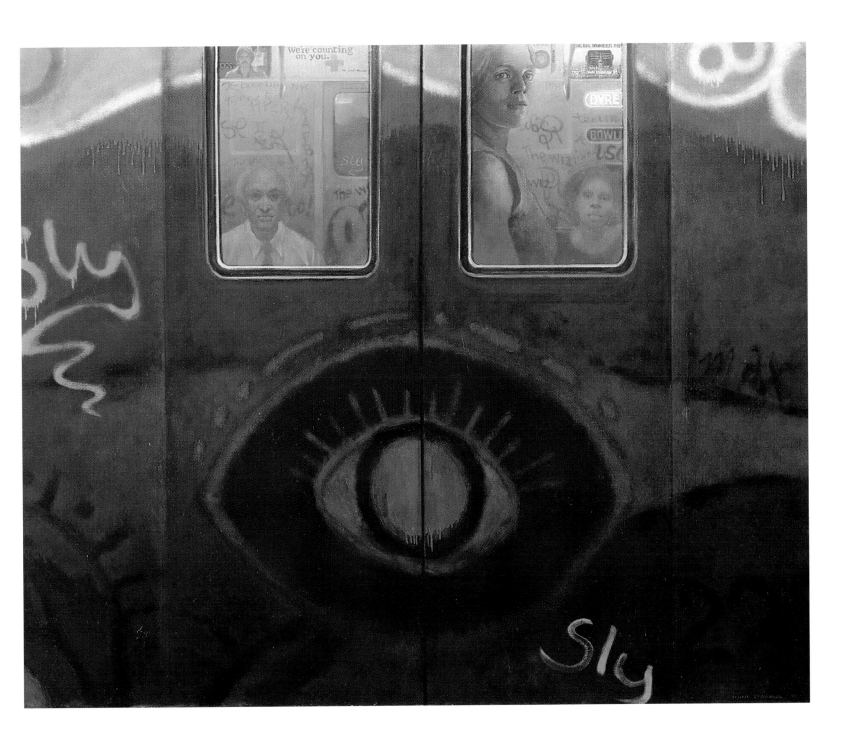

In every child who is born, under no matter what the circumstances, and of no matter what parents, the potentiality of the human race is born again: and in him, too, once more, and of each of us, our terrific responsibility toward human life; toward the utmost idea of goodness, of the horror of terror, and of God.

James Agee/*Let Us Now Praise Famous Men*, 1941

SHELLY CANTON

BORN
April 16, 1930, Chicago

EDUCATION
Institute of Design, Misch Cohen, Instructor, 1955

Printmaking, William Hayter, Instructor, 1950

University of Iowa, Mario Lasansky, Professor, 1948

SELECTED SOLO EXHIBITIONS
Covenant Club of Chicago, 1969

Bernard Horwich Center, 1968

Gilman's Gallery, Chicago, 1961–63

Hull House, Chicago, 1962

Chicago Public Library, 1960

SELECTED GROUP EXHIBITIONS
Arts Club of Chicago, Yearly since 1970

Old Orchard Show, Skokie, IL, Yearly since 1958

West/ART & THE LAW, 1983

Boston Fine Arts Festival, 1962

Ravinia, Highland Park, IL, 1960–62

Art Institute of Chicago, 1958

AWARDS, GRANTS, FELLOWSHIPS
West/ART & THE LAW, Purchase, 1983

Ravinia, Print Award, 1964

Print of The Year, 1961

Pauline Palmer Prize, Purchase, 1958

Old Orchard Show, Three Awards, 1958–86

SELECTED COLLECTIONS
Charles Benton

Borg-Warner Corporation

Abel Fagen

Willard Gidwitz

Samuel Insull III

Kemper Insurance Company

McArthur Foundation

Studs Terkel

The West Collection

POSITIONS
Editorial drawings for the *Chicago Tribune*

Full-time Artist

ARTIST'S STATEMENT
I believe that civilization is but a thin veneer under which lurks a primitive nature. It is the delicate job of the law to provide restraints on that nature and still afford enough freedom to allow creativity and the exploration of individuality.

Freud and others have argued that civilization runs contrary to our natures. But if our natures were allowed to run unbridled, it would be the end of order and civility, and it would ultimately destroy us.

We should remember that, as Robert Ardrey, author of *The Territorial Imperative*, has stated, we are not fallen angels, but risen apes.

Shelly Canton
Under the Veneer of the Law
engraved plexiglass, oil wash/21 x 30/1983

116

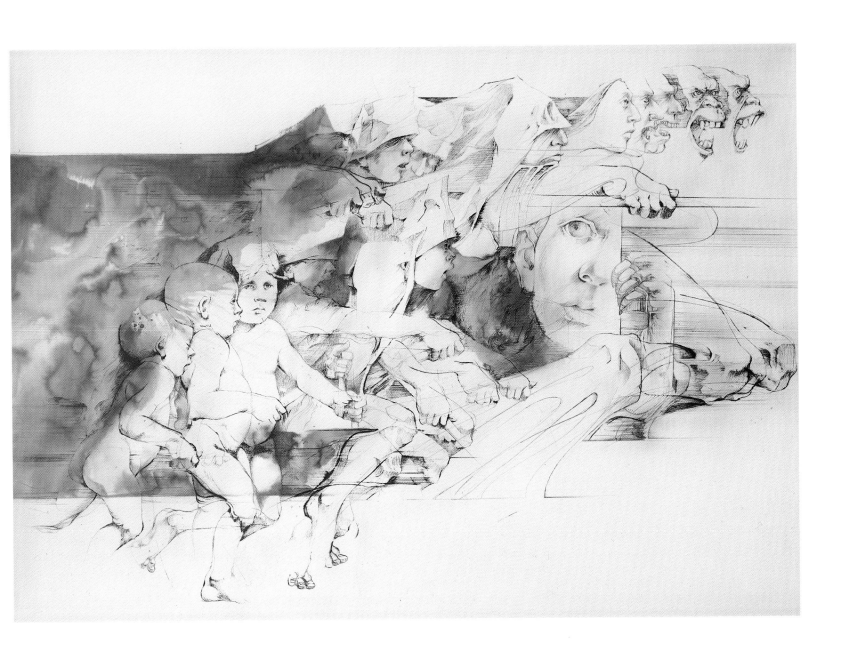

*M*an's discovery that his genitalia could serve as a weapon to generate fear must rank as one of the most important discoveries of prehistoric times, along with the use of fire and the first crude stone axe. From prehistoric times to the present, I believe, rape has played a critical function. It is nothing more or less than a conscious process of intimidation by which all men keep all women in a state of fear.

Susan Brownmiller/*Against Our Wills: Men, Women, and Rape,* 1975

HARVEY DINNERSTEIN

BORN
April 3, 1928, Brooklyn, NY

EDUCATION
Tyler Art School, Temple University, Philadelphia, 1950
Art Students League, NYC, 1946–47
Study with Moses Soyer, NYC, 1944–46

SELECTED SOLO EXHIBITIONS
Sindin Galleries, NYC, 1983
Capricorn Galleries, Bethesda, MD, 1980
FAR Galleries, NYC, 1972, 79
Gallery 1199, NYC, 1976
Kenmore Galleries, Philadelphia, 1964, 66, 69, 70
Davis Galleries, NYC, 1955, 60, 61, 63

SELECTED GROUP EXHIBITIONS
West/ART & THE LAW, 1982, 83
Pennsylvania State University Museum of Art, University Park, PA, 1979
New York Historical Society, NYC, 1976
New York Cultural Center, NYC, 1976
American Academy of Arts and Letters, NYC, 1974

Whitney Museum of American Art, NYC, 1964

AWARDS, GRANTS, FELLOWSHIPS
West/ART & THE LAW, Purchase, 1982, 83
American Academy of Arts and Letters, Hassam-Speicher Fund Painting Purchase, 1974, 78
National Academy of Design, Ranger Purchase Award, 1976
Pennsylvania Academy of Fine Arts, Temple Gold Medal, 1950

SELECTED COLLECTIONS
Chase Manhattan Bank
Chemical Bank
Martin Luther King Labor Center
Metropolitan Museum of Art, Lehman Collection
National Academy of Design
New Britain Museum of American Art
Parrish Museum of Southhampton
Pennsylvania Academy of Fine Arts
The West Collection
Whitney Museum of American Art

POSITIONS
Art Students League, NYC, Instructor, 1980–Present
National Academy of Design, NYC, Instructor, 1975–Present
National Academy of Design, NYC, Academician, 1974
School of Visual Arts, NYC, Instructor, 1965–80

ARTIST'S STATEMENT
An incident in a neighborhood park in Brooklyn. The age, sex, and color of the particular victim, which would appear in a police report and court records, are intended in the painting as a metaphor of violence in contemporary life. In a society where human values are demeaned and sentiment is made trivial, sex as rape is the ultimate violation of the human spirit.

Harvey Dinnerstein
Raped
pastel/18¼ x 28¾/1981

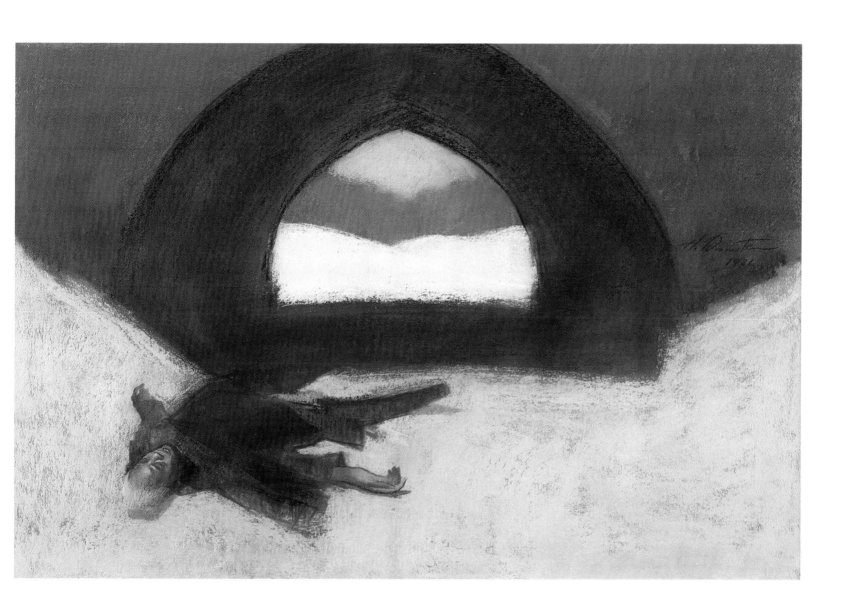

> *Children's liberation is the next item on our civil rights shopping list.*
>
> Letty Cottin Pogrebin/*Down with Sexist Upbringing*, 1972

SCOTT FRASER

BORN
November 23, 1957, Evanston, IL

EDUCATION
European Study—Atelierhaus, Worpswede, West Germany, 1985–86
University of Colorado at Denver, 1983
Kansas City Art Institute, 1976–79

SELECTED SOLO EXHIBITIONS
Ken Caryl, Littleton, CO, 1978

SELECTED GROUP EXHIBITIONS
NSPCA, NYC, 1986
West/ART & THE LAW, 1984, 85
Audubon Artists, NYC, 1985
Foothills Art Center, Golden, CO, 1984
NSPCA and Audubon Annuals, Lotus Club, NYC, 1984
Allied Artists of America, NYC, 1983
Carson Gallery of Western American Art, Denver, 1983
International Watercolor Exhibition, San Diego, CA, 1983

AWARDS, GRANTS, FELLOWSHIPS
Dr. Maury Leibovitz Artists' Welfare Fund Award, 1985
Audubon Artists, Alice G. Melrose Memorial Award, 1984
NSPCA, Doris Kreindler Award, 1984
International Watercolor Exhibition, Winsor/Newton Award, 1983–84, Travel Exhibition
Allied Artists of America, Silver Medal of Honor, 1983
National Portrait Awards, Certificate of Special Commendation #1, 1983
Rocky Mountain National Watermedia Exhibition, Columbine Award, 1982, Century Award of Merit, 1981
Scholastic Magazine National Competition, Two Gold Medals, 1976

SELECTED COLLECTIONS
Cherry Creek National Bank
Hiwan Homestead Museum
International State Bank
Petro–Lewis Oil Company
United Bank
The West Collection

POSITIONS
Full–time Artist

ARTIST'S STATEMENT
The wisdom of the court is well tested in deciding the fate of a child in a custody dispute.

Scott Fraser
The Pawn
acrylic on masonite/16¼ x 16/1985

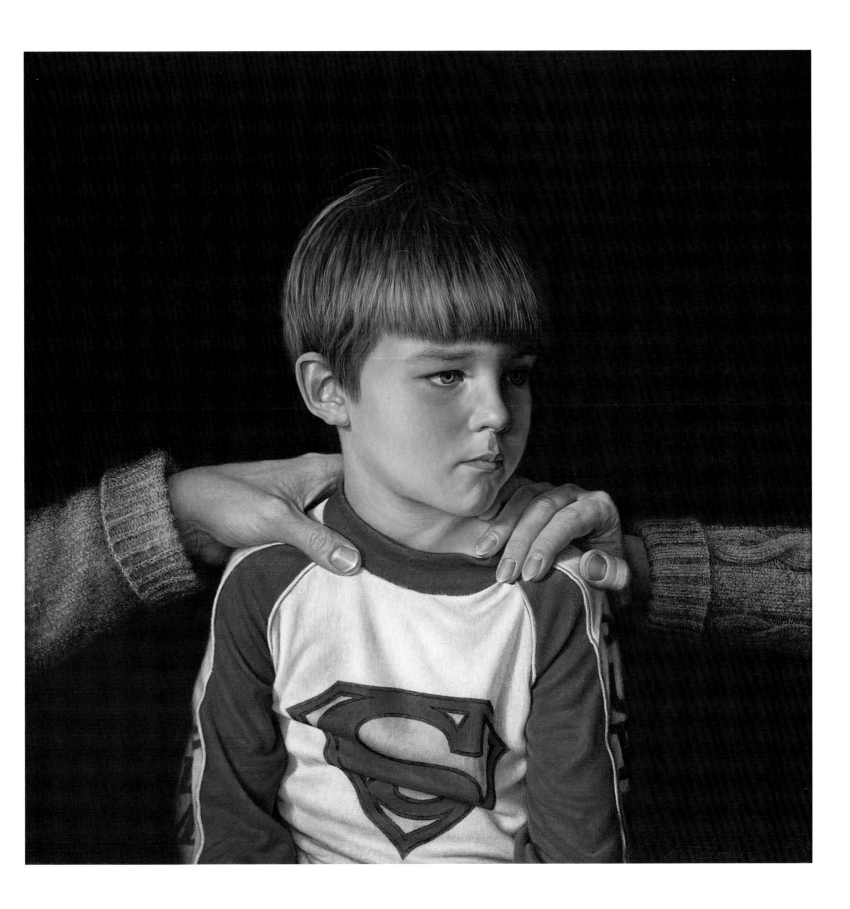

> *You can only protect your liberties in this world by protecting the other man's freedom. You can only be free if I am free.*
>
> Clarence Darrow/Address to jury, Communist labor party trial, Chicago, 1920

DAN F. HOWARD

BORN

August 4, 1931, Iowa City, IA

EDUCATION

University of Iowa, MFA, 1958

University of Iowa, BA, 1953

SELECTED SOLO EXHIBITIONS

Claypool-Young Art Center, Morehead State University, KY, 1985

Retrospective Exhibition: Tarble Art Center, Charleston, IL; Sheldon Memorial Art Gallery, Lincoln, NE; Conkling Gallery, Mankato State University, MN; Blanden Memorial Art Museum, Fort Dodge, IA; Sioux City Art Center, IA; 1983-84

Art Gallery, University of Texas, Tyler, 1983

Joy Horwich Gallery, Chicago, 1982

Joslyn Art Museum, Omaha, NE, 1981

SELECTED GROUP EXHIBITIONS

Contemporary American Painting Exhibition, Palm Beach, FL, 1979, 83, 84, 85

Olin Fine Arts Center, Washington, PA, 1985

Hoyt National Painting Show, New Castle, PA, 1984

Owensboro Museum of Fine Art, Owensboro, KY, 1984

Butler Institute of American Art, Youngstown, OH, 1983, 84

World's Fair Exposition, New Orleans, 1984

Laguna Gloria Art Museum, Austin, TX, 1982, 83, 84

Chautauqua Art Galleries, Chautauqua, NY, 1978, 80, 83

West/ART & THE LAW, 1979, 82

AWARDS, GRANTS, FELLOWSHIPS

Contemporary American Painting Exhibition, Bernis Gold Award, 1985

Mid-America Biennial National Exhibition, Purchase, 1984

National Art Exhibition/World's Fair Exposition, 1st Place, 1984

Spiva Regional Competitive Exhibition, Best in Show Award, 1984

Tom Butler Institute, Top Award, 1984

Biennial Regional Exhibition, Juror's Citation-Purchase Award, 1983

Chautauqua National Exhibition, Baker Memorial Award, 1983

Contemporary American Painting Exhibition, Atwater Kent Award, 1983

West/ART & THE LAW, Purchases, 1979, 82

Mid-Four Annual Exhibition, Top Patron Award, 1982

SELECTED COLLECTIONS

Dick Cavett

Con Agra Corporate Headquarters

Aaron Copland

CPM Corporation

Senator Nancy Landon Kassebaum

Jack Levine

Lowe Art Museum

Omaha National Bank

3M Companies

The West Collection

POSITIONS

University of Nebraska, Lincoln, Professor of Art and Chair, 1974-83

Professor of Art, 1983-Present

Kansas State University, Manhattan, Professor of Art and Head, 1971-74

Arkansas State University, Jonesboro,

Associate Professor of Art and Chair, 1965-71; Associate Professor, 1963-71; Assistant Professor, 1961-63; Instructor, 1958-61

ARTIST'S STATEMENT

In all my work, I attempt to convey the enthusiasm and respect I have for the art medium, usually oil paint, being employed in the service of the imagery I wish to project. The visual problems I set for myself quite often contain the element of satire, the paintings thereby becoming a visual commentary on aspects of the human condition and its foibles. In this instance, I kept the composition at the minimal level of surface development to concentrate and focus on the aberrational distortions of our precious heritage under law, the right to "life, liberty, and the pursuit of happiness."

Dan F. Howard

Brotherly Love and Patriotism Too

oil/49 x 65

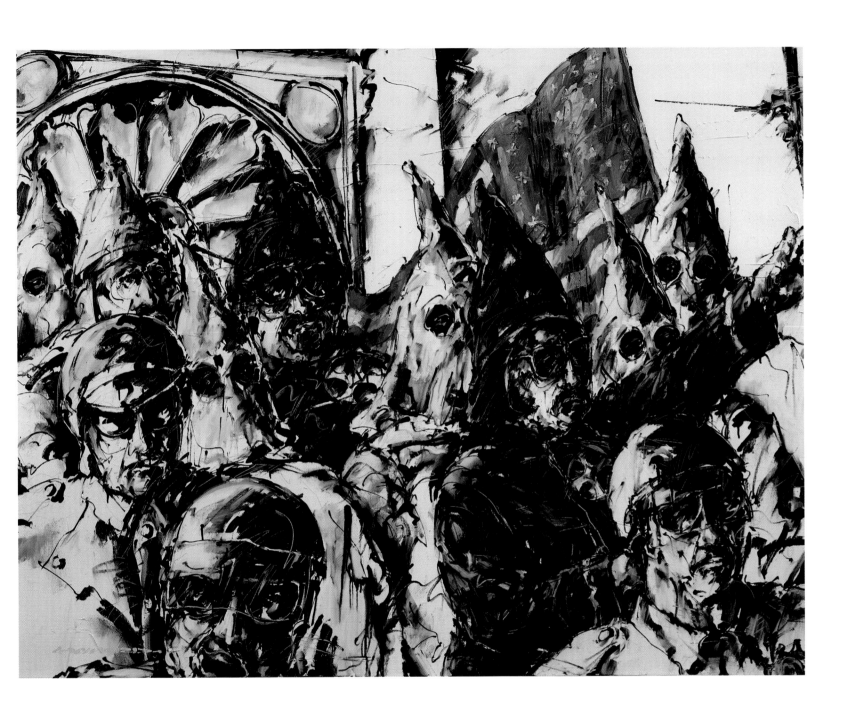

> *There are two kinds of restrictions upon human liberty—the restraint of law and that of custom. No written law has ever been more binding than unwritten custom supported by popular opinion.*
>
> Carrie Chapman Catt/Speech, 1900

JESSE L. HOWARD

BORN
December 27, 1949, Chicago

EDUCATION
Ball State University, 1969–73

SELECTED SOLO EXHIBITIONS
University of Illinois, Medical Graduate School, 1978

SELECTED GROUP EXHIBITIONS
West/ART & THE LAW, 1979, 82
Zriny-Hayes Gallery, 1979

AWARDS, GRANTS, FELLOWSHIPS
West/ART & THE LAW, Purchase, 1979

SELECTED COLLECTIONS
Chicago State Permanent Collection
Kemper Insurance
Rutgers University Permanent Collection
The West Collection

Jesse L. Howard
Is Justice Blind for Caged Birds That Don't Sing
charcoal/36¾ x 44¾

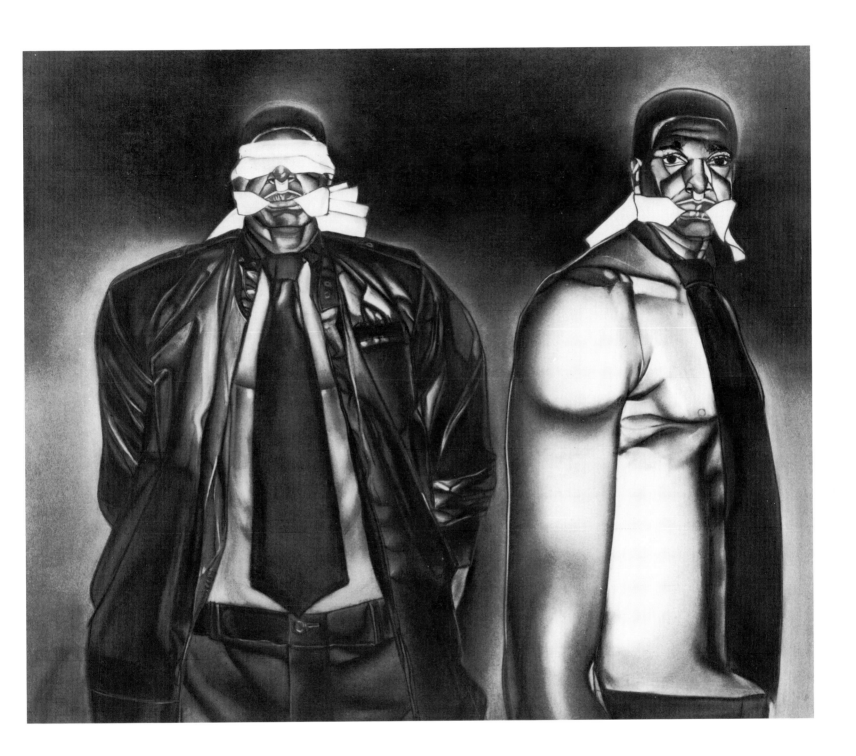

Arbitrary retirement at a fixed age ought to be negotiated and decided according to the wishes of the people involved! Mandatory retirement ought to be illegal.

Maggie Kuhn, 1972

KIRK LYBECKER

BORN

November 4, 1951, Tacoma, WA

EDUCATION

University of Idaho, Moscow, MFA, 1976

Washburn University of Topeka, KS, BFA, 1973

SELECTED SOLO EXHIBITIONS

Lane Community College, Eugene, OR, 1984

Mt. Hood Community College, Gresham, OR, 1984

Washington State University, Pullman, WA, 1983

Chemekata Community College, Salem, OR, 1983

University of Portland, OR, 1983

Sandpiper Gallery, Cannon Beach, OR, 1983

Mayer Gallery, Marylhurst, OR, 1982

Western Oregon State College, Monmouth, 1979

McMinnville Art Association, OR, 1978

Portland Community College, 1978

SELECTED GROUP EXHIBITIONS

Bellevue Art Museum, Bellevue, WA, International Tour, 1983

Butler Institute of American Art, Youngstown, OH, 1981, 83

Cheney Cowles Memorial Museum, Spokane, 1979–83

Portland Museum of Art, 1982

West/ART & THE LAW, 1982

Coos Art Museum, Coos Bay, OR, 1978, 79, 81

Chautauqua Art Association, Chautauqua, NY, 1979, 80

I. V. Bear Gallery, Rhododendron, OR, 1980

Open Gallery, Eugene, OR, 1979

Portland Community College, 1977, 78, 79

AWARDS, GRANTS, FELLOWSHIPS

Northwest Watercolor Society Cash Award, 1982, 83

West/ART & THE LAW, Purchase, 1983

Coos Art Museum, Award, 1980

22nd Chautauqua Exhibition, MHJW Memorial Award, 1979

SELECTED COLLECTIONS

Coos Art Museum

Eastern Washington State University

Gresham AAUW

Tom Hardy

University of Idaho

University of Oregon

City of Scottsdale

Washburn University of Topeka

The West Collection

POSITIONS

Clark College, Vancouver, WA, Instructor, 1979–Present

Artist in the Schools Program, Portland, OR, 1978–82

Oregon Arts Foundation, Salem, Visiting Artist, 1978–81

Portland Community College, Instructor, 1976–79

University of Idaho, Moscow, 1974–76

ARTIST'S STATEMENT

This could be seen as a portrait of those most capable of shaping the law. These are people looking at the world from the perspective of their age, their position, and their values. They are, I suppose, enjoying the sunshine of their achievement, eclipsing, not yet eclipsed.

Kirk Lybecker
Eclypse
watercolor/35 x 42/1982

> *The family is the building block for whatever solidarity there is in society.*
>
> Jill Ruckelshaus/*Saturday Evening Post*, March 3, 1973

LAUREL O'GORMAN

BORN

January 9, 1947, St. Paul

EDUCATION

University of Minnesota, Minneapolis, MFA, 1979

University of Minnesota, BES, 1976

SELECTED SOLO EXHIBITIONS

Katherine Nash Gallery, University of Minnesota, 1984

Catherine G. Murphy Galleries, St. Paul, 1982

Coffman Gallery, University of Minnesota, 1979

SELECTED GROUP EXHIBITIONS

College of St. Catherine, St. Paul, 1985

West/ART & THE LAW, 1982–84

General Mills Corporate Show, Minneapolis, 1983

Coffman Gallery, University of Minnesota, 1982

WARM Gallery, Minneapolis, 1982

Friends Gallery, Minneapolis Institute of Art, 1980

Purdue University, 1979

AWARDS, GRANTS, FELLOWSHIPS

West/ART & THE LAW, Purchases, 1982–84

SELECTED COLLECTIONS

Judith Connor Design

MS Interiors

University of Minnesota

The West Collection

POSITIONS

College of St. Catherine, Art Instructor, 1982–Present

Catherine G. Murphy Galleries, St. Paul, Gallery Director, 1981–Present

West Publishing Company, Art Consultant, 1983–Present

Minnesota Museum of Art, St. Paul, Exhibitions Coordinator, 1979–81

ARTIST'S STATEMENT

Around she goes, helpless and torn as she looks out at the parent she is with today. The mirror reflection is a vivid reality for her. And what about tomorrow? The hearts involved are consumed by their emotions, and, so often, the answer from the court becomes the stabilizing influence in the lives involved in custody cases.

Laurel O'Gorman
Custody
acrylic/57$\frac{1}{2}$ x 45/1983

We come to the question presented: Does segregation of children in public schools solely on the basis of race, even though the physical facilities and other "tangible" factors may be equal, deprive the children of the minority group of equal educational opportunities? We believe that it does.

Chief Justice Earl Warren/*Brown vs. The Board of Education of Topeka*

SUE OLSON-MANDLER

BORN
June 17, 1941, Janesville, WI

EDUCATION
Bellevue College, NE, 1982
University of Nebraska at Omaha, 1979
University of Wisconsin at Whitewater, 1961–62

SELECTED SOLO EXHIBITIONS
Norfolk Art Center, NE, 1984
Paine Webber Jackson Curtis, Omaha, NE, 1983
Creighton St. Joseph Hospital, Omaha, 1982
Sarachek Gallery, Kansas City, 1978
Stuhr Museum of the Prairie Pioneer, Grand Island, NE, 1978
Jewish Community Center, Omaha, 1977
Joslyn Art Museum, Omaha, 1974

SELECTED GROUP EXHIBITIONS
Nebraska Wesleyan University, Lincoln, 1983, 84, 86
Butler Institute of American Art, Youngstown, OH, 1984, 85
United States National Arts Competition & Intl. Exhibition, The Capitol, Tallahassee, FL, 1984
Palm Springs Desert Museum, CA, 1983
Atrium of the Imperial Bank, San Diego, CA, 1983
Hilmer Gallery, College of St. Mary, Omaha, 1983
West/ART & THE LAW, Purchase, 1979
University of South Dakota, 1978

AWARDS, GRANTS, FELLOWSHIPS
National Watercolor Society, elected Signature Member, 1983
San Diego Watercolor Society, Purchase, Best of Show
Association of Nebraska Arts Club 20th Annual, Best of Show
Elder Gallery, Purchase, 1982, 83
Limited Image Gallery, Best of Show, 1983
West/ART & THE LAW, Purchase, 1979
Northwestern Bell Calendar Competition, 1976, 79
AAO 5-State Print, Drawing & Small Sculpture, Omaha, Best of Show, 1977, 78

SELECTED COLLECTIONS
American Medical Institute, St. Joseph Hospital
Boys Town and Boys Town Institute for Speech and Hearing Disorders
College of St. Mary
Dana Rouble Larson & Assoc.
Douglas County Bank & Trust
Bob Hope Enterprises
Nebraska Wesleyan University
San Antonio Air Force Village
The West Collection

POSITIONS
Freelance Artist, 1968–Present
University of Nebraska, Omaha, Fine Arts Advisory Council, 1975–85
Artist for Omaha's Sister City Association at Cultural & Trade Fair, Shizuoka, Japan, 1985
St. Joseph Hospital, Denver, CO, Graphic Artist, 1966–67

ARTIST'S STATEMENT
The Door, Open began after I started attending school programs of my two children. I wanted to record the sea of delightful, smiling faces and the wonderful variety of racial and ethnic mixes I'd see. In 1977 my son was involved in the integration of the Omaha public school system.

I wanted to express my feeling that whatever changes in the law the fathers of our country made, the youngsters could adjust and with all their vigor and potential would prove that the laws governing their lives would benefit them and the future of our country.

The painting was done from my son's second-grade picture. Leaving off the last row of children, I superimposed the Supreme Court justices in graphite covered with clear acrylic to appear as a shadow over the children.

With integration of the schools, the door had been opened to equality in education and the opportunity for each child to fulfill his or her potential.

Sue Olson-Mandler
The Door, Open
pencil, acrylic/27¼ x 36½/1979

> *The law, in its majestic equality, forbids the rich as well as the poor to sleep under bridges, to beg in the streets, and to steal bread.*
>
> Anatole France/*Le Lys Rouge,* 1894

CAROLYN PLOCHMANN

BORN
May 4, 1926, Toledo, OH

EDUCATION
Southern Illinois University Graduate School, 1951–52

Instruction from Alfeo Faggi, Woodstock, NY, 1950

State University of Iowa, MFA, 1949

University of Toledo, BA, 1947

SELECTED SOLO EXHIBITIONS
Witte Memorial, San Antonio, TX, 1968, 83

Kennedy Galleries, NYC, 1973, 81

Paine Art Center, Oshkosh, WI, 1975

Evansville Museum of Arts and Science, IN, 1962, 73

Nieman-Marcus Gallery in the Square, Fort Worth, TX, 1966, 68

Bergstrom-Mahler Museum, Neenah, WI, 1959

Toledo Museum of Art, OH, 1955

Southern Illinois University at Carbondale, 1952

SELECTED GROUP EXHIBITIONS
West/ART & THE LAW, 1985, 86

Kennedy Galleries, NYC, 1979–85

Pennsylvania Academy of Fine Arts, Philadelphia, 1969

Woodstock Art Association, NY, 1969

Toledo Museum of Art, 1967

Escuela Nacional de Artes Plasticas, Mexico City, 1965

Butler Institute of American Art, Youngstown, OH, 1964

National Council of Churches, San Francisco, 1964

Evansville Museum of Arts and Science, IN, 1955–58, 62

Carnegie Institute, Pittsburgh, 1942

AWARDS, GRANTS, FELLOWSHIPS
Toledo Federation of Art Societies, Roulet Medal, 1973

Philadelphia Watercolor Society, M.V. Zimmerman Award, 1968

Magnificent Mile Art Festival, 1965

New York Graphics Society Award, 1959

Norton Memorial Award, 1959

Emily Lowe Competition, 1958

Toledo Museum of Art, Junior League Award, 1955

Tupperware Art Fund Fellowship, 1954

George W. Stevens Fellowships, 1947–49

SELECTED COLLECTIONS
Butler Institute of American Art

Evansville Museum of Arts and Science

Fleischmann Collection

Mr. & Mrs. Arthur Magill

Selden Rodman Collection

SIU Morris Library Collection

SIU School of Medicine

University of Toledo

Tupperware Art Museum

The West Collection

POSITIONS
Full-time Artist

ARTIST'S STATEMENT
The Sheltered was motivated by an account in the *Toledo Blade* of a hardworking though illegally established Mexican family uprooted by the strict enforcement of the immigration laws. The painting is about the timeless plight of honorable people, obeying a law that is unjust in their case, an imperfect law, with the result that they become once again displaced persons.

As the work proceeded, I hoped that the ironically ceremonial color and the rhythmic structure of interlocking forms implied the inner orderliness that in turn implied a second language, one of promise, not defeat, a resiliency where hardship is a way of life, home a pickup truck. The opening line of a poem by Peretz Kaminsky, "When it was dark/ I had many dreams," bespeaks this renewal of the human spirit, which may be the genesis of needed reform when the law itself has killed the spirit of the law.

Carolyn Plochmann
The Sheltered
oil on masonite/32 x 38½ /1983

M en, their rights and nothing more; women, their rights and nothing less.

Susan B. Anthony/Address, 1873

NORINE SPURLING

BORN
January 16, 1930, Bermuda

EDUCATION
State University of New York, Buffalo, MFA, 1975

Moore College of Art, Philadelphia, 1947–51

Pennsylvania Academy of Fine Arts, Philadelphia, 1947–51

SELECTED SOLO EXHIBITIONS
Charlotte Gallery, Brantford, Ontario, Canada, 1986

Access to the Arts, Dunkirk, NY, 1984

Sheila Nussbaum Gallery, Millburn, NJ, 1983

Bruce Gallery, Edinboro, PA, 1982

Hamilton, Ontario, Canada, 1982

Jerel Gallery, Snyder, NY, 1981

Black Mountain College II, SUNY, Buffalo, NY, 1981

De Land Museum, De Land, FL, 1977

SELECTED GROUP EXHIBITIONS
Nabisco Gallery, East Hanover, NJ, 1985

Vida Gallery, San Francisco, 1984

Wilson Art Center, Rochester, NY, 1984

Rutgers National, Camden, NJ, 1983–84

National Drawing '83, Trenton, NJ, 1983

Port of History Museum, Philadelphia, 1983

Ball State University, Muncie, IN, 1981, 82

West/ART & THE LAW, 1980

Begegnung mit Buffalo, Auslands Institute, Dortmund, West Germany, 1976

AWARDS, GRANTS, FELLOWSHIPS
National Organization of Women Award, 1982

West/ART & THE LAW, Purchase, 1980

SELECTED COLLECTIONS
Erie Press Systems

The Kemper Group

Charles Rand Penney Upstate New York Collection

The West Collection

POSITIONS
Black Mountain College, State University of NY, Buffalo, Lecturer, 1977–Present

ARTIST'S STATEMENT
This drawing, completed in 1981, not only reflects my continuing fascination with old photos, but also my concern for women's rights, and my deep respect and admiration for those women who fought so long and hard to obtain the right to vote. We won't have fully realized their goals until the notion of equality has spread beyond the voting booth to permeate every aspect of our lives.

Norine Spurling
ERA Then
charcoal/23¾ x 29¾/1980

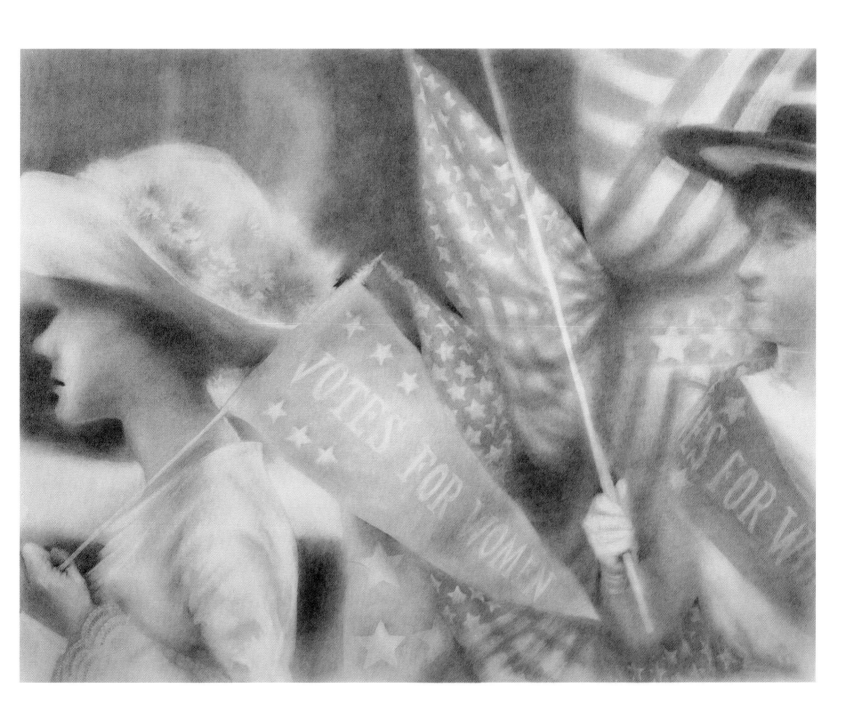

The question is not whether we will be extremists, but what kind of extremists we will be The nation and the world are in dire need of creative extremists.

Martin Luther King, Jr./Speech, 1963

JAMES SWILER

BORN

January 16, 1942, Chanute, KS

EDUCATION

Wichita State University, MFA, 1970
Kansas State College at Emporia, BS, 1966

SELECTED GROUP EXHIBITIONS

West/ART & THE LAW, 1980
Apokalypsis, Nardin Gallery, NYC, 1980
Salina Art Center, Salina, KS, 1980
Kansas State University, Union Gallery, 1979
Union National Bank, Manhattan, KS, 1978
Senate Office Building, Washington, DC, 1975
Oklahoma State University, Stillwater, 1975
Mulvane Art Center, Topeka, KS, 1974
Wichita Art Museum, KS, 1974
Winfield Art Center, KS, 1974

AWARDS, GRANTS, FELLOWSHIPS

West/ART & THE LAW, Purchase, 1980
Abilene Fine Arts Museum, Purchase, 1980
Spiva Art Center, Joplin, Best of Show, 1980
Faculty Research Grant, 1979–80
Sterling College Art Center, Best of Show, 1979
Faculty Research Grant, 1978–79
Foothills Art Gallery, Palette Award, 1978
Cape Coral Art Association, Honorable Mention, 1975
College of St. Mary, Second Place, 1975
Wichita Art Museum, Honorable Mention, 1973

SELECTED COLLECTIONS

Abilene Fine Arts Museum
Birger Sandzen Gallery
Kansas State College
The West Collection
Wichita State University

POSITIONS

Kansas State University, Head Painting, 1977–Present, Assistant Professor, 1974–Present, Instructor, 1970–74

ARTIST'S STATEMENT

My paintings have reflected my concern with various social changes that have occurred in the last decade.

Because of the complexity of our society, many images have overlapping meanings. These paintings deal with both moral and legal concepts and do not attempt to make a judgment about right or wrong.

In *The Past Is Prologue* series I have used symbols that encompass both sides of the law and that deal with groups, movements, and the concepts of organizations from the Symbionese Liberation Army to the feminists. The painting in The West Collection was done in 1980.

James Swiler
The Past is Prologue
oil/40 x 46¾

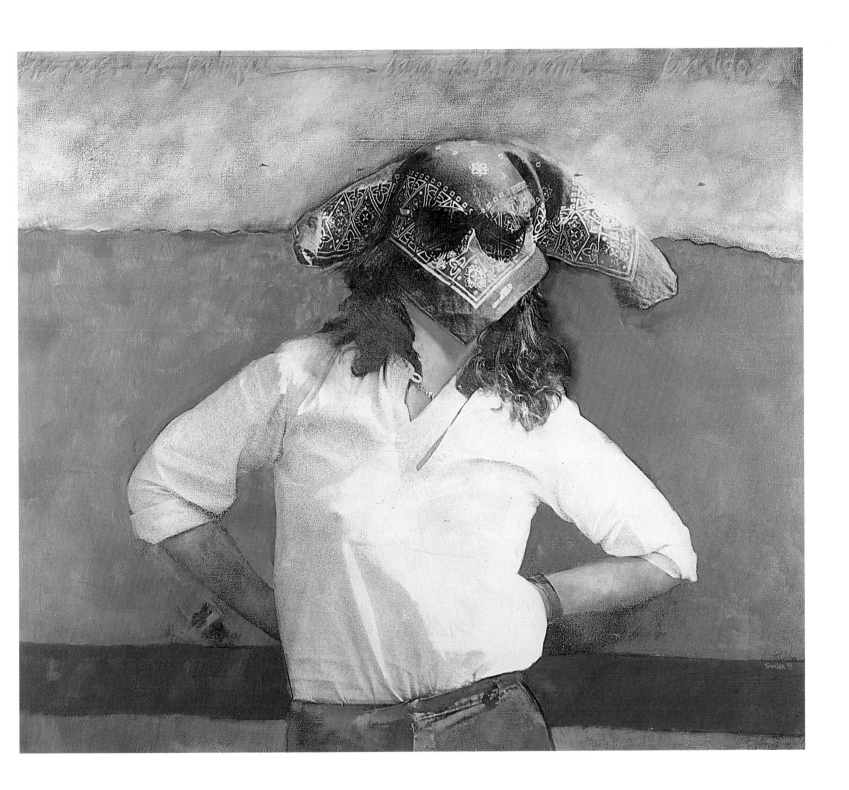

> *he glorification of the "women's role," then, seems to be in proportion to society's reluctance to treat women as complete human beings; for the less real function that role has, the more it is decorated with meaningless details to conceal its emptiness.*
>
> Betty Friedan/ *The Feminine Mystique,* 1963

STAN TAFT

BORN

November 21, 1945, Vancouver, WA

EDUCATION

Fort Wright College, Spokane, 1967–69

California College of Arts and Crafts, Oakland, 1964–67

SELECTED SOLO EXHIBITIONS

Josef Gallery, NYC, 1980

Benjaman's Gallery, Buffalo, 1980

Fort Wright College, Spokane, 1970, 72

House of Art Gallery, Spokane, 1968

California College of Arts and Crafts, Oakland, 1967

SELECTED GROUP EXHIBITIONS

Johnson Museum, Cornell University, Ithaca, NY, 1985

West/ART & THE LAW, 1983, 84

Alex Rosenberg Gallery, NYC, 1979, 80

Metropolitan Museum of Art/McGraw Hill Publishing Company, Reader's Digest, Pfizer Chemical Company, NYC, 1979

Community Gallery, NYC, 1978

Juniper Tree Gallery, Spokane, 1975

First National Bank, Spokane, 1974

Seattle Art Pavilion, 1968

Arleigh Gallery, San Francisco

AWARDS, GRANTS, FELLOWSHIPS

West/ART & THE LAW, Purchase, 1983

California College of Arts and Crafts, Scholarship, 1964, 66

National Scholastic Art Awards, 1963

SELECTED COLLECTIONS

The West Collection

POSITIONS

Cornell University, Ithaca, NY, Assistant Professor, 1985–86

University of Iowa, Visiting Artist, 1979; Assistant Professor, 1985

The Studio School, Spokane, Instructor, 1972–74

Fort Wright College, Spokane, Instructor, 1968–72

ARTIST'S STATEMENT

Phryne was a Greek courtesan who lived in the 4th Century B.C. She is known for having posed for the great sculptor Praxiteles and for the painter Apelles. During the festival of Poseidon at Eleusis, she disrobed and walked into the sea. Because this happened within view of the celebrants, she was arrested for profaning the gods. At the trial, she was defended by the orator Hypereides. As the trial progressed, it became evident that the judges were leaning toward a conviction. At a particularly dramatic point in the proceedings, Hypereides ripped the clothes from Phryne's body to reveal her beauty. The judges were so moved that she was acquitted. Such beauty could not possibly have profaned the gods.

I am attracted to this story because it seems to me to present a wonderful relationship between art and law. Each is subject to interpretation. Each element must be brought into balance with the other.

Stan Taft

Phryne

oil/24 x 36/1983

140

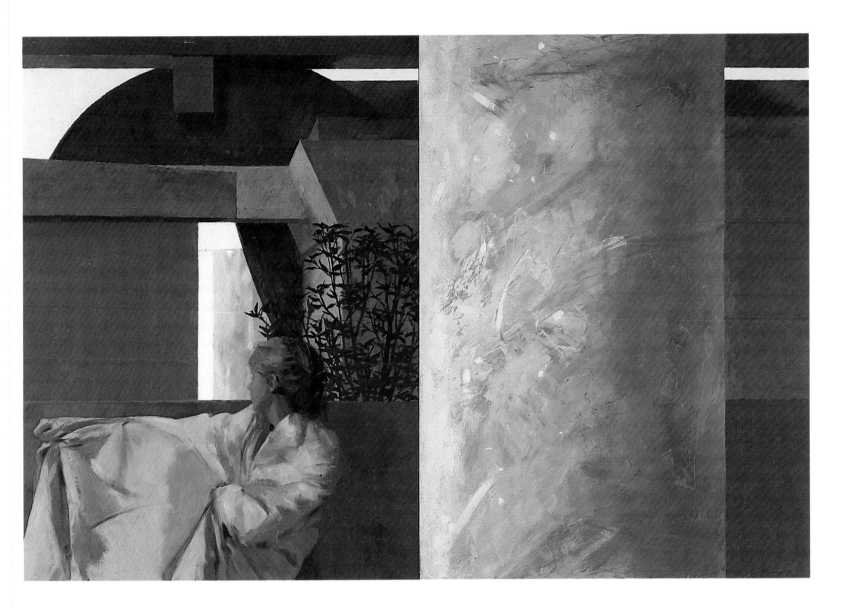

ature is profoundly imperturbable. We may adjust the beating of our hearts to her pendulum if we will and can, but we may be very sure that she will not change the pendulum's rate of going because our hearts are palpitating.

Oliver Wendell Holmes, 1860

JANET COOLING

BORN
October 14, 1951, Chester, PA

EDUCATION
School of Art Institute of Chicago, MFA, 1975
Pratt Institute, Brooklyn, BFA, 1973

SELECTED SOLO EXHIBITIONS
Patty Aande Gallery, San Diego, 1986
Natural History Museum, San Diego, 1986
Feature Gallery, Chicago, 1985, 86
Getler/Pall/Saper Gallery, NYC, 1985
University of Arizona, Tucson, 1984
Nancy Lurie Gallery, Chicago, 1979, 80, 83
Roger Litz Gallery, NYC, 1982
Carolyn Schneeback Gallery, Cincinnati, 1982
Canis Gallery, Los Angeles, 1976

SELECTED GROUP EXHIBITIONS
Allen Memorial Art Museum, Oberlin College, OH, 1984–86
Contemporary Arts Center, New Orleans and New York Academy of Arts, 1986
New Strategies, Los Angeles, 1986
WARM Gallery, Minneapolis, 1986
Patty Aande Gallery, San Diego, 1985
Herron Gallery, Indianapolis Center for Contemporary Art, 1985
Nohr Haime Gallery, NYC, 1985
Hal Bromm, NYC, 1984, 85
Fahion Moda, Bronx, NY, 1984
New Museum of Contemporary Art, Venice, Italy, 1984

SELECTED COLLECTIONS
Private Collections, National & International
The West Collection

POSITIONS
Art Institute of Chicago, Visiting Artist, 1986
Ohio State University, Columbus, 1985
San Diego State University, Department of Art, Lecturer, 1984–85
Illinois Wesleyan College, Bloomington, Guest Lecturer, 1983
Millikin University, Decatur, IL, 1983
Illinois State University, Normal, Visiting Artist, 1983

ARTIST'S STATEMENT
My work honors the laws of nature, which are the underlying principles that govern all life.

I continue to glorify the life force and the cycles of change.

I take this approach because I wish to communicate information about healing, spirituality, freedom, and integration—luscious paintings of my reverence for nature.

Janet Cooling
Untitled
oil on canvas/36 x 36/1985

*Accuse not nature,
she hath done her
part; do thou but
thine!*

John Milton/*Paradise Lost,* VIII, 1667

JOSEPH DiGIORGIO

BORN
January 1, 1931, Brooklyn, NY

EDUCATION
Cooper Union, NYC, 1958

SELECTED SOLO EXHIBITIONS
Ruth Siegel Gallery, NYC, 1983, 86
William Sawyer Gallery, San Francisco, 1985
Squibb Art Gallery, Princeton, NJ, 1985
Harris Gallery, Houston, 1984
Nina Freudenheim Gallery, Buffalo, NY, 1984
Bienville Gallery, New Orleans, 1982
A. M. Sachs Gallery, NYC, 1980
Michael Walls, NYC, 1975

SELECTED GROUP EXHIBITIONS
Albany Institute of History and Art, NY, 1985
Rahr West Museum, Manitowoc, WI, 1984
Hudson River Museum, Yonkers, NY, 1984
Siger Gallery, NYC, 1983
Art Museum of Santa Cruz County, CA, 1983
West/ART & THE LAW, 1981
Cornell University, Ithaca, NY, 1978
Art Institute of Chicago, 1977
Whitney Museum of American Art
Biennial, 1975

AWARDS, GRANTS, FELLOWSHIPS
Virginia Center for the Creative Arts
Fellowship, 1982, 83
West/ART & THE LAW, Purchase, 1981

SELECTED COLLECTIONS
AT&T
Apple Computer
Art Museum of Santa Cruz County
Chemical Bank
Art Institute of Chicago
General Electric
Hyatt Regency
Shell Oil Company
Western Electric
The West Collection

POSITIONS
Full-time Artist

ARTIST'S STATEMENT
"The American landscape is now an
endangered species." This is what interests
me as a painter: those special places in
America that are unspoiled, uncluttered,
unpolluted. I paint these places in perhaps
a lyrical and romantic way. I feel they won't
ever be that way again. It is a rewarding
experience for me to happen upon a place
in the countryside without a smokestack,
without a polluted river or a "townhouse"
put up by an insensitive developer and to
record my impressions in an invented and
idealized manner.

Joseph DiGiorgio
Hudson River Clean-up
oil/28½ x 46⅛/1981

As cruel a weapon as the cave man's club, the chemical barrage has been hurled against the fabric of life.

Rachel Carson/*The Silent Spring*, 1962

JOHN FITZGERALD

BORN

August 24, 1950, Stockton, CA

EDUCATION

San Francisco State University, BA, 1973

Hartnell College, Salinas, CA, AA, 1971

SELECTED SOLO EXHIBITIONS

Cerro Cosso Community College, Ridgecrest, CA, 1984

Antelope Valley College, Lancaster, CA, 1978

SELECTED GROUP EXHIBITIONS

International Watercolor Exhibition, San Diego Watercolor Society, 1984

Butler Institute of American Art, Youngstown, OH, 1982, 83, 84

National Academy of Design, NYC, 1980–84

Rocky Mountain National Watercolor Exhibit, Golden, CO, 1981, 82

California State Fair, Sacramento, 1980, 81, 82

Aqueous 81, Kentucky Watercolor Society, Frankfort, 1981

National Watercolor Society, Palm Springs Desert Museum, 1979–80

Springfield Art Museum, Springfield, MO, 1979

West/ART & THE LAW, 1979

National Small Painting Exhibition, Albuquerque, NM, 1979

AWARDS, GRANTS, FELLOWSHIPS

California State Fair, 1st Award, 1981

National Orange Show, 3rd Award, 1981

Watercolor West 12th Anniversary National Exhibition, Grumbacher Award, 1980

West/ART & THE LAW, Purchase, 1979

National Small Painting Exhibition, 1st Award, 1979

San Diego National Watercolor Exhibition, Jurors Award, 1978

SELECTED COLLECTIONS

Cedar City Municipal Collection

Chico University Gallery

La Mirada Municipal Collection

Sun Telegram Collection

The West Collection

POSITIONS

Cerro Coso College, Art Instructor, 1976

ARTIST'S STATEMENT

When I was a child my father would take us to the ocean. He told me never to turn my back on the sea because it could rise up in a moment and sweep away the unaware. Through the years the ocean continues to be a subject for my thoughts: the awesome majesty of a single great wave, the thunder as it hits the beach. I remain committed to the sea; we all share in the consequence of its use.

Regulate the Water is the final work of a compendium of sketches and hand-colored Xerox proofs. It is an attempt to portray the power of the sea as well as my abuses of it. The pop-top and fishhook, symbolized in the skeleton, play antagonists to the natural order represented in the wave. This allegory, frozen in time, provides the visual logic for our reflection. It asks to what degree we have been a part of the "pop-top fishhook" carelessness or of the natural order.

John Fitzgerald
Regulate the Water
watercolor/28¼ x 20¼ (sight)

Nature is perfect, wherever we look, but man always deforms it.

Friedrich von Schiller/*Die Braut von Messina,* 1803

ROBERT J. LARSON

BORN
November 22, 1950, Willmar, MN

EDUCATION
Southwest Minnesota State College, Marshall, 1970–73

Willmar State Jr. College, Willmar, MN, 1968–70

SELECTED SOLO EXHIBITIONS
Western Plains Library, Montevideo, MN, 1981

Gallery 401, Willmar, MN, 1977

Southwest Minnesota State College, Marshall, 1975

SELECTED GROUP EXHIBITIONS
West/ART & THE LAW, 1979, 81, 83, 85

Minnesota State Fair, 1978, 79, 80, 85

Sioux City Art Center, IA, 1985

Red River Juried Show, Moorhead, MN, 1979

Manisphere, Winnipeg, Canada, 1976

College Group Shows, 1970–73

AWARDS, GRANTS, FELLOWSHIPS
West/ART & THE LAW, Purchases, 1979, 81, 83

SELECTED COLLECTIONS
The West Collection

Private Collections

POSITIONS
Full-time Artist

ARTIST'S STATEMENT
In regard to *Kosher Man* and his pickle inspection: in the future, pickles may have to be examined for radiation or other contamination. For now, they are only being checked for common impurities.

Robert J. Larson
Kosher Man
oil, acrylic/40 x 45¼/1976

We are living beyond our means. As a people we have developed a life-style that is draining the earth of its priceless and irreplaceable resources without regard for the future of our children and people all around the world.

Margaret Mead/*Redbook,* 1974

JACQUELYN McELROY

BORN
June 28, 1942, Rice Lake, WI

EDUCATION
University of Montana, BA, 1965; MA, 1966; MFA, 1967

SELECTED SOLO EXHIBITIONS
Browning Arts, Grand Forks, ND, 1985

North Dakota State University, Fargo, 1984

Heritage Center, Bismarck, ND, 1983

Winona State University, MN, 1982

College of St. Thomas, St. Paul, 1982

Iowa State University, Ames, 1982

University of Minnesota, Morris, 1982

Dakotah Prairie Museum, Aberdeen, SD, 1981

Bemidji State University, MN, 1981

Prairie Art Center, Jamestown, ND, 1980

SELECTED GROUP EXHIBITIONS
Minnesota Historical Society, 1985

Springville Museum of Art, UT, 1985

University of North Dakota, Grand Forks, 1984

Plains Art Museum, Moorhead, MN, 1984

Rourke Gallery, Moorhead, MN, 1984

College Art Association, Philadelphia, 1983

Miriam Perlman, Inc., Chicago, 1982

West/ART & THE LAW, 1980

AWARDS, GRANTS, FELLOWSHIPS
Instructional Development Grant, Color Theory, 1985

University of Dallas, Irving, Award, 1983

Tempo Gallery, Appleton, WI, Best in Show, 1982

Pillsbury Company, Purchase, 1981

West/ART & THE LAW, Purchase, 1980

SELECTED COLLECTIONS
Chattahoochee Valley Art Association Gallery

Minnesota Historical Society

Oklahoma Art Center

Pillsbury Company

Plains Art Museum

University of Dallas

University of Wisconsin

The West Collection

Winnipeg Art Gallery

POSITIONS
College of Fine Arts, UND, Assistant Dean, 1979–83

UND, Professor of Visual Arts, 1968

Northland State Junior College, Instructor, 1967–68

ARTIST'S STATEMENT
The land in my part of North Dakota is dominated by the horizon and the sky. I suspect that I too am thus dominated because I often see both in my work. I'm not content to imitate the effects of nature because no artist can duplicate the complexities and the riches of the visual world. Rather, I enjoy starting with the familiar and stretching the truth a bit. Laws of natural phenomena may be broken, but within the context of the work the color and the imagery make their own kind of truth.

This print, done in 1977, seeks to construct a new awareness by the juxtaposition of familiar things taken out of their usual context. In this way I amuse myself. I hope the results amuse others as well.

Jacquelyn McElroy
Drain Field
serigraph (12/25)/ 25$\frac{1}{3}$ x 57$\frac{3}{4}$ /1977

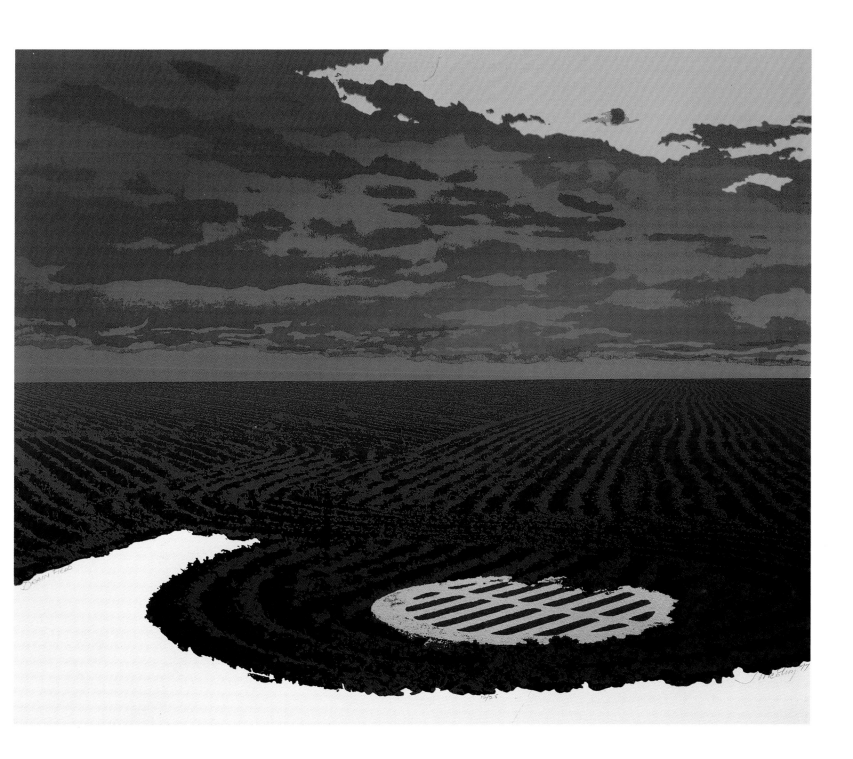

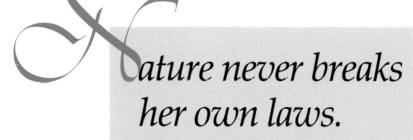

Nature never breaks her own laws.

Leonardo da Vinci/*Notebooks*, c. 1500

J. L. STEG

BORN
February 6, 1922, Alexandria, VA

EDUCATION
State University of Iowa, BFA, 1947; MFA, 1949
Rochester Institute of Technology, 1939–42

SELECTED SOLO EXHIBITIONS
New Orleans World's Fair, 1984
New Orleans Academy of Art, 1983
New Orleans Museum of Art, 1978
University of Mississippi, Oxford, 1978

SELECTED GROUP EXHIBITIONS
Alabama International, 1985
National Show at Hawaii Academy of Art, 1984
Southern Graphic Art Exchange for Russia, 1984
American Drawing II, Portsmouth, VA, 1982
Rutgers University, New Brunswick, NJ, 1982
Oklahoma Art Center, 1980

AWARDS, GRANTS, FELLOWSHIPS
West/ART & THE LAW, Purchase, 1980
Eighth International Print & Drawing Exhibit, Purchase
Philadelphia Print Club, Charles Lea Prize
Potsdam Print Exhibitions, Purchases

SELECTED COLLECTIONS
Brooklyn Museum
Fogg Art Museum
Library of Congress
Museum of Modern Art
Smithsonian National Collection
The West Collection

POSITIONS
Tulane University, New Orleans, Professor, 1951 to Present
Cornell University, Ithaca, NY, Instructor, 1949–51

J. L. Steg
Polluted Wetland
pencil, dry color/30¼ x 38¾/1979

He grew up and married, and raised a large family, and brained them all with an axe one night, and got wealthy by all manner of cheating and rascality; and now he is the infernalist wickedest scoundrel in his native village, and is universally respected, and belongs to the Legislature.

Mark Twain/*Story of the Bad Little Boy*, 1875

MILES G. BATT

BORN
October 12, 1933, Nazareth, PA

EDUCATION
Over 30 years in the Arts

SELECTED SOLO EXHIBITIONS
Boca Raton Museum of Art, FL, 1984

SELECTED GROUP EXHIBITIONS
West/ART & THE LAW, 1982

Southeastern Center for Contemporary Art, Winston-Salem, NC, 1979–80

Museum of Fine Arts of St. Petersburg, FL, 1978

Art and Culture Center of Hollywood, FL, 1977

Aldrich Museum of Contemporary Art, Ridgefield, CT, 1975

L. K. Miesel Gallery, NYC, 1975

AWARDS, GRANTS, FELLOWSHIPS
Florida Watercolor Society, Award, 1976, 82, 85

National Watercolor Society, 6 Awards, 1970–85

West/ART & THE LAW, Purchase, 1982

Watercolor, USA, Purchase Award, 1981

Atwater Kent Award, 1973, 81

San Diego National Watercolor Exhibition, Award & Purchase, 1978, 80

Watercolor West National Competition, Awards, 1977, 78, 79

Gulf Coast Annual, Awards, 1974, 75, 77

SELECTED COLLECTIONS
Bendix Avionics

Brand Library

Ford Motor Company

Fort Lauderdale Museum

House of Representatives, State of Florida Collection

Miami Metropolitan Dade County Art Collection

Museum of Fine Arts of St. Petersburg

Pepsi-Cola Bottling Company

Springfield Art Museum

Utah State University

The West Collection

POSITIONS
Creative Painting Workshops (International), Fort Lauderdale, FL, 1986–Present

Purdue University, Calumet, IN, Instructor, 1984–86

Art Institute of South Florida, Hollywood, 1977–83

Museum of Art, Fort Lauderdale, FL, 1970–82

Hewitt Painting Workshops (International), San Diego, 1977

Norton School of Art, West Palm Beach, FL, Instructor, 1971–76

ARTIST'S STATEMENT
White Collar Crime creates visual/psychological tensions through contrast. The tie string usually found on an envelope, perhaps enclosing a legal document, is now the tie for a man's shirt collar. The tie is where a tie should be, but it's not the correct kind, producing visual heresy and the deeper implication that crime is a burden shared by all classes in society.

Miles G. Batt
White Collar Crime
watercolor/15 x 10/1982

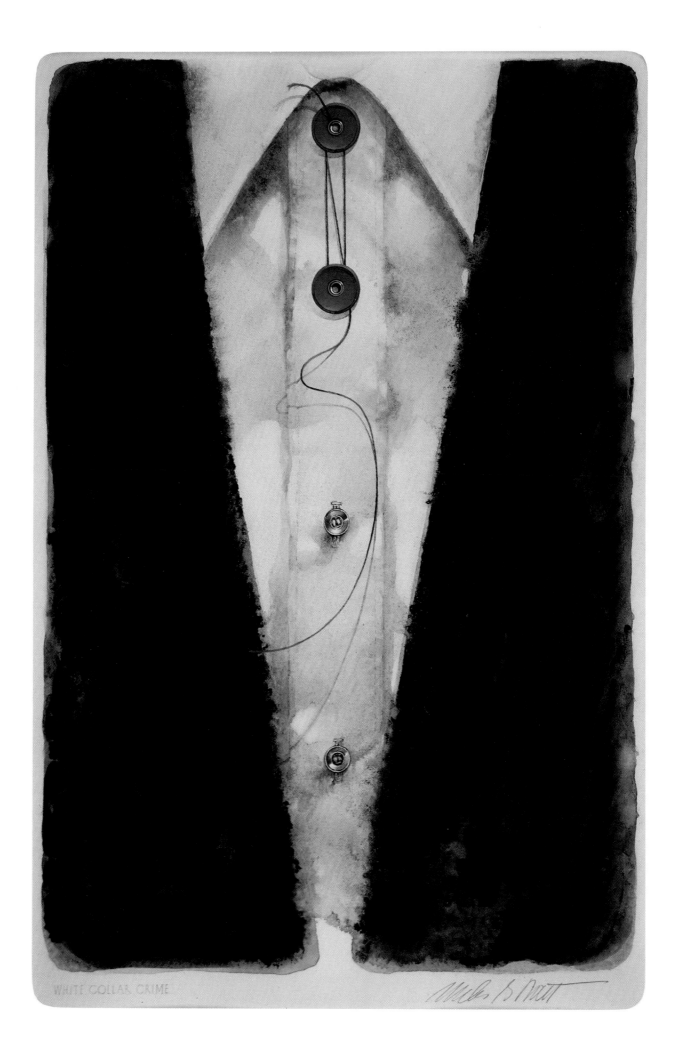

WHITE COLLAR CRIME

*Will all great Neptune's ocean wash this
blood
Clean from my hand? No, this my
hand will rather
The multitudinous seas incarnadine.*

William Shakespeare/*Macbeth, II,* 1605

MORRIS BRODERSON

BORN
November 4, 1928, Los Angeles

EDUCATION
Jepson Art Institute, Los Angeles, 1948
University of Southern California, 1943–47

SELECTED SOLO EXHIBITIONS
San Diego Museum of Art, 1969, 82
Gallaudet College, Washington, DC, 1981
Ankrum Gallery, Los Angeles, 1965, 70, 79
Staempfli Gallery, NYC, 1971, 79
University of Arizona, Tucson, 1975

SELECTED GROUP EXHIBITIONS
West/ART & THE LAW, 1983, 86
Carnegie-Mellon University, Pittsburgh, 1983
Huntington Galleries, W V, 1981
Museum of Fine Arts, Houston, 1981
Mitchell Museum, Mt. Vernon and Cedar
Rapids Art Center, IA, 1980
Santa Barbara Museum of Art, CA, 1976, 79
National Academy of Design, NYC, 1977, 78
Springfield Art Museum, MO, 1976
American Academy of Arts and Letters,
NYC, 1976
Hirshhorn Museum and Sculpture Garden,
Washington, DC, 1974

AWARDS, GRANTS, FELLOWSHIPS
West/ART & THE LAW, Purchase Award,
1983, 86
Commission Theater Poster, Mark Taper
Theater, 1979
Los Angeles Municipal Gallery, First
Prize, 1959
New Talent USA, Art in America, 1959
Art Directors Club, Purchase

SELECTED COLLECTIONS
Hirshhorn Museum and Sculpture Garden
Joslyn Art Museum
Los Angeles County Museum of Art
National Collection of Fine Arts
National Institute of Arts and Letters
San Francisco Museum of Modern Art
Santa Barbara Museum of Art
University of Texas, Austin, James A.
Michener Collection
The West Collection
Whitney Museum of American Art

POSITIONS
Full-time Artist

ARTIST'S STATEMENT
This continues a series of paintings based
on the story of Lizzie Borden, in which I
became very much involved when I saw
the ballet "Fall River Legend." Although
Lizzie was acquitted of murdering her father
and stepmother, her innocence is still in
question. The axe is a symbol of her possible
guilt.

Morris Broderson
Lizzie Borden's Axe, II
watercolor/23¾ x 17¾/1986

> *ince people will never cease trying to interfere with the liberties of others in pursuing their own, the state can never wither away.*
>
> W. H. Auden

ROBERT BIRMELIN

BORN
November 7, 1933

EDUCATION
Yale University, School of Art and Architecture, BFA, 1956; MFA, 1960
Cooper Union Art School, NYC, 1951–54

SELECTED SOLO EXHIBITIONS
Sherry French Gallery, NYC, 1986
Fendrick Gallery, Washington, DC, 1982, 85
Montclair Art Museum, Montclair, NJ, 1984
Galerie Claude Bernard, Paris, 1981
Odyssia Gallery, NYC, 1980, 81
Bowdoin College Museum of Art, Brunswick, ME, 1980
Capricorn Gallery, Bethesda, MD, 1979
Terry Dintenfass Gallery, NYC, 1975
Jason-Teff Gallery, Montreal, Canada, 1965
Rochester Art Center, MN, 1964

SELECTED GROUP EXHIBITIONS
West/ART & THE LAW, 1986
Rhode Island School of Design, Providence, 1986
Contemporary Arts Center, New Orleans, 1986
Isetan Museum, Tokyo, and Daimary Museum, Osaka, Japan, 1985
Seattle Art Museum, 1985
Columbus Museum of Arts and Sciences, OH, 1985
Sherry French Gallery, NYC, 1983, 84, 85
Metropolitan Museum of Art, NYC, 1984
Pace University Art Gallery, 1984
Tamayo Museum, Mexico City, 1984

AWARDS, GRANTS, FELLOWSHIPS
West/ART & THE LAW, Purchase Award, 1986

SELECTED COLLECTIONS
Brooklyn Museum
Denver Art Museum
Hirshhorn Museum and Sculpture Garden
Library of Congress
Metropolitan Museum of Art
Museum of Fine Arts, Boston
Museum of Modern Art
Museum of Rhode Island School of Design
National Museum of American Art
Whitney Museum of American Art
The West Collection

POSITIONS
Full-time Artist

ARTIST'S STATEMENT
In the midst of the city crowd one cannot remain solely an observer. Willingly or not, we are enmeshed in its field of energies, participants in its tensions. Being in motion ourselves we must be alert, aware of incidents happening at the periphery of our visual field as well as those which immediately confront us.

To invent a painting language that can intensely recreate the quality and immediacy of such experience is a task that continues to absorb my energies as an artist.

Robert Birmelin
City Crowd—Event with Two Police
acrylic/diptych, each 48 x 72/1981-82

rimes become innocent and even glorious by their splendor, number, and enormity.

La Rochefoucauld/*Maxims,* 1665

CARMEN CICERO

BORN
August 14, 1926, Newark, NJ

EDUCATION
Hunter College, NYC, Graduate Study, 1953

Newark State Teacher's College, NJ, BA, 1951

SELECTED SOLO EXHIBITIONS
Graham Modern Gallery, NYC, 1984, 86

Fair Lawn Library, NJ, 1985

Long Point Gallery, Provincetown, MA, 1977, 79, 81, 84

Cincinnati Art Museum, 1983

Gracie Mansion Gallery, NYC, 1982

Gurewitsch Gallery, NYC, 1979

Dubins Gallery, Los Angeles, 1978

Caldwell College, NJ, 1976

South Houston Gallery, NYC, 1975

SELECTED GROUP EXHIBITIONS
Rhode Island School of Design, Providence, 1986

West/ART & THE LAW, 1985, 86

Yares Gallery, Scottsdale, AZ, 1985

Graham Modern Gallery, NYC, 1984

Long Point Gallery, Provincetown, MA, 1980, 82, 84

Gracie Mansion Gallery, NYC, 1982, 83

Kean College, Union, NJ, 1980

Grippi Gallery, NYC, 1980

University of Michigan, Ann Arbor, 1979

AWARDS, GRANTS, FELLOWSHIPS
West/ART & THE LAW, Purchase Award, 1986

Ford Foundation, Purchase Prize, 1961, 65

Guggenheim Memorial Foundation Fellowship Renewal, 1957, 63

SELECTED COLLECTIONS
Art Gallery of Toronto

Cornell University

Ford Foundation

Hirshhorn Museum and Sculpture Garden

Museum of Modern Art

Solomon R. Guggenheim Museum

Springfield Museum

The West Collection

Whitney Museum of American Art

POSITIONS
Full-time Artist

ARTIST'S STATEMENT
I have lived in a loft on the Bowery in New York City for over a decade. Here, the struggle between the law and the criminal is a daily occurrence, and we see lawlessness in all its forms, from petty theft to organized crime. *Crime Boss* represents one of my impressions of this eternal struggle.

Carmen Cicero
Crime Boss
oil/40 x 50/1983

The sad truth is that most evil is done by people who never make up their minds to be either good or evil.

Hannah Arendt/*The New Yorker*, Dec. 5, 1977

RUBY GRADY

BORN
January 11, 1934, Bedford, VA

EDUCATION
Maryland University, College Park, 1963
Corcoran School of Art, Washington, DC, 1959–62

SELECTED SOLO EXHIBITIONS
VVKR Atrium, Alexandria, VA, 1984
Roanoke Museum of Fine Arts, VA, 1980
Jack Rasmussen Gallery, Washington, DC, 1978, 79
Second Story Spring Street Gallery, NYC, 1975
Dickson Gallery, Washington, DC, 1974
Agra Gallery of Fine Art, 1970, 71, 72
Pierre's Gallery, Alexandria, VA, 1968
Lee Gallery, Alexandria, VA, 1962, 64, 67
The R Street Gallery, Washington, DC, 1964

SELECTED GROUP EXHIBITIONS
Washington Square Sculpture 84, Washington, DC, 1984
Virginia Sculpture Exhibition, Alexandria, 1983–84
West/ART & THE LAW, 1982
15th Annual Avant Garde Show, NYC, 1981
Virginia Museum of Fine Arts, Richmond, 1978
American Artists Exhibit, Paris, 1975–76
Corcoran Gallery of Art, Washington, DC, 1972, 76
Textile Museum, Washington, DC, 1973–75
Southeastern Museums Tour of Washington Artists, 1973
Washington Artists Annual, 1966

AWARDS, GRANTS, FELLOWSHIPS
West/ART & THE LAW, Purchase, 1982
John James Audubon Bronze Medal, 1974
American Fine Arts Exhibits, 18 Paintings Purchased
Annapolis Fine Arts Foundation, Cash Award

Included in *The National Community Arts Book*
Virginia Beach Foundation Exhibit Catalogue Cover, Purchase Award

SELECTED COLLECTIONS
Agra Collections Palm Beach
Americana Hotel and Executive House
Chakin Enterprises, Inc.
Kiplinger Collection
Maeght Collection, Paris
The West Collection

POSITIONS
Painter and Sculptor, Present
Three Washington, DC, Restaurants, Exhibitions Coordinator, 1961–74
Potowmack Studio, Fort Washington, MD, Instructor, 1961–73
Federal Bureau of Investigation, Washington, DC, Art Illustrator, 1956–59

ARTIST'S STATEMENT
In *Crime and Victim* I used my brush to add just enough paint to transform the collage format into an aesthetic and emotional work on crime, organized and unorganized violence. To complete it and make a lasting impression, I added the victim, the half image of a beautiful and fragile face behind a chained door, a captive surrounded by the ugly images of our world of crime and violence.

Ruby Grady
Crime and Victim
acrylic collage/41½ x 48/1981

Do you think there could be something like victims without crimes?

Rosellen Brown/*Street Games*, 1974

JOSEPH HIRSCH

BORN
April 25, 1910, Philadelphia

DIED
September 21, 1981

EDUCATION
Philadelphia College of Art, 1927–31

SELECTED SOLO EXHIBITIONS
Kennedy Galleries, NYC, 1975, 76, 78

Oklahoma Art Center, Oklahoma City, 1974

University of Maine, Orono, 1973

University of Georgia Museum of Art, 1970

Forum Gallery, NYC, 1962, 65, 69

New Jersey Art Association,
Long Beach, 1968

Retrospective, Philadelphia Art Alliance,
1947, 66

University of Utah, Salt Lake City, 1959

SELECTED GROUP EXHIBITIONS
Kennedy Galleries, NYC, 1985

West/ART & THE LAW, 1980, 84 (Tribute to
Joseph Hirsch)

American Academy of Arts and Letters,
NYC, 1982

Wilkes College, Wilkes-Barre, PA, 1981

Forum Gallery, NYC, 1959, 64, 66, 68

National Council of Churches,
Los Angeles, 1960

Art Institute of Chicago, 1951

Metropolitan Museum of Art, NYC, 1950

AWARDS, GRANTS, FELLOWSHIPS
West/ART & THE LAW, Purchase, 1980

National Academy of Design Altman Prizes,
1959, 66, 78

Carnegie Institute Prize, 1968

Butler Institute of American Art Award, 1964

Metropolitan Museum of Art Award, 1950

Fulbright Fellowship, 1949

National Institute of Arts and Letters
Grant, 1947

Guggenheim Foundation Fellowships,
1942, 47

SELECTED COLLECTIONS
Dallas Museum of Art

Hirshhorn Museum and Sculpture Garden

Metropolitan Museum of Art

Museum of Fine Arts, Boston

Museum of Modern Art

National Academy of Design

National Collection of Fine Arts

Walker Art Center, Minneapolis

The West Collection

Whitney Museum of American Art

POSITIONS
University of Utah, Distinguished
Bicentennial Professor, 1975

Utah State University, Visiting Artist, 1967

Dartmouth College, Visiting Artist, 1966

Art Students League, NYC, Instructor,
1959–67

ARTIST'S STATEMENT
When a critic wrote that one abstract painter closed the door, another pulled down the shade, and the third turned out the light, it was meant to be funny. It suggests that art must stay clear of all that is outside. Art is for the silence of the chapel, art is surcease from confrontation, from thought, from anguish, from blinding light, from thought. Art is "no comment."

This is a grotesque notion, grown in this century, shared by none of our picture-making forebearers. The illustrious dead, my painter ancestors, needed the sustenance of living circumstance for their productive time at the easel. Every blessed one of them, from Piero through Goya to Hartley, had robust views on beauty, on relevance, on the wonder of visible rhythms to be uncovered in the welter of everyday. Theirs was a brotherhood of responsiveness. So, inevitably, I was brought up to believe that indifference is a sin. Any painting that has to do with life is a commemoration.

Joseph Hirsch
Motards
oil/15½ x 24½/1977

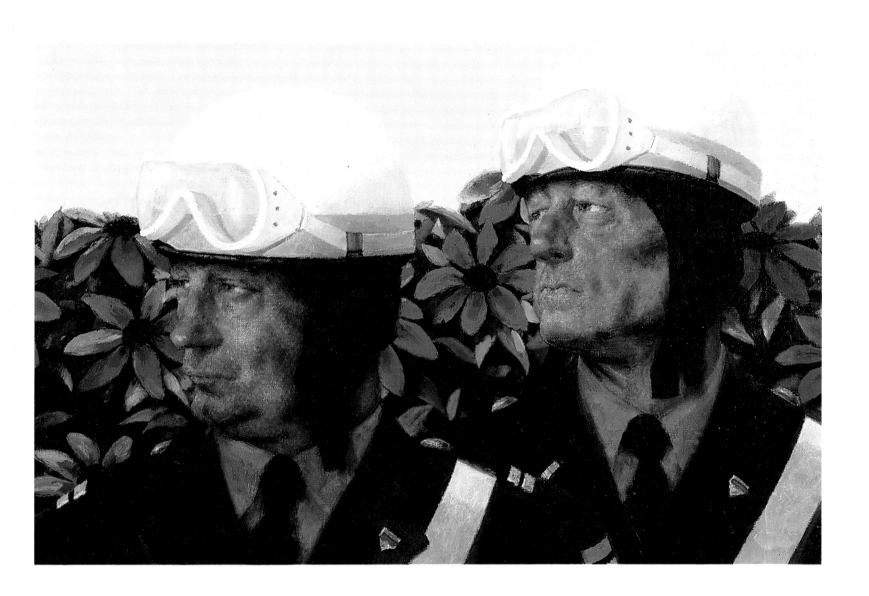

Integrity without knowledge is weak and useless, and knowledge without integrity is dangerous and dreadful.

Samuel Johnson/*Rasselas,* 1759

BARBARA D. HULTMANN

BORN

January 18, 1941, Minneapolis

EDUCATION

San Jose State College, CA, Summer Sessions, 1964–65

University of Minnesota, Minneapolis, BS, 1963

SELECTED SOLO EXHIBITIONS

White Oak Gallery, Minneapolis, 1985

SELECTED GROUP EXHIBITIONS

West/ART & THE LAW, 1982–85

AWARDS, GRANTS, FELLOWSHIPS

West/ART & THE LAW, Purchases, 1982–85

Minnesota State Fair, Merit Award, Jurors' Award, Celebrity Peoples' Choice Award, 1977–82, 84

Art Center of Minnesota, Honorable Mention, 1981–84

SELECTED COLLECTIONS

Amfac Hotel

Barclay Bank

Farm Credit Bureau

Federal Land Bank

First Bank of Robbinsdale

First Bank Plaza

First Federal Bank

The West Collection

POSITIONS

Art Center of Minnesota, Minnetonka, Instructor, 1985

Governor's Task Force: A High School for the Arts, 1985

Edina Public Schools, MN, Instructor, 1964–80

North St. Paul Public Schools, Instructor, 1963–64

ARTIST'S STATEMENT

I have been toying with the idea of doing some work with portraiture for the last year and a half. The human face and its 3-dimensional qualities are a fascinating challenge. Commissioned portraiture is very difficult to deal with, however, because of the vanities and tastes of the subject. I decided to satisfy this urge to work the face in paint via the ART AND THE LAW challenge. My husband, Tom, on the right, posed with his friend, John, to act out the scene of *The Informer.* The finished painting is the result of a composite of two slides.

Barbara D. Hultmann
The Informer
acrylic/27 x 24/1984

The Informer Barbara D. Huttmann

mortal men, be wary how ye judge.

Dante/*Paradiso*, xx, c. 1320

JACOB LANDAU

BORN
December 17, 1917, Philadelphia

EDUCATION
New School for Social Research, NY, 1948–49, 1952–53

Académie de la Grande Chaumière, Paris, 1950–52

Académie Julian, Paris, 1949–50

Philadelphia College of Art, 1935–38

Samuel S. Fleishe, Art Memorial, Philadelphia, 1931–36

SELECTED SOLO EXHIBITIONS
Philadelphia College of Art, 1985

Nevheisel Gallery, Saarbrucken, West Germany, 1985

Michael Hagen Gallery, Offenburg, West Germany, 1985

University of Northern Iowa, Cedar Falls, 1982

New Jersey State Museum, Trenton, 1981

University of Arizona, Tucson, 1979

ACA Gallery, NYC, 1976

Galeria Pecanins, Mexico City, 1972

Associated American Artists, NY, 1970

University of Notre Dame, IN, 1969

SELECTED GROUP EXHIBITIONS
West/ART & THE LAW, 1980, 85

National Academy of Design, NYC, 1974, 82, 85

Noyes Museum, Oceanville, NJ, 1985

Worcester Art Museum, MA, 1981

Print Club, Philadelphia, 1980

Society of Illustrators, NY, 1978

Smithsonian Institution, Washington, DC, 1977

Honolulu Academy of Arts, 1975

American Academy of Arts and Letters, NYC, 1973

AWARDS, GRANTS, FELLOWSHIPS
West/ART & THE LAW, Purchase, 1980

Ford Foundation Grant, 1974

John Simon Guggenheim Memorial Fellowship, 1968

Tamarind Lithography Workshop Fellowship, 1965

Lessing Rosenwald Purchase Award, 1955

Louis Comfort Tiffany Scholarship Award

National Academy of Design, NYC, Helen M. Loggie Prize

Philadelphia College of Art, Silver Star Alumni Award

SELECTED COLLECTIONS
Bibliothèque Nationale, Paris

Butler Institute of American Art

Fine Arts Museums of San Francisco

Hirshhorn Museum and Sculpture Garden

Metropolitan Museum of Art

Munson-Williams-Proctor Institute

Museum of Modern Art

National Gallery of Art

The West Collection

Whitney Museum of American Art

POSITIONS
Pratt Institute, Brooklyn: Instructor, Assistant Professor, Associate Professor, Professor, 1957–84; Professor Emeritus, 1984–Present

Philadelphia College of Art, 1954–57

School of Visual Arts, NY, Instructor, 1954–55

ARTIST'S STATEMENT
According to Dante, the Thieves of Florence are not entitled to their own bodies in Hell. John Ciardi, the translator, explains: "In life they took the substance of others, transforming it into their own. So in Hell their very bodies are constantly being taken from them, and they are left to steal back a human form from some other sinner. Thus they waver constantly between man and reptile, and no sinner knows what to call his own."

In Dante's *Inferno*, the punishment is designed to fit the crime, but it seems only to perpetuate it, just as in real life. This image is about the ongoing hell of trying to deter crime by punishing it—or perhaps, about thievery as the human condition. The female figure is a reminder of beauty, and of the possibility of redemption or transcendence.

This lithograph, part of a series illustrating the *Divine Comedy*, was supported by a grant from the Ford Foundation.

Jacob Landau

The Noble Thieves (Dante's Inferno)

pencil on mylar/23¾ x 17¾ (sight)

VIII XXV

Successful crimes are praised very much like virtue itself.

Jean de la Bruyère/*Caractères*, 1688

ROBERT J. LARSON

BORN
November 22, 1950, Willmar, MN

EDUCATION
Southwest Minnesota State College, Marshall, 1970–73

Willmar State Jr. College, Willmar, MN, 1968–70

SELECTED SOLO EXHIBITIONS
Western Plains Library, Montevideo, MN, 1981

Gallery 401, Willmar, MN, 1977

Southwest Minnesota State College, Marshall, 1975

SELECTED GROUP EXHIBITIONS
West/ART & THE LAW, 1979, 81, 83, 85

Minnesota State Fair, 1978, 79, 80, 85

Sioux City Art Center, IA, 1985

Red River Juried Show, Moorhead, MN, 1979

Manisphere, Winnipeg, Canada, 1976

College Group Shows, 1970–73

AWARDS, GRANTS, FELLOWSHIPS
West/ART & THE LAW, Purchases, 1979, 81, 83

SELECTED COLLECTIONS
The West Collection

Private Collections

POSITIONS
Full-time Artist

ARTIST'S STATEMENT
As a small-town country boy, I grew up afraid of big cities and crime. Doing this painting and others helped me cope with those fears.

By painting a big-time Chicago mobster under interrogation, handcuffed to a chair, possibly in a local precinct, I hoped to convey that the law is doing its job and is on guard across this country, prepared for any organized crime that might surface.

Robert J. Larson
Momo
oil, acrylic/70½ x 34½/1980

> *We enact many laws that manufacture criminals, and then a few that punish them.*
>
> Benjamin R. Tucker/*Instead of a Book,* 1893

ROBERT J. LARSON

BORN
November 22, 1950, Willmar, MN

EDUCATION
Southwest Minnesota State College, Marshall, 1970–73

Willmar State Jr. College, Willmar, MN, 1968–70

SELECTED SOLO EXHIBITIONS
Western Plains Library, Montevideo, MN, 1981

Gallery 401, Willmar, MN, 1977

Southwest Minnesota State College, Marshall, 1975

SELECTED GROUP EXHIBITIONS
West/ART & THE LAW, 1979, 81, 83, 85

Minnesota State Fair, 1978, 79, 80, 85

Sioux City Art Center, IA, 1985

Red River Juried Show, Moorhead, MN, 1979

Manisphere, Winnipeg, Canada, 1976

College Group Shows, 1970–73

AWARDS, GRANTS, FELLOWSHIPS
West/ART & THE LAW, Purchases, 1979, 81, 83

SELECTED COLLECTIONS
The West Collection

Private Collections

POSITIONS
Full-time Artist

Robert J. Larson
Take Him Alive
oil, acrylic/43¼ x 59½ /1977-78

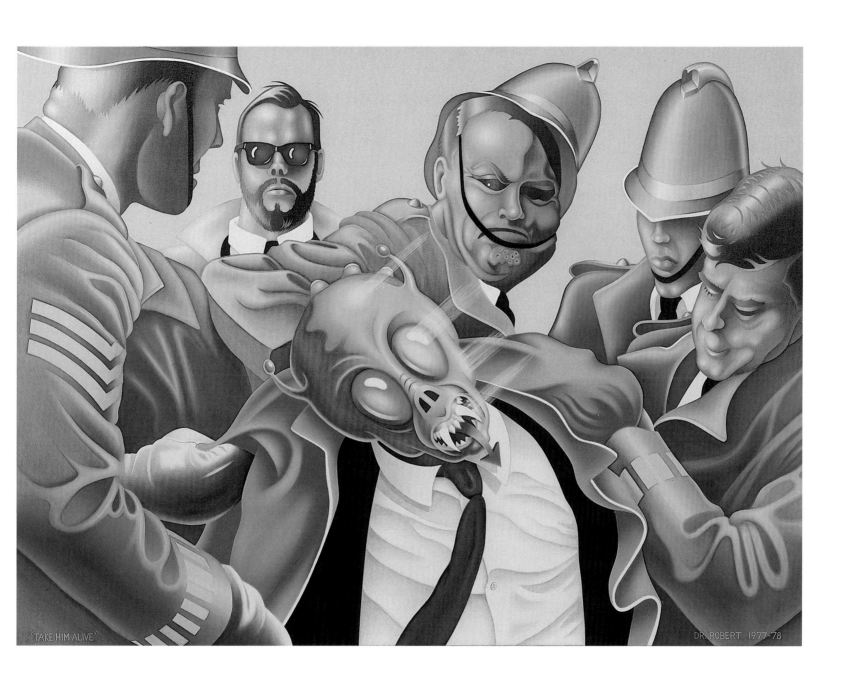

"TAKE HIM ALIVE"

DR. ROBERT 1977-78

he only stable state is the one in which all men are equal before the law.

Aristotle

JACK LEVINE

BORN
January 3, 1915, Boston

EDUCATION
Harvard University, Cambridge, MA, 1929–32

SELECTED SOLO EXHIBITIONS
The Jewish Museum, NYC; Brooks Memorial Art Gallery, Memphis; Montgomery Museum of Fine Arts, AL; Portland Museum of Art; Minnesota Museum of Art, St. Paul; 1978, 79

Rodman Hall Arts Centre, Ontario, 1978

Hyde Collection, Glens Falls, NY, 1978

Kennedy Galleries, NYC, 1975

Downtown Gallery, NYC, 1938, 48, 52

SELECTED GROUP EXHIBITIONS
West/ART & THE LAW, 1979, 81, 82, 83

Hamilton College, Clinton, NY, 1982

Oklahoma Art Center, Oklahoma City, 1982

Chrysler Museum, Norfolk, VA, 1980

National Academy of Design, NYC, 1981

American Academy of Arts and Sciences, NYC, 1981

Butler Institute of American Art, Youngstown, OH, 1981

Wilkes College, Wilkes-Barre, PA, 1981

Kennedy Galleries, NYC, 1977

Miami University Museum of Art, 1957

AWARDS, GRANTS, FELLOWSHIPS
National Academy of Design, Altman Prize, 1975

Pennsylvania Academy of Fine Arts, Lippincott Award, 1964

Corcoran Gallery of Art, Bronze Medal, 1947, W. A. Clark Award, 1959

Instituto National De Bellas Artes, Grand Prize, 1958

Colby College, Honorary Degree, DFA, 1957

Fulbright Grant, Rome, Italy, 1950–51

American Academy of Arts and Letters, Award, 1946

Carnegie Institute, Award, 1946

Guggenheim Memorial Fellowship, 1945

SELECTED COLLECTIONS
William Benton

Encyclopedia Britannica

Joseph Hirshhorn

Metropolitan Museum of Art

Anthony Mitchell

Jacob Schulman

Philip Sills

Arnold Weissberger

The West Collection

POSITIONS
Pennsylvania Academy of Fine Arts, Instructor, 1966–69

Skowhegan School, Summer Instructor, 1958–59

Cleveland Institute of Art, Instructor, 1950

ARTIST'S STATEMENT
My younger years were spent in the Depression, which was also the Century of the Common Man, of Jeffersonian pluralism, of "The People, Yes!" Today one doesn't like to go out in the street after dark. In *At the Precinct* I tried to find out what I feel about the human race rather than to deal out a sermon in oil paint.

Jack Levine
At the Precinct
oil/21 x 24 / 1979

A crowded police court docket is the surest of all signs that trade is brisk and money plenty.

Mark Twain/*Roughing It,* 1872

SANFORD T. M. MOCK

BORN
April 22, 1953, Honolulu

EDUCATION
University of Hawaii, 1971–75

SELECTED GROUP EXHIBITIONS
Japanese Centennial Art Exhibit,
Honolulu, 1985
West/ART & THE LAW, 1980
Honolulu Academy of Arts
Writer and Artist Collaboration

AWARDS, GRANTS, FELLOWSHIPS
Pele Award for Illustration, 1985
Print Magazine's Certificate of
Excellence, 1985
West/ART & THE LAW, Purchase, 1980
Easter Art Contest, Cash Award, 1977

SELECTED COLLECTIONS
The West Collection

POSITIONS
Aloha, RSVP, and *The Pacific* magazines,
Publication Designer, Present
Graphic Design
Commercial Arts

ARTIST'S STATEMENT
Hand Gun Blues was a piece created in
reference to violence motivated
emotionally, psychologically, or monetarily
and expressed so often with such a small
tool of destruction.

Sanford T. M. Mock
Hand Gun Blues
collage drawing/16 x 20

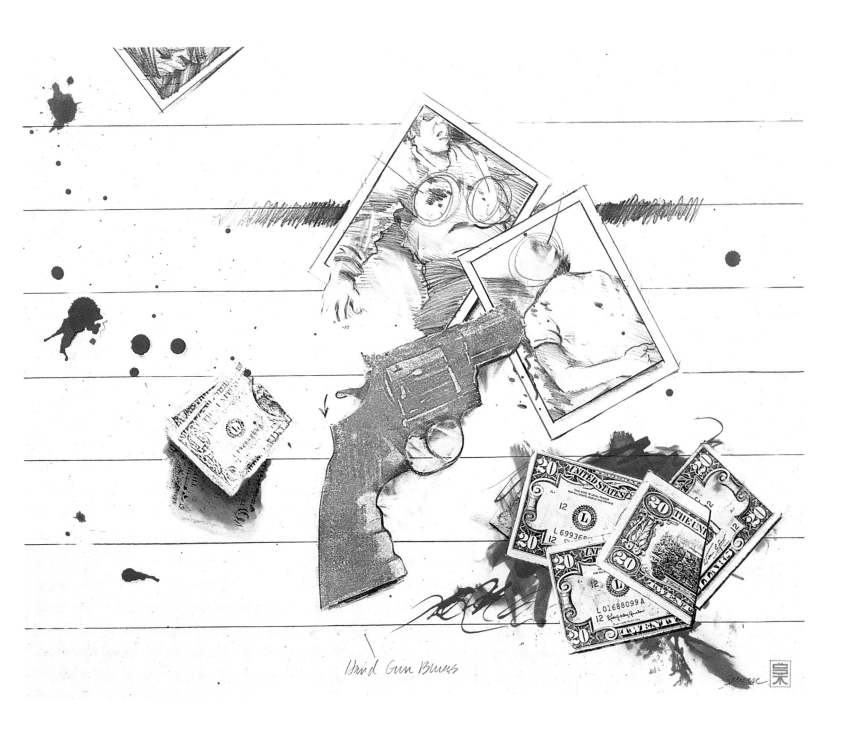

Hand Gun Blues

Sell not virtue to purchase wealth, nor liberty to purchase power.

Benjamin Franklin/*Poor Richard's Almanac,* 1738

DOUG ROESCH

BORN
April 13, 1950, San Francisco

EDUCATION
San Francisco Art Institute, MFA, 1983
Southern Illinois University, Carbondale, BFA, 1973

SELECTED SOLO EXHIBITIONS
Aglaia Production, NYC, 1986
85 Mercer Street Collaboration, NYC, 1985
Rorick Gallery, San Francisco, 1982–83
Brand X Studio, San Francisco, 1982
Performance Gallery, San Francisco, 1982

SELECTED GROUP EXHIBITIONS
Sound Shore Gallery, Port Chester, NY, 1985
West/ART & THE LAW, 1984
Emmanuel Walter Gallery, San Francisco, 1983
Rorick Gallery, San Francisco, 1982–83
Valencia Tool & Die, San Francisco, 1981–82
AAO Gallery, Buffalo, NY, 1981

AWARDS, GRANTS, FELLOWSHIPS
West/ART & THE LAW, Purchase, 1980

SELECTED COLLECTIONS
The West Collection

POSITIONS
Full-time Artist

ARTIST'S STATEMENT
Police Artist Walking His Beat started out as a drawing of myself on a midnight food shopping trip in San Francisco's Tenderloin District (my old neighborhood). While working on the piece, I made an erasure above the left eye and ripped the paper. I guess I was in an impatient mood because I chose to remedy the situation by putting a band-aid over the ripped paper. The band-aid on the forehead made me look like a TV cop, and that is how the police artist character was created.

Doug Roesch
Police Artist Walking His Beat
mixed media/35 x 23/1980

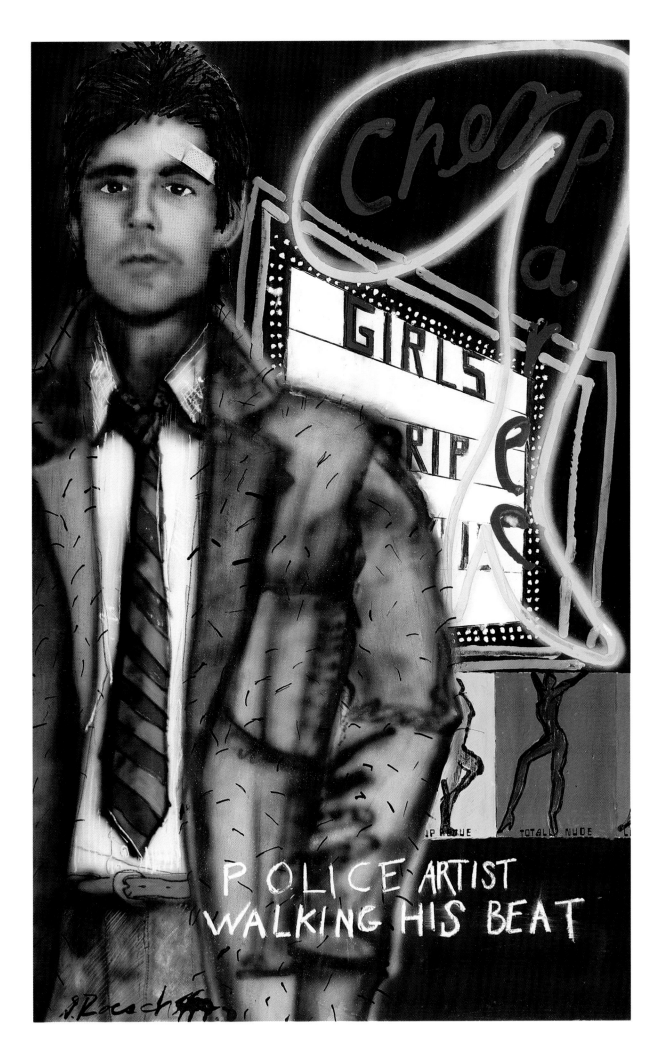

> *The greater the man the greater the crime.*
>
> Thomas Fuller/*Gnomologia*, 1732

KEN AKIVA SEGAN

BORN

February 19, 1950, NYC

EDUCATION

Jagiellonian University, Crakow, Poland, Summer, 1985

Academy of Fine Arts, Crakow, Poland, 1984

University of Missouri, MFA, 1980

Southern Illinois University, BFA, 1977

SELECTED SOLO EXHIBITIONS

Equivalents Gallery, Seattle, 1985

American Institute of Architects, Seattle, 1984

University of Illinois, Urbana, 1980, 82

Springfield Art Center, OH, 1982

Mittleman Jewish Community Center, Portland, 1982

Stroum Jewish Community Center, Mercer Island, 1982

Temple de Hirsch Sinai, Seattle, 1981

Donald Batman Gallery, Kansas City, 1980

SELECTED GROUP EXHIBITIONS

Aberdeen Art Museum, Aberdeen, Scotland, 1986

DeCordova & Dana Museum, Lincoln, MA, 1982, 85

Kanagawa Perfectural Gallery, Yokohama, Japan, 1984, 85

Stone Press Gallery, Seattle, 1984

Portland Art Museum, Portland, 1983, 84

Society of American Graphic Artists, NYC, 1983

Cheney Cowles Memorial Museum, Spokane, 1983

Alexandria Museum, Visual Art Center, LA, 1983

West/ART & THE LAW, 1980

AWARDS, GRANTS, FELLOWSHIPS

West/ART & THE LAW, Purchase, 1980

SELECTED COLLECTIONS

Bibliotèque Nationale, Paris

First Interstate Bank of Washington

Albertina Graphic Arts Collection, Vienna, Austria

Haifa Museum-Museum of Modern Art, Israel

Musée des Beaux-Arts Budapest, Hungary

Musée d'Art Juif de Paris

National Museum of American History, Smithsonian Institution

Nelson-Atkins Museum of Art

The New York Public Library

Warner-Lambert Corporation

The West Collection

POSITIONS

Artist-in-residence, Aberdeen Art Museum, Scotland, 1987

Kenneth Segan Fine Arts, Seattle

ARTIST'S STATEMENT

My image of the prisoner represents hope, both from inside the confines of a cell, and in the politically and socially complex world in which we all live.

I sought to portray the humanity of the prisoner, who is often an anonymous and forgotten member of society.

I hope that we, as Americans, and others in the world community can keep that flame of hope and humanity lit for all of the earth's inhabitants.

Ken Akiva Segan
The Prisoner
mixed media/40 x 28/1980

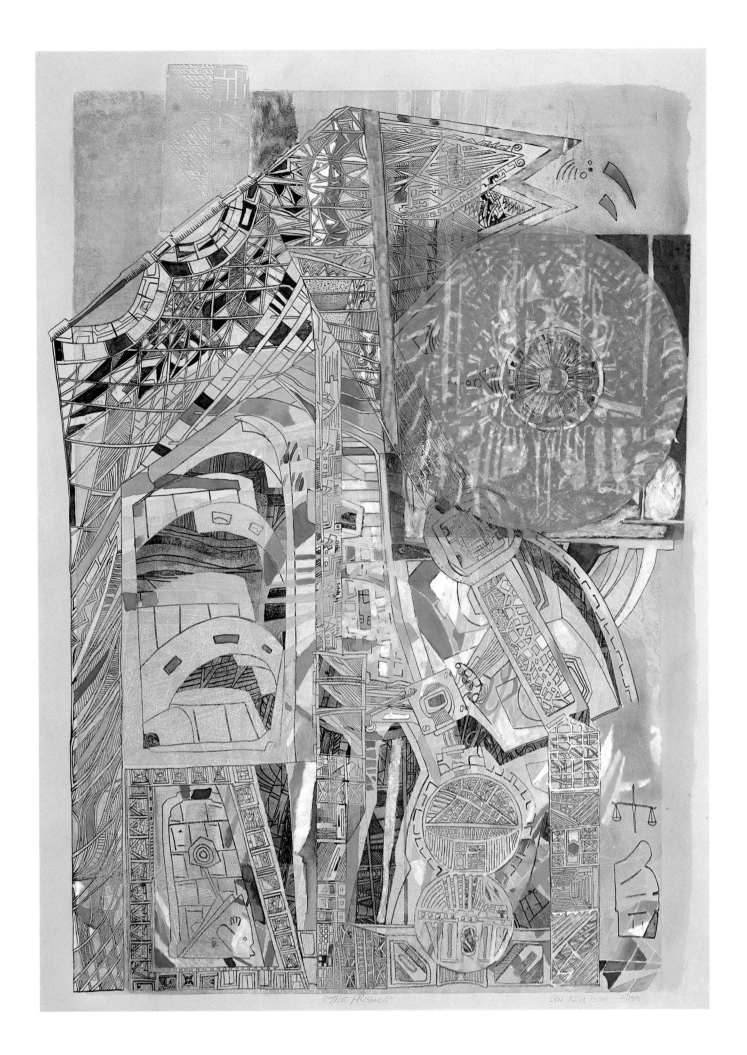

"THE PRISONER" Len Arthurson I/1980

et us begin by committing ourselves to the truth–to see it as it is, and tell it like it is–to find the truth, to speak the truth, and to live the truth.

Richard M. Nixon/Speech, accepting nomination, 1968

PATRICIA HOPE WINDROW

BORN
September 12, 1923, London

EDUCATION
Institute Lamartine, Paris

SELECTED SOLO EXHIBITIONS
Belanthi Gallery, Brooklyn, 1980, 83, 85
Pace University, NYC, 1983
State University of NY, Stony Brook, 1976
Professional Children's School, NYC, 1974
Rockefeller Foundation, NYC, 1972
Highgate Gallery, Upper Montclair, NJ, 1970
Gallery North, Setauket, NY, 1969
Pelham Arts Club, NYC, 1968
Worth Avenue Gallery, Palm Beach, FL, 1964
Arawac Hotel, Jamaica, BWI, 1955

SELECTED GROUP EXHIBITIONS
Smithtown Arts Council, Hauppauge, NY, 1978
State University of New York, Albany, 1963
Arts Club, NYC, 1962
Guild Hall, Easthampton, NY, 1961
Art USA, NYC, 1958
Allied Artists of America
Grand Central Art Galleries, NYC
Miniature Art Society of Washington, DC; FL, NJ

AWARDS, GRANTS, FELLOWSHIPS
West/ART & THE LAW, Purchase, 1979
Smithtown Arts Council Show, 1976
Arts Club, NYC, Award, 1962
Gallery North Outdoor Art Show
Guild Hall, Easthampton, NY, First Prize
National Arts Club, Wolfe Award

SELECTED COLLECTIONS
Berkshire Museum
Vladimir Horowitz
Parrish Museum
The West Collection

POSITIONS
Painting Instructor
Weekly TV Program, Brookhaven

ARTIST'S STATEMENT
In 1973, the Watergate affair clearly showed that the leaders of this country thought they were above the law.

My painting voices my opinion that they ought to be thrown out with the trash, namely, impeached.

Patricia Hope Windrow
Protest
oil on panel/12 x 16/1978

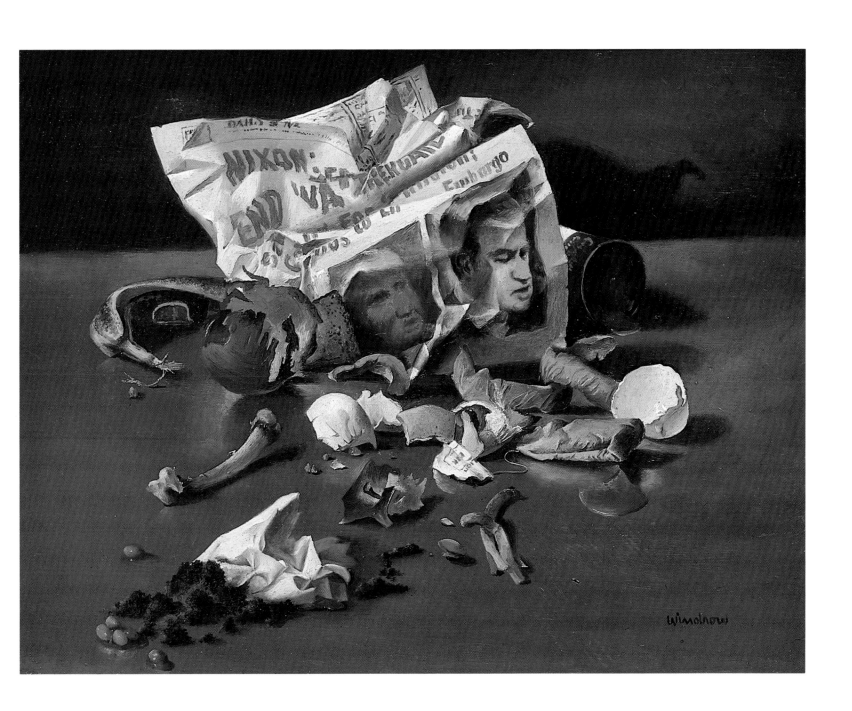

Inhumanities

n all, or nearly all, the states of Europe punishment for crimes has diminished or increased in proportion as they have approached nearer or removed farther from liberty.

C.L. de Montesquieu/*The Spirit of Laws,* 1748

LOUIS BERTRAND

BORN
August 26, 1928, Brussels, Belgium

EDUCATION
Military Service, Navy, Ostende, Belgium, 1948–1949

School of Agriculture, Vilvorde, Belgium, 1948

SELECTED SOLO EXHIBITIONS
Meriden Galleries, 1985

Manhattan Manor Gallery, Manhattan Beach, CA, 1981

Los Angeles County Museum of Art, 1976

Alley Gallery, Los Angeles, 1969

Great Western Savings, Los Angeles, 1968

Bognar Gallery, Los Angeles, 1967

SELECTED GROUP EXHIBITIONS
Artquest Exhibit, Los Angeles, 1986

International Art Show, Los Angeles, 1984

National Art Festival, Athens, OH, 1983

El Paso Museum of Art, TX, 1982

West/ART & THE LAW, 1981

Raymond Duncan Gallery, Paris, 1981

Los Angeles City Art Festival, 1976

International Art Festival, Century City, CA, 1965

AWARDS, GRANTS, FELLOWSHIPS
Raymond Duncan Award, Paris, 1981

West/ART & THE LAW, Purchase, 1981

"The Seaside" USA, Award, 1977

Los Angeles City Art Festival, Jury Award, 1976

International Art Festival, Honorable Mention, 1965

SELECTED COLLECTIONS
Mrs. Gary Cooper

Jerry Donahue

W. Ferrari, Monaco

Bob Hope

Jack Palance

Tom Selleck

Red Skelton

N.V. Vaerenbergh, Belgium

The West Collection

The White House

POSITIONS
Antiques-Collectibles Dealer, Present

ARTIST'S STATEMENT
The idea for this painting comes from photographs and sketches, which I have seen and read about, of the penal colony in French Guiana. The painting represents the Tribunal Maritime in Cayenne. The verdict is death by the guillotine. One convict—the one at right—is perhaps not guilty of a major crime, but the verdict stands the same for all three men; maybe justice is blind in more ways than one.

Louis Bertrand
Tribunal, French Guiana, 1930s
acrylic/11⅝ x 15½/1981

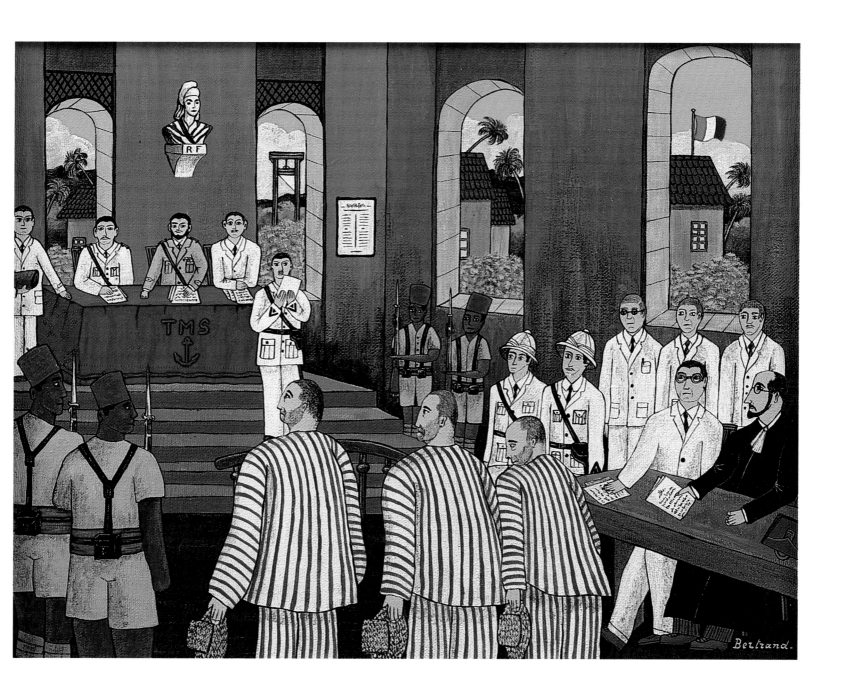

There is a road to freedom. Its milestones are Obedience, Endeavor, Honesty, Order, Cleanliness, Sobriety, Truthfulness, Sacrifice, and love of the Fatherland.

Adolf Hitler/Message painted on concentration camp walls

OLEXANDER KANIUKA

BORN
November 4, 1910, Huzhiwka, Ukraine,

EDUCATION
University of Minnesota, Department of Art, 1952–1979

Munich Academy of Arts, West Germany, 1946–51

Industrial Art School, Kiev, Ukraine, 1937–41

SELECTED SOLO EXHIBITIONS
Phipps Center For the Arts, Hudson, WI, 1985

Jean's Art Display, Minneapolis, 1985

Sofia Skrypnyk, Edmonton, Canada, 1975, 85

Harabash Gallery, Parma, OH, 1983, 84

Dakota Center for the Arts Gallery, 1984

Niagara Falls Art Gallery and Museum, Ontario, Canada, 1978

Twin City Federal Savings and Loan, 1976

University of Minnesota, 1951, 56

SELECTED GROUP EXHIBITIONS
Winfield Walker Gallery, Minneapolis, 1985, 86

International Institute of Minnesota, St. Paul, 1983

West/ART & THE LAW, 1979–82

Northern Lights, White Bear Arts Council, 1979

Flanders Contemporary Art, Minneapolis, 1977

Kramer Gallery, St. Paul, 1964

AWARDS, GRANTS, FELLOWSHIPS
West/ART & THE LAW, Purchase, 1982

SELECTED COLLECTIONS
I. Marian Boraczok

Eugene Steckiv, MD

The West Collection

Private Collections in USA and Canada

POSITIONS
Full-time Artist

ARTIST'S STATEMENT
At one time I sat in the Kiev jail in Ukraine, quite innocent, next to a woman's cell from which I heard mournful crying every day around 6:00 p.m. This is when the day ended and the night began. The interiors of the women's cells was the same as those of the men's, except that their guards were women. I still cannot forget their choral wailing. Even to this day my heart aches when I remember this experience, and it is for this reason that I decided to paint it. They were sentenced to prison for refusing to join the Kolhosp (collective farm). This experience was in 1930.

Olexander Kaniuka
Gulag No. 2
oil/27³⁄₄ x 43³⁄₄

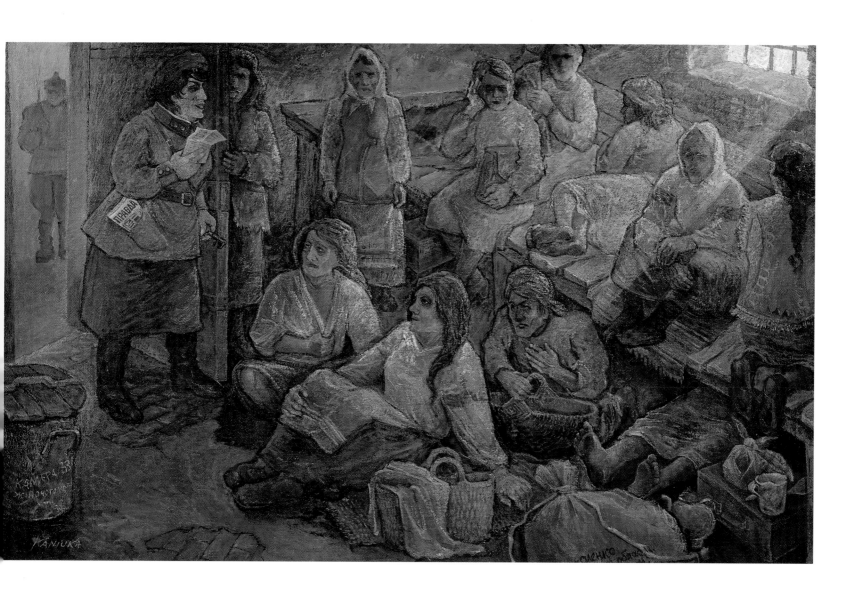

Disobedience to the law, civil and criminal , has become a mass phenomenon in recent years, not only in America, but also in a great many other parts of the world. The defiance of established authority, religious and secular, social and political, as a world-wide phenomenon may well one day be accounted the outstanding event of the last decade.

Hannah Arendt/*Crises of the Republic,* 1972

JEFFREY ELGIN

BORN
March 17, 1943, Cleveland

EDUCATION
University of Cincinnati, BS, 1966, MFA, 1968
Cincinnati Art Academy, 1967

SELECTED SOLO EXHIBITIONS
Graphic Artists, Schenectady, NY, 1975, 77, 81
Rensselaer County Council for the Arts, Troy, NY, 1980
WMHT-TV, Documentary Film, 1976
Skidmore College, Saratoga Springs, NY, 1970, 75
Oklahoma Art Center, Oklahoma City, 1974
State University of New York, Cobleskill, 1973
Schenectady Museum, NY, 1973
University of Cincinnati, 1968

SELECTED GROUP EXHIBITIONS
Clemson University, SC, 1985
University of North Dakota, 1981, 85
Ball State, Muncie, IN, 7 National Drawing & Small Sculpture Shows, 1970–84
West/ART & THE LAW, 1979–81
State University Art Gallery, 1973, 76, 78, 81
Portsmouth Art Center, VA, 1978, 79, 81

American Academy of Arts and Letters, 1979, 80
Butler Institute of American Art, Youngstown, OH, 1979, 80
Munson-Williams-Proctor Institute, Utica, NY, 1979

AWARDS, GRANTS, FELLOWSHIPS
Ball State National Drawing & Small Sculpture Show, Purchase, 1980, 84
Appalachian State University, Purchase 1977, 80, 83
Fort Hays State University, Jurors Award, 1978, 80
West/ART & THE LAW, Purchase, 1980
Washington and Jefferson College, Purchase Award, 1979, 80
American Academy of Arts and Letters, Hassam-Speicher Fund Purchase, 1979
State University Art Gallery, Purchase, 1973
Selected for Smithsonian Institution Circulating Exhibition

SELECTED COLLECTIONS
Albany Institute of History and Art
Appalachian State University
Ball State University
Dayton Museum of Art
Minot State College
Oklahoma Art Center
St. Lawrence University
State University of New York
Washington & Jefferson College
The West Collection

POSITIONS
Skidmore College, Saratoga Springs, NY, Professor of Art, 1968–Present
University of Cincinnati, College of Design, Architecture and Art, Instructor, 1967–68

ARTIST'S STATEMENT
The seen reality was wrenching.
The unseen reality was even worse.
Disorder rending order.
Bitter malaise.
Bruised moments of the soul.
A desperate act. Bearing witness.
All codes, all laws, all boundaries violated.
A desperate search for solution.
A prayer.

Jeffrey Elgin
Held (Dedicated to the American Hostages)
oil/triptych/70 x 168

Success is the sole earthly judge of right or wrong.

Adolf Hitler/*Mein Kampf,* 1925–26

JEROME WITKIN

BORN

September 13, 1939, Brooklyn, NY

EDUCATION

University of Pennsylvania, MFA, 1968–70
Cooper Union School of Art, NYC, 1957–60
Skowhegan School of Painting and Sculpture, Summers of 1955, 57

SELECTED SOLO EXHIBITIONS

Sherry French Gallery, NYC, 1985
Community College of the Finger Lakes, Canandaigua, NY, 1984
Traveling Museum, 1983
Kraushaar Galleries, NYC, 1973, 76, 82
Penn State University, PA, 1978
State University of New York, Cortland, 1977

SELECTED GROUP EXHIBITIONS

West/ART & THE LAW, 1985, 86
National Academy of Design, NYC, 1985
Sherry French Gallery, NYC, 1985
Munson-Williams-Proctor Institute, Utica, NY, 1982
Pratt Manhattan Center, 1982
Villanova University Art Gallery, PA, 1982
Smithsonian Institution, National Traveling Exhibit, 1979
State University of New York, Potsdam, 1979
Skidmore College, Saratoga Springs, NY, 1977
DeCordova Museum, Lincoln, MA, 1975

AWARDS, GRANTS, FELLOWSHIPS

West/ART & THE LAW, Purchase, 1985
National Academy of Design, Benjamin Altman Prize, 1985
Guggenheim, Ford, Pulitzer, E.D., Foundation Grants

SELECTED COLLECTIONS

Butler Institute of American Art
Cleveland Museum of Art
Cornell University of Veterinary Medicine
Gallerie Degli Uffizi, Florence
Hirshhorn Museum and Sculpture Garden
Memorial Art Gallery
Metropolitan Museum of Art
Minnesota Museum of Art
Phillips Exeter Academy
The West Collection

POSITIONS

Syracuse University, Professor in Studio Arts
Full-time Artist

ARTIST'S STATEMENT

I have tried to convey my own deeply felt reactions to the atrocities of war, the war against the Jews of Europe between 1933 and 1945. In an attempt to understand fully what happened, what it was like, I have read personal accounts describing the horrors of the victims—their helplessness and panic, the agony of watching their loved ones be destroyed.

We see what the running girl sees, as she moves between realities, toward the prophecy of the Final Solution. I chose the triptych form since it is traditionally used to represent martyrs. This form, reading from left to right, gave me a way of moving the girl, filmlike, through the different spaces and light.

Jerome Witkin
Death as an Usher: Germany, 1933
oil/triptych/219⅞ x 304⅞/1979-81

The brazen-throated clarion blows
Across the Pathan's reedy fen,
And the high steeps of Indian snows
Shake to the tread of armed men . . .
Such greeting as should come from those
Whose fathers faced the Sepoy hordes,
Or served you in the Russian snows
And dying, left their sons their swords.

Rudyard Kipling/Candy Crow

ROBERT NELSON

BORN
August 1, 1925, Milwaukee

EDUCATION
New York University, NYC, ED. D., 1971
Art Institute of Chicago, MAE, 1951
Art Institute of Chicago, BAE, 1950

SELECTED SOLO EXHIBITIONS
Community Art Gallery, Lancaster, PA, 1986
Plains Art Museum, Moorhead, MN, 1985

SELECTED GROUP EXHIBITIONS
Philadelphia Print Club, 1984
Springfield Art Museum, MO, 1972
Smithsonian Institution, Washington, DC, 1968

AWARDS, GRANTS, FELLOWSHIPS
Tamarind Lithographic Fellowship, John Herron Art School, 1964
Danforth Teacher Grant for Doctoral Study at NYU, 1962–64
Bryant/Lathrop Traveling European Fellowship, Art Institute of Chicago, 1951

SELECTED COLLECTIONS
Addison Gallery of American Art
Columbia Museum of Art
Mint Museum
R. J. Reynolds Collection
US Judges Collection
Walker Art Center
The West Collection

POSITIONS
Millersville University, PA, 1979–Present
University of North Carolina, Chapel Hill, 1973–79
Cleveland State University, 1971–73
University of North Dakota, 1956–71
University of Manitoba, Canada, 1953–56
Art Institute of Chicago, 1951–53

Robert Nelson
Candy Crow
lithograph (27/30)/ 22 x 29¾ (image)/1979

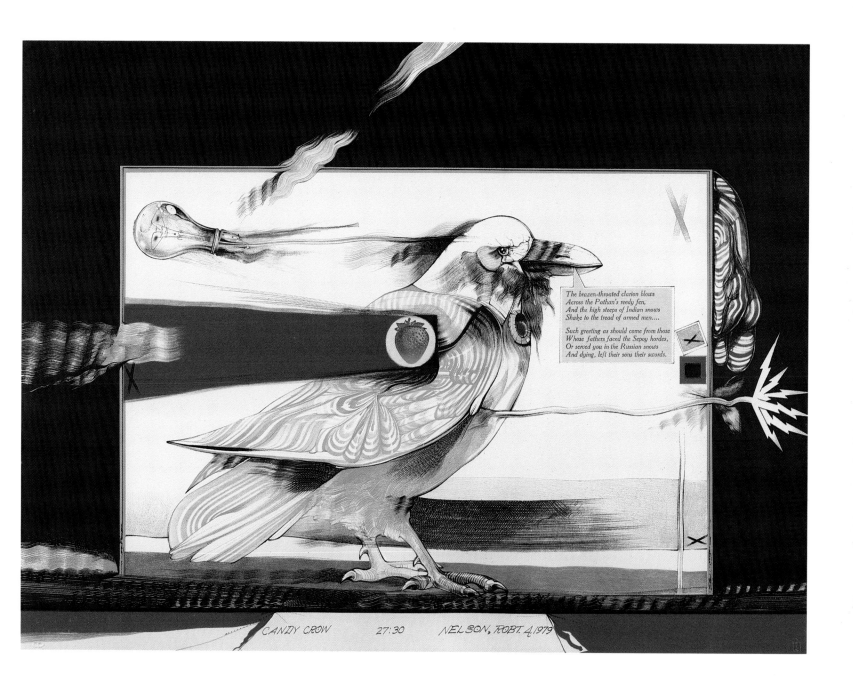

The brazen-throated clarion blows
Across the Pathan's reedy fen,
And the high steeps of Indian snows
Shake to the tread of armed men....

Such greeting as should come from those
Whose fathers faced the Sepoy hordes,
Or served you in the Russian snows
And dying, left their sons their swords.

CANDY CROW 27:30 NELSON, ROBT. A, 1979

f it's natural to kill, why do men have to go into training to learn how?

Joan Baez/*Daybreak,* 1966

JOSE S. PEREZ

BORN
June 30, 1929, Houston

EDUCATION
American Academy, Chicago, 1955–57
Chicago Academy, 1948–51

SELECTED SOLO EXHIBITIONS
Jack Meier Gallery, Houston, 1982, 84
Witte Memorial, San Antonio, 1967
Mexican Institute of North American
Cultural Relations, Monterrey, Mexico, 1963

SELECTED GROUP EXHIBITIONS
West/ART & THE LAW, 1980
Washington Gallery of Modern Art,
Washington, DC, 1965

AWARDS, GRANTS, FELLOWSHIPS
City of Houston, Artistic Recognition, 1981
Houston Library, Commission, Portrait of
Archbishop of San Antonio

SELECTED COLLECTIONS
Patricio Flores Branch Library, Houston
The West Collection
Private Collections

POSITIONS
Instructor, Private Classes, 1960–85
Currently completing two books, one on
drawing the human figure, the other on
ecology

ARTIST'S STATEMENT
Judging from the expression of the recruit, a
matter of serious consequence is in sight:
perhaps a historic event in the making, a
rare occurrence to be witnessed by few.
The volunteer reluctantly stands his ground.
Loyalty and patriotism are in question; only
the presence of the three illustrious citizens
keeps him from leaving his post.
The Volunteer was based on the Vietnam
War.

Jose S. Perez
The Volunteer
oil/35⅛ x 55⅛/1980

202

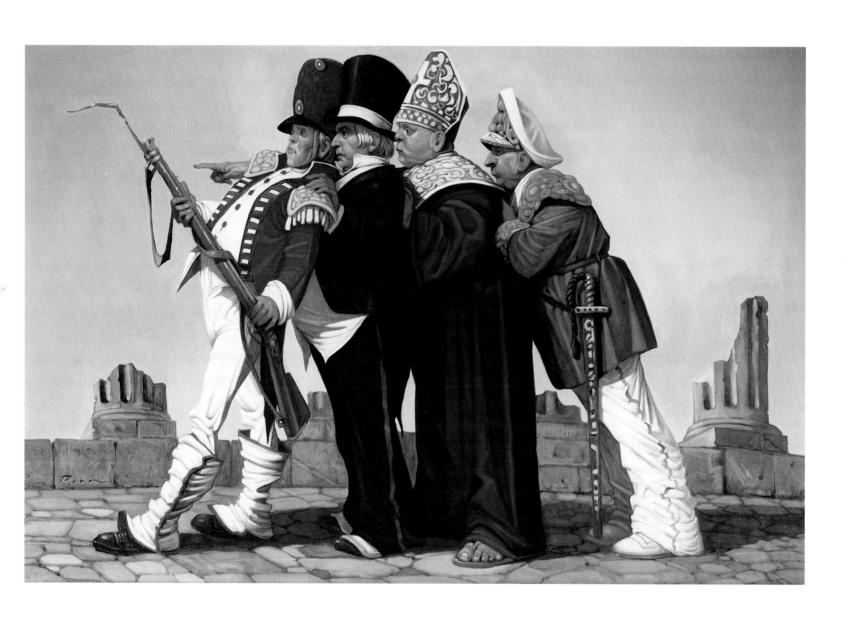

Artists Represented in the Collection

Apatoff, David B.
Arfstrom, Jon
Armstrong, B. H.
Batt, Miles G.
Beard, Robert D.
Bedwell, Edward E.
Benedict, Grace
Berrier, Terry
Bertrand, Louis
Birmelin, Robert
Blagden, Allen
Bowen, William E.
Brannen, John R.
Breverman, Harvey
Broderson, Morris
Brown, Alice Dalton
Browning, Colleen
Cameron, George D., III
Canton, Shelly
Carter, Edwin Robert
Cicero, Carmen
Connealy, Ross
Cooling, Janet
DeFrees, Jonathan
DiGiorgio, Joseph

Dinnerstein, Harvey
Drexler, Henry J.
Dubyn, Jerome M.
Durkee, Carl A.
Early, Janet Fritz
Echeverria, Frje
Elgin, Jeffrey
Essner, Gene
Feldman, Franklin
Fitzgerald, John
Frankenstein, Curt
Fraser, Scott
Gilderhus, Grant
Goldstein, Linda Grip
Grady, Ruby
Hruen, Shirley Schanen
Hagen, Cathryn C.
Haines, Richard
Haughey, James M.
Hirsch, Joseph
Houseman, Charles N.
Howard, Dan F.
Howard, Jesse L.
Hubbard, Bruce A.
Hultmann, Barbara D.

Irle, Judith L.
Jahnke, Violette
Joseph, Joel D.
Kaniuka, Olexander
Kepets, Hugh
Landau, Jacob
Landon, Edward
Larson, Robert J.
Lasansky, Leonardo
Levine, Jack
Little, George
Loven, Del Rey
Lybecker, Kirk
Margolius, Richard V.
Mattes, Hans A.
May, Jack A.
McCormick, Curtis G.
McElroy, Jacquelyn
McNeil, William Oil
McNulty, Mary Zimmer
Miller, Michael R.
Mock, Sanford T. M.
Murphy, Joyce E.
Nahstoll, R. W.
Narber, Gregg R.

Nelson, Robert
Newcomb, William L.
O'Gorman, Laurel
Olson-Mandler, Sue
Pacheco, Erasmo C.
Peckar, Robert S.
Pepito, Tony
Perez, Jose S.
Pink, James B.
Pletka, Paul
Plochmann, Carolyn
Pribble, Fred T.
Quinn, Thomas J.
Rattner, Abraham
Richards, Edward P.
Roberts, James H., III
Roesch, Doug
Rothchild, R. C.
Rudquist, Jerry
Sawyer, Thomas Alan
Schmidt, Charles
Segan, Ken Akiva
Shannon, Charles
Shechter, Ben-Zion
Singer, Arnold

Smith, Lee N., III
Solomon, Charles M.
Spurling, Norine
Steg, J. L.
Stevens, Jane Greengold
Storch, Sally
Swenson, James T.
Swiler, James
Taft, Stan
Taylor, Joe E.
Thompson, Donald Roy
Tripp, David E.
Virgona, Hank
Walcott, Anne Bennett
Wall, Bud
Waterhouse, Charles H.
Wilde, John
Windrow, Patricia Hope
Witkin, Jerome
Wright, Robert M.
Zeldin, Betsy

PATRIOTISM–SYMBOLISM

THE COURT AS AN INSTITUTION

THE LEGAL PROFESSION

DUE PROCESS OF LAW—JUSTICE